The Nikon D90 Companion

BEN LONG

O'REILLY®

Beijing · Cambridge · Farnham · Köln · Sebastopol · Taipei · Tokyo

The Nikon D90 Companion
by Ben Long

Copyright © 2009 Ben Long. All rights reserved.

Published by O'Reilly Media, Inc. 1005 Gravenstein Highway North, Sebastopol CA 95472

O'Reilly books may be purchased for educational, business, or sales promotional use. Online editions are also available for most titles (*safari.oreilly.com*). For more information, contact our corporate/institutional sales department: (800) 998-9938 or *corporate@oreilly.com*.

Editor: Colleen Wheeler
Production Editor: Molly Sharp
Technical Editor: Jon Canfield
Copyeditor: Kim Wimpsett
Indexer: Denise Getz
Interior Design: David Futato, Ron Bilodeau
Cover Designer: Steve Fehler
Photographer: Ben Long

Print History: March 2009, First Edition

ISBN-13: 978-0-596-15987-0
[F] [12/09]
Printed in Canada

Contents

CHAPTER 8 Finding and Composing a Photo
Exploring the art of photography. 187

CHAPTER 9 Specialty Shooting
Using special features for shooting in specific conditions 213

CHAPTER 10 Flash Shooting

Using a flash and other tools for better control of the
lighting in your scene

CHAPTER 11 Raw Shooting

Using raw format to gain more control and better image
quality

Acknowledgments

Ask anyone who knows me and they'll probably say that it's not a good idea to be around when I'm working on a book, because I'll invariably ask to make a photographic example of you. This book was no exception, and I'd like to thank Konrad Eek, Rossitza Jekova-Goza, Emily Clinton, Jeanne Phyllis Verity Parkhurst, Hans Wendl, Rick Poland, Regina Saisi, Joanna Silber, and Marz the cat for standing (or laying) there while they were turned into example images. Special thanks to Susan Skapic for cover modeling outside, barefoot, on a very cold November day.

Also, a big thanks to the photography students of the 2008 Oklahoma Summer Arts Institute. Always inspiring and fun to work with, they also served as willing models. Check out *www.oaiquartz.org* to learn more about this exceptional, one-of-a-kind program.

Thanks, too, to the grandmothers of GAPA—Grandmothers Against Poverty and AIDS—an amazing NGO in South Africa composed of grandmothers who are trying to hold their families and communities together in the face of the AIDS pandemic while simultaneously raising their own grandchildren and fighting to improve the lives of people in townships all over South Africa. Some images of them (and their grandchildren) appear in Chapters 8, 12, and 14. Check out *www.gapa.org.za* to learn more about this amazing organization.

Finally, thanks to Dennis Fitzgerald for ushering this project through all of the rigamarole required to make a book; to the aptly-surnamed Molly Sharp for catching even the tiny mistakes and inconsistencies; and to Colleen Wheeler for concocting the idea in the first place and for being so helpful in bending it into its current shape.

Preface

Before we get to how cool your Nikon D90 is, I want to clear up an important issue: Why in the world do you need this book? This camera comes with a very detailed manual, so you might be wondering why you should slog through another big batch of pages.

If you've already looked at the manual that came with your camera, then you've probably discovered that it details each and every button in reasonably clear language and it's well-organized, leading you from simple features to more advanced ones. However, knowing what each button on your camera does won't necessarily mean you can shoot great pictures. Personally, I know the basic concept of a paintbrush, but I can't paint a decent painting to save my life. To use a creative tool well, you must understand both the technique and the craft of the tool, as well as have some sense of artistry when you use it.

That's the idea behind this book. While the automatic systems in the Nikon D90 mean you can shoot snapshots that are almost always properly exposed and possessed of great color, if you want to go further and create images that express something more than a simple documentation of an event, then you need to know something of the art of photography. This book is intended to serve as a full-on photography class, one that covers everything including technical matters and exposure theory, composition theory, and how to find images and expand your visual sense. However, unlike a regular photography class, the class presented in this book is built specifically around the D90. That means every concept is written about in terms of the D90's controls and features.

Automatic cameras are great because they do a lot of the work for you, but sometimes you must take manual control and make decisions on your own. This D90 companion will walk you through all the basic photography theories that apply to any camera—whether film or digital—and that you need to understand to be able to fully exploit the capabilities of the D90.

So, by the time you're done with this book, you'll not only know how all the D90's controls function, but you'll also know how to recognize a good photo and how to use the D90's controls to represent that subject as a compelling image. In other words, you'll be a better photographer, whether you're shooting simple snapshots or aiming for something more.

I realize once you start using this camera, you probably won't be able to resist taking lots of pictures. This is a good thing; one of the great advantages of digital photography is that it doesn't cost you anything to shoot. Because your storage media is reusable and because there's not an expensive chemical process, you can shoot for

free, making it easy to practice and experiment. The freedom to practice will do more to improve your photographic skill than anything else. However, all that practice and experimentation can also mean that you'll soon find yourself mired in a huge number of images. Managing the editing, output, and long-term storage of all of these files can be daunting, but there are a few strategies you can employ to ease your workflow. I've covered these in a bonus online chapter, "Workflow: Managing Your Postproduction," available at *www.oreilly.com/catalog/9780596159870*.

This book has been great fun to write, largely because the D90 is a fantastic camera. At one time or another I've had my hands on just about every digital SLR made, and I own several that I shoot with all the time. The camera's image quality is top-notch, and the compact design and excellent interface make it a lot of fun to work with. This is a camera that delivers a tremendous amount of imaging power right out of the box, and with this book, you'll learn to get the most from it.

For More Information

You can address comments and questions concerning this book to the publisher:

O'Reilly Media, Inc.
1005 Gravenstein Highway North
Sebastopol, CA 95472
(800) 998-9938 (in the United States or Canada)
(707) 829-0515 (international or local)
(707) 829-0104 (fax)

We'll list errata, examples, and any additional information at:
 http://www.oreilly.com/catalog/9780596159870

To comment or ask technical questions about this book, send email to:
 bookquestions@oreilly.com

You can also find more information by going to O'Reilly's general Digital Media site:
 digitalmedia.oreilly.com

Safari® Books Online

Safari Books Online

When you see a Safari® Books Online icon on the cover of your favorite technology book, that means the book is available online through the O'Reilly Network Safari Bookshelf.

Safari offers a solution that's better than e-books. It's a virtual library that lets you easily search thousands of top tech books, cut and paste code samples, download chapters, and find quick answers when you need the most accurate, current information. Try it for free at *http://my.safaribooksonline.com*.

Getting to Know the Nikon D90

SHOOTING SNAPSHOTS USING AUTO MODE

If you're new to the Nikon D90, then you're probably much more interested in doing some shooting than in reading a book. So, in this chapter I'm going to quickly get you up to speed on the camera's automatic features so that you can get out the door right away and start using the camera. One of the great features of the D90's design is that you can use it just like a point-and-shoot camera and then activate more sophisticated controls as you need them. This first chapter explains the fundamental concepts of camera and photographic technique that I'll build on through the rest of the book.

BEFORE YOU CAN SHOOT WITH THE D90

If you haven't yet set up your camera, you need to do a few things before you can shoot with it. Fortunately, the D90 manual is very good, and you can learn everything you need to know about setup by reading the following sections of the manual:

- While the camera battery may have a little charge when you first unpack the camera, it's best to give it a good refueling before you head out to shoot. Read pages 22–24 of the Nikon D90 manual to learn about charging and installing the battery.

- You'll need a Secure Digital (SD) memory card for your camera. The D90 does not ship with a card, so you'll have to buy one separately. Any photography store or electronics store should carry them. You can learn how to install and remove the card on pages 29–31 of the D90 manual.

- A lens must be attached to your camera. If you bought the D90 kit, then you probably got an 18-105mm lens. If you bought the body-only package, then you should have bought a lens separately. You can learn how to attach and remove a lens on pages 25–26 of the D90 manual.

- The power switch on the top of the camera powers up the D90 (as long as you have a charged battery installed). If it's the first time you're turning the camera on, then the camera will prompt you to enter the date and time. Pages 27–28 will walk you through setting the date, time, and language that you want to use in the camera's menus.

- Finally, the camera includes a shoulder strap. The best way to ensure that your camera doesn't get damaged is to attach the shoulder strap and use it! The camera will be more secure and easier to carry if you have the strap attached. Page 17 of the D90 manual shows how to attach the strap.

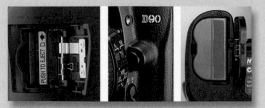

From left to right, the D90's media slot (with card inserted), lens mount button and reference dot, and battery.

If you've shot only with a point-and-shoot camera, then you'll find much to like about working with a single-lens reflex (SLR). The bright, clear viewfinder, the ability to change lenses, and the advanced manual controls will give you far more creative power than you probably had on your point-and-shoot camera. If you're an old-school SLR film shooter, then the switch to digital will bring you huge improvements in workflow, image editing, and overall image quality.

Obviously, with all the power packed into a camera like the D90, you have a lot to learn. However, since the camera also has advanced auto functions, you can get started shooting with it right away and, to a degree, use it just like you used your point-and-shoot.

The best way to learn your camera is to use it, so before I cover the specific parts and components of your D90, you should do a little snapshot shooting just to get your hands on the camera and get a feel for the general control layout.

Resetting the Camera's Defaults

If you've already been playing with your D90, you might have changed some of the internal settings. To ensure that your camera behaves the way that I'll describe in this book, you should reset to the camera's defaults.

To reset the D90 to its default settings, follow these steps:

1. Set the Mode dial to P.

2. Press and hold the ☒ and **AF** buttons for two seconds.

The LCD screen on the top of the camera will go blank for a moment, and when it comes back up, the camera's essential settings will be reset to their factory defaults. (On page 260 of the D90 manual, you'll find a complete list of the settings that are affected by this operation.)

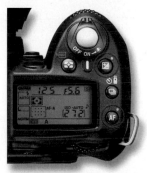

Press and hold the two circled buttons for two seconds to reset the camera to its factory defaults. Note that the two buttons each have a green dot next to them.

Snapshot Shooting in Auto Mode

The D90 has full autofocus and autoexposure features that can make all of the photographic decisions that you need to make in most situations. When in Auto, all you have to do is frame the shot and press the shutter button, and the camera will automatically figure out just about every other relevant setting. However, you still need to know a few things to get the most out of Auto mode.

On the top of the D90, on the left side of the camera, is a Mode dial. The mode that you choose with this dial determines which functions the camera will perform automatically and which will be left up to you. So if you want more creative control, then you'll want to select a mode that offers less automation and leaves more power in your hands.

For snapshot shooting, Auto mode will be your best bet and will make your D90 function much like a simple point-and-shoot camera—but one that delivers the superior image quality of an SLR.

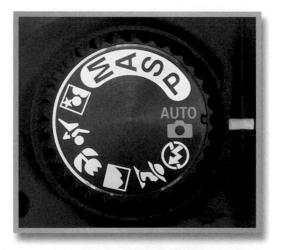

Set the camera's Mode dial to the green box to select Auto mode.

If you haven't done so already, take the lens cap off the camera. You don't have to worry about accidentally shooting with it on, because if the lens cap is on, you won't see anything in the viewfinder. Make sure the switch on the lens is set to autofocus, not manual.

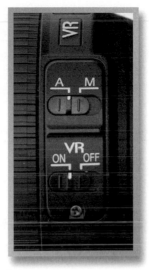

The 18-55mm lens kit includes an autofocus switch, and most other lenses will have a similar switch. Make certain it's set to A.

Framing Your Shot

This next part you probably already know: Look through the viewfinder, and frame your shot. If you have a zoom lens attached to your camera, you can zoom to frame tighter or wider. For now, you don't have to worry about composition, because I'll be discussing that in detail later.

Autofocus, or "How to Press the Shutter Button"

With your shot framed, you're ready to shoot. However, although pressing the shutter button may seem a simple thing, there are some important things to understand about it, because it's your key to the camera's autofocus feature.

Once you've framed the shot, press the shutter button *halfway*. When you do this, the camera will analyze your scene and try to determine what the subject is.

There are eleven focus points that the camera can analyze. The D90 will light up all of the focus points that are sitting on what it has determined to be the subject. The lens will focus on that subject.

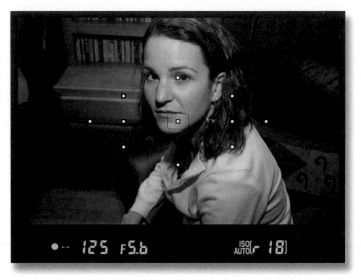

When you half-press the shutter button to autofocus, the D90 will light up the focus spots that it thinks are correct for your subject.

Note that the camera may light up more than one focus point. Often, several potential subjects sit on the same plane (that is, they're all the same distance from the camera). The D90 will show you all of the focus points that it considers in focus. As long as one of them is on your subject, then it has focused correctly.

When the D90 has achieved focus, it will beep and show a green circle on the left side of the viewfinder status display. (You can see this in the previous figure.)

This half-press of the shutter is a *crucial* step when using the D90 (or any other autofocus camera). If you wait until the moment you want to take the shot and *then* press the shutter button all the way down, you'll miss the shot, because the camera will have to focus, meter, and calculate white balance before it can fire, and these things take time.

> **WARNING:** Don't Zoom After Locking Focus
>
> Once the camera has locked focus, don't adjust the zoom control. Focusing at a specific distance is a function of your current focal length. If you change focal length (that is, if you zoom in or out), you'll throw your image out of focus.

Take the Shot

Once the camera has told you that it's focused and ready to shoot, gently squeeze the shutter button. If you jab at the button, you might jar the camera, resulting in a potential loss of sharpness in your image.

> **REMINDER:** "My flash popped up!"
>
> In Auto mode, the D90 will decide whether it needs to use the flash. If it decides that it needs it, the flash will automatically pop up and will be fired when you take the shot.

OOPS!

ARE YOU IN AUTOFOCUS?

If your camera doesn't beep or flash the confirmation light when you half-press the shutter, you might be set to manual focus mode. Just beneath the lens release button is a switch that has two settings: AF and M. Set this to AF for autofocus or M for manual.

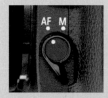

On the D90 body, just below the lens release button is a switch for changing between auto and manual focus.

Make sure this switch is set to AF. As you've seen, your lens might also have a switch for changing from auto to manual focus. You can use either switch to activate autofocus. The lens provides a switch because lenses can be used on different camera bodies, and not all bodies have an AF/M switch. Personally, I find it easier to use the lens-mounted switch, because I can find it without looking at the camera. Note that *both* switches must be on auto for autofocus to work.

- If your autofocus light blinks but doesn't lock focus, it's because the camera can't find a subject that has strong contrast. As you'll see, strong contrast is necessary for autofocus to work. You'll learn how to compensate for this problem later.

- If the focus beep repeats rapidly, then the camera has locked onto a moving subject and is tracking it. Shoot as normal.

After you shoot, the camera will display the image for two seconds, giving you a moment to review. When you're ready to shoot again, follow the same procedure. It's very important to remember to do a *half-press* of the shutter to give the camera time to autofocus.

Those are the basics of shooting. Compose your shot, press the shutter button halfway to focus, and then squeeze the shutter button. This is the process that you'll use no matter what mode you're shooting in.

> **TIP:** Flash Shooting
>
> In a low-light situation, you may see some strange flashes coming from the flash when you press the shutter halfway. These flashes serve to help the camera's autofocus mechanism "see" when the light is low. Once focus is locked, the camera will beep, indicating that you can press the button the rest of the way, whenever you're ready, to take your shot.

Spend some time shooting in Auto mode to get a feel for the shutter and basic camera controls.

The Viewfinder Status Display

When you press the shutter button halfway down, several things happen inside the D90's viewfinder. As I already mentioned, the camera shows you which focus points it has selected for autofocus. It also uses the readout at the bottom of the viewfinder to tell you about its exposure choices and to give you some additional status information.

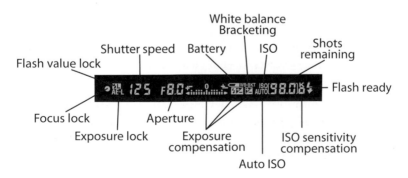

The D90's viewfinder shows all the settings you need access to while shooting.

From left to right, the readout works as follows:

- When the camera locks focus after you half-press the shutter, then the focus lock circle will appear. If you are using either the flash value lock or auto-exposure lock feature, then the appropriate indicator will highlight.

- Next, the camera displays its chosen shutter speed and aperture. You'll learn more about these in Chapter 5.

- If you are using exposure compensation features, the appropriate indicators will light. Several other indicators reveal ISO settings, white balance settings, and battery life. For now, all you need to know about these is that the higher the ISO number is, the grainier your images will be.

- Next comes the shots remaining indicator. When the shutter button is not pressed, this indicator shows how many shots will fit in the remaining space on your card. When you half-press the shutter, the indicator changes to a lowercase r and shows the number of shots that you can shoot before you will have to wait for the camera's buffer to empty. The camera has enough onboard RAM to shoot approximately 21 images when in Auto mode.

 However, as soon as you shoot, the camera immediately starts writing its buffer out to the storage card. So, if you're not shooting too fast, you'll never come close to overrunning the buffer. If you're shooting bursts of images—at a sporting event, say—then there's a chance that you'll fill up the buffer and have to wait a moment before you can shoot again.

 You don't have to wait until all 21 images are available again. As long as the number reads at least 1, you can still shoot.

 If the number of remaining images is greater than 1,000, then the camera will switch to an abbreviated view. For example, if your card has room for 1,159 images, the remaining images display will read "1.1 K."

- The S in the upper-right corner indicates that the camera is set to shoot a single image when you press the shutter button down, rather than continuing to shoot for as long as you keep the shutter pressed.

- Finally, if the camera has chosen to use the flash, then it will display the ⚡ icon. Note that the ⚡ icon will not appear until the flash is charged and ready to go. How quickly the flash will charge depends on several factors, including the strength of your battery.

The LCD Control Panel

In addition to the in-viewfinder status display, the D90 also shows a lot of status information on the LCD control panel located on the top of the camera. What's displayed on the screen varies depending on what mode you're in simply because in some modes you don't have as much manual control and so don't need as much status feedback. In Auto mode, your screen should look something like this:

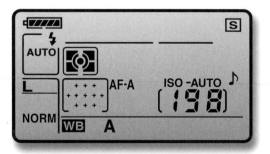

In Auto mode, the LCD control panel on the top of the D90 should look something like this.

As you can see, you can easily tell how many shots are remaining, how charged the battery is, and the image format that you're shooting in. The camera also shows what light metering mode you're using, which, to be honest, is kind of strange, because you can't actually change this when shooting in Auto.

Other readouts show which focus point has been selected, your current white balance mode, and whether the camera is set to beep.

When you half-press the shutter button to tell the camera to focus and meter, it displays its chosen shutter speed and aperture at the top of the status display, as well as the number of shots remaining in the buffer. In later chapters, I'll explore what these exposure settings mean. (As you've already seen, this same data is also shown in the viewfinder status display.)

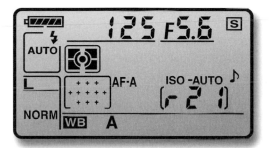

After you half-press the shutter button, the status screen will show the shutter speed and aperture that the camera's meter selected.

If you don't do anything else with the camera, the shutter speed, aperture, and remaining buffer displays will go blank after about six seconds to save battery power. Pressing the shutter button halfway again will re-meter and reactivate the display.

Note that even when the camera is turned off, the number of remaining images is still displayed on the control panel. This makes it easy to determine whether the camera's card has enough space for your intended shoot. If it doesn't, then you'll want to change cards or clean off the card that's in the camera. You'll learn how to do all of these things later in this book.

If you rotate the power switch to the right, past the On position, a light will illuminate the control panel. For working in low-light conditions, this feature can be essential for reading the control panel.

Shoot some more in Auto mode, and get comfortable with the camera's controls. Although the camera has a lot of other buttons and dials, you don't really need to worry about them right now.

TIP: If the Viewfinder Is Not Sharp

If you wear glasses and like to remove them when shooting, you can use the *diopter control,* the small knob next to the viewfinder, to compensate for some near- or farsightedness. Turn the knob until the nine autofocus boxes inside the viewfinder are sharp. Note that the diopter may not be able to completely compensate for extremely bad vision. Also, you'll have to change it back if you put your glasses back on. If the viewfinder ever inexplicably goes out of focus, it might just be that you bumped the diopter knob. Turn it until focus is restored.

Viewing Your Images

As you've seen, the D90 displays your image for a brief time after you shoot. Later, you'll learn how you can change this time by altering a menu setting. When it comes time to review more than the most recent image, you'll want to use the camera's playback mode.

To review your images, press the Playback button ▶ on the back of the camera (obviously, the camera needs to be powered on for this to work).

The camera displays the last image that you shot, along with some status information.

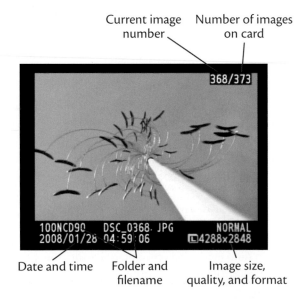

Current image number / Number of images on card

100NCD90 DSC_0368. JPG NORMAL
2008/01/28 04:59:06 ▢4288x2848

Date and time / Folder and filename / Image size, quality, and format

When you play back an image on the D90, the camera displays some important status information along with your image.

On the back of the camera is a four-way control pad, with a big OK button in the middle. The left and right buttons on this control pad let you navigate forward and backward through your images. Playback mode has a number of other features that you'll learn about in Chapter 3.

At any time, you can press the Playback button again or give a half-press to the shutter button to return to shooting mode. Note that the D90 can change between shooting and playback modes very quickly, much faster than most point-and-shoot

cameras, meaning you don't have to worry about missing a shot because the camera is locked up in playback mode.

Using Scene Modes

You should now be fairly comfortable with how the D90's Auto mode works. Since Auto mode takes care of all of the critical decisions regarding camera settings, it's an ideal mode for snapshot shooting and for getting used to the camera. Before you go off for more shooting, though, let's take a quick look at some other auto features that you might find useful while getting started.

On the Mode dial, you'll see a bunch of little icons underneath the Auto setting. These are the D90's scene modes.

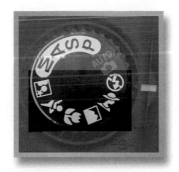

These options on the Mode dial are scene modes, which bias the camera's decisions under specific conditions so that it calculates more appropriate exposures.

Scene modes are also fully automatic, but each one biases some of the camera's decisions in a certain way so that the camera makes decisions that are more appropriate to particular types of shooting.

⚡ Disabled Flash

Normally, when shooting in Auto mode, the camera will pop up the flash any time it thinks it's necessary to get a good exposure. If you're shooting in an environment where you know you don't want flash—say, a museum or auditorium where flash is not allowed—then you'll want to choose the Auto (Flash Off) mode, which works just like Auto mode but never uses the flash.

When shooting without the flash, you may find that when you meter, the camera displays "Lo" where it would normally show the shutter speed. When this

happens, you'll also see the exposure compensation display flash. This is the camera's way of telling you that light is low, so you need to be extra careful to hold the camera steady. Also, be aware that when these indicators are going, there's a good chance that your resulting image will be too dark.

💃 Portrait Mode

Portrait mode is ideal for shooting—you guessed it!—portraits. What makes a portrait different from any other type of shot? Typically, in a portrait you want the background blurred out, to bring more attention to your subject. Ideally you also want softer skin tones. Portrait mode biases its exposure decisions to attempt to blur the background.

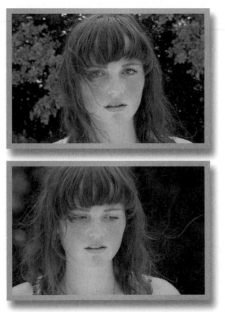

In the upper image, I shot with a deeper depth of field to reveal details in the background. In the lower image, I shot with a shallow depth of field to blur the background out and bring more focus to the subject.

If you want a really soft background, try to position your subject away from the background as much as possible.

◪ Landscape Mode

Landscape mode can help your landscape shots because it will choose settings that attempt to maximize the amount of your scene that will be in focus. It's basically the opposite of Portrait mode. Landscape mode also cancels the flash.

✿ Close-Up Mode

Close-up shots of flowers or small objects (what is traditionally referred to as *macro* photography) are made easier with Close-up mode. In this mode, the camera automatically focus on the subject under the center focus point.

☆ Sports Mode

When shooting fast-moving subject matter such as moving wildlife or a sporting event, opt for Sports mode. Sports mode biases the camera's exposure so that fast-moving objects will be sharp and clear.

When using Sports mode, make sure that the center focus point is on your subject when you press the shutter button halfway down. Unlike other modes, you won't hear a beep when the camera has locked focus. Instead, the camera will begin beeping continuously to indicate that it is now *tracking your subject!* Yes, Sports mode uses the D90's Continuous-servo focus feature to track a moving object and keep it in focus. Sports mode also deactivates the camera's flash.

Press the shutter to take a shot. If you keep the shutter button held down, the camera will continue to shoot.

▣ Night Portrait Mode

One of the biggest mistakes people make when shooting with flash is that they assume that a flash can light up an entire scene, just as if it were daylight. But the flash on any camera has a limited range. It's usually enough to light up your subject but not your background, leaving you with a subject that appears to be standing in the middle of a dark limbo.

REMINDER: Night Portraits Require Still Subjects

When shooting with Night Portrait mode, the flash will fire, but the camera's shutter will *stay open* for a bit. So, it's important to tell your subject not to move until after you say so.

At night, if you take a flash picture, you'll usually end up with a well-exposed subject on a background of complete black. This is because the range of the flash is only about 10 feet. Objects beyond that will not be illuminated by the flash.

Night Portrait mode uses the flash and a longer shutter speed so that both your subject and background are well-exposed.

Snapshot Tips

While the rest of this book is going to cover just about every aspect of shooting in great detail—from holding the camera to processing images—you can do a lot with the Auto capability that you've already learned about. Since the camera is taking care of most of the technical issues for you, it's a good time to practice handling the camera and composing shots. I'm going to talk about composition in great detail in Chapter 8. For now, consider the following tips when shooting snapshots.

Watch That Headroom: Fill the Frame

When shooting a portrait or candid snapshot of someone, you usually do not need a lot of headroom, unless you want to show something about the environment they're in.

The extra head room doesn't contribute anything to the image.

For example, in this image, the extra headroom doesn't add anything to the picture. In fact, it's kind of distracting and takes up space that could be used to show a larger image of the person. In the next image, I fill the frame with more of the person. You can see a better view of them, but you still get enough background detail to get an idea of the environment they're in.

In this image I've filled the entire frame, which results in a larger view of the subject.

"Fill the frame" is one of the most important compositional rules you can learn, no matter what type of image you're shooting. Don't waste space in the frame. Empty space in your image is space that could be used to provide a larger, better view of your subject.

Don't Be Afraid to Get in Close

Another portrait tip: You don't have to show a person's entire face or head. Don't be afraid to crop them and get in close for a very personal shot.

When shooting portraits, don't be afraid to get in close. You don't have to show a person's whole head. It's fine to crop.

Remember That Your Knees Can Bend

It's easy to forget about that third dimension that you can move in and shoot all of your shots while standing up. Don't forget that you can bend your knees (or even lie on the ground) to get a different angle. Getting down low is especially important when shooting children and animals, since it puts you at a more personal, eye-to-eye relationship with them.

Often, the best pictures of animals and children occur at their altitude.

Watch the Background

Don't pay attention just to your subject; remember that they're also standing in front of something. Make sure there's nothing "sticking out" of their head or juxtaposed in a distracting way.

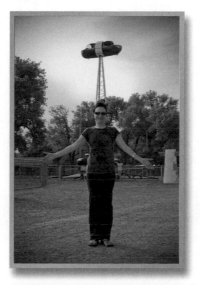

Pay attention to the background in your image to prevent distracting juxtapositions.

You can get close either by standing physically close to the person or by star
ing farther away and zooming in. However, as you'll see in Chapter 6, these tw
options produce very different images, so you'll want to think about whic
approach is right for your subject.

Lead Your Subject

When shooting a portrait of someone who's looking off-frame, consider *leading* the subject. When someone is looking out of the frame, we're more interested in the space that's in front of them than the space that's behind them. Even if we can't see what it is they're looking at, we still want to feel extra space that sits in the direction they're looking.

When your subject is looking off-frame, it's almost always better to "lead" them. Frame the shot so that you can see in the direction they're looking—even if what they're looking at isn't in the frame.

Watch Out for Backlighting

This is loosely related to the previous tip. Be careful about shooting your subject in front of a brightly lit background, such as a window, or shooting into the sun. Although sometimes you can use such an approach to great effect, for simple snapshots you'll get better results keeping a close eye on the backlight in your shots.

If you find yourself shooting someone in front of a window or bright light, try to move them or yourself so that the light is not directly behind them.

The window is throwing off the camera's meter. Shooting with flash helps illuminate the foreground and evens out the exposure.

The problem with bright lights in the background of a shot is that they confuse the camera's light meter. When a bright light appears in the background, the camera meters to properly expose that bright light. This usually means the foreground is left underexposed and appears too dark.

In Auto mode, the D90 should recognize such a situation and automatically pop up the flash. The flash will serve to light up the foreground, creating a more even exposure with the background.

You'll learn more about metering, as well as other strategies for handling back-lighting, in Chapter 7. For now, even if you aren't sure exactly how to handle such a situation, at least start learning to recognize when you're shooting in this type of difficult lighting condition.

Understand Flash Range

Although the flash on the D90 can do a good job of illuminating a subject, you have to remember that it has a limited range. Anything beyond about 13 feet from the camera will fall out of the flash's range and not be illuminated at all. So if you're standing at night across the street from a person or building and you shoot a picture with the flash popped up, you'll probably get a shot that's completely black.

For this situation, flash is not the answer. Instead, you'll need to employ some low-light shooting strategies, which we'll discuss in Chapter 7.

> **TIP:** Use Night Portrait Mode
>
> As you saw earlier, flash range can also impact the background of your scene. If your subject is in range of the flash but your background isn't, you can end up with people standing in totally black, limbo environments. See "Night Portrait Mode" earlier in this chapter.

Cover Your Shot, or "One Shot Is Rarely Enough"

There's one mistake that all beginning photographers make: They think an expert photographer sees a scene or subject, determines how to best frame and expose it, and then takes a picture of it. If you describe this process to an "expert" or "professional" photographer, they'll most likely laugh.

The fact is, even the most accomplished photographer rarely gets it right the first time and so rarely shoots only one exposure of a subject. Instead, they *work* their subject—something we'll be talking about a lot through the rest of this book.

Very often, the only way to find the best composition or angle on a shot is to move around. Get closer and farther, stand on your tiptoes, squat down low,

circle the object—and look through the viewfinder the whole time, and shoot the whole time.

If you like, review your shots and try again. Often, photography is like sculpture. You can't see the finished shot right away. Instead, you have to "sculpt" the scene, trying different vantage points until you find the angle that makes for the most interesting composition and play of light, shadow, and color.

Remember: When a subject catches your eye, the chances that you happen to be standing in the very best spot in the world and that you happen to be the perfect height to photograph it are pretty slim. So, go out now and practice shooting broad coverage of some scenes. Stay moving, play with distance and angle, and notice the difference in what you see in the viewfinder, what you recognize while you're shooting, and what the final results look like on the camera's screen.

You may be surprised to find that the final images you like best are the ones that are very different from what you originally envisioned

GETTING TO KNOW THE NIKON D90 23

Anatomy of the Nikon D90

LEARNING TO HOLD AND CONTROL YOUR CAMERA

In the previous chapter you saw how you can use the Nikon D90's automatic features for easy snapshot shooting. Before you go on to learn about its more advanced shooting features, you're going to take a tour of the camera and learn its parts. The D90 is a complex tool, and the better you know its workings, the more easily and effectively you'll be able to make it do what you want.

What Is an SLR Anyway?

The Nikon D90 is an *SLR* camera, a term you may have come across when you were shopping. SLR stands for *single-lens reflex*, and those words tell you some important things about how the camera operates.

As the name implies, a *single*-lens reflex camera has only one lens on it. If you're wondering why a camera might have two lenses, consider a point-and-shoot camera. If you look at the front of a lot of point-and-shoot cameras, you'll see two lenses, one that is used to expose the image sensor and a separate lens that serves as a viewfinder. The advantage of this type of arrangement is that it's very simple to engineer, and it doesn't take up much space, so a point-and-shoot camera can be made very small.

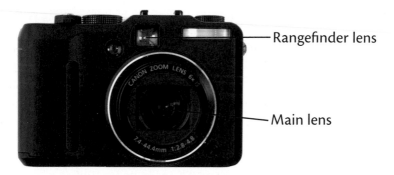

Rangefinder lens

Main lens

Unlike an SLR, this point-and-shoot camera has two lenses, one that exposes the image sensor and another that serves as a viewfinder.

The downside to this setup is that when you look through the viewfinder, you're not necessarily seeing the same thing the camera's image sensor sees. First of all, you're not seeing the effects of any filters or lens attachments you might be using, and because you're looking at your scene from a slightly different vantage point, the cropping you see in your viewfinder might be slightly different from what the camera actually shoots (this problem is referred to as *parallax*).

With an SLR, when you look through the viewfinder, you're actually looking through the same lens that is used to expose the image sensor. As in a film camera, the image sensor in a digital camera sits on the *focal plane*, a flat area directly behind the lens. In front of the sensor is the shutter, a mechanical curtain that opens and closes very quickly when you press the shutter button. The shutter lets you control how long the sensor gets exposed to light. Obviously, because there's

an image sensor and a shutter sitting directly behind the lens, you can't easily get a clear view through the lens without some work, because the shutter and image sensor are in the way.

> **DEFINITION:** Parallax
>
> The easiest way to understand parallax is simply to hold your index finger in front of your face and close one eye. Now close the other eye, and you'll perceive that your finger has jumped sideways. As you can see, at close distances even a change of view as small as the distance between your eyes can create a very different perspective on your subject. A camera that uses one lens for framing and another for shooting faces the same problems. Parallax is not a problem at longer ranges because the parallax shift is imperceptible.

Take a look at the profile of your camera, and note that the lens is actually sitting much lower than the viewfinder. If you could take a cross section of your camera, you would see that the image sensor and shutter are directly behind the lens. In *front* of the shutter sits a mirror set at a 45° angle. This mirror bounces the light from the lens *up* into a complex optical arrangement called a *pentamirror*, a complex array of mirrors that bounces the light back out through the viewfinder. Thanks to this system of mirrors, you can see out the lens that's mounted on the camera.

Of course, since the mirror sits between the lens and the focal plane, the image sensor can't see out the lens. This is where the *reflex* part of "SLR" comes into play.

When you press the camera's shutter button, the camera flips the mirror up so that it's completely out of the way of the focal plane. Then the shutter is opened, the sensor is exposed, the shutter closes, and then the mirror comes back down. Part of the distinctive sound of shooting with an SLR is the sound of the mirror going up and down.

You can actually see the mirror itself any time you take the lens off your camera. It sits inside the *mirror chamber*. If you look toward the top of the mirror chamber, you can see where the light gets bounced up into the pentamirror.

SLRs have many advantages over point-and-shoot cameras, and the fact that you and the sensor look through a single lens is a very big one. It means that what you see through the viewfinder is much more accurate than what you typically find with a point-and-shoot camera. Also, because they're larger than point-and-shoot viewfinders, SLR viewfinders are usually much brighter, clearer, and easier to see.

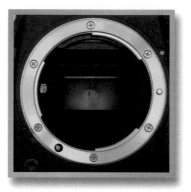

If you take the lens off your camera, you can see the mirror and look up into the pentamirror assembly.

In addition to the brighter, clearer view of the scene, many photographers choose SLRs because they like to block out the rest of the world with the camera so that they can fully concentrate on the image in the viewfinder. This is much harder to do with the inferior viewfinder or LCD viewfinder on a point-and-shoot camera.

TIP: Watch the Mirror Move

With the lens off and the power on, you can press the shutter button and actually see the mirror flip up and, if you're quick, see the shutter open behind it. *However*, before you do this, know that shooting the camera with the mirror off will expose your sensor to dust. Don't do this outside or in a dusty room (or at all, if you don't want to take chances). Better still, if you have a friend with an SLR, try it with their camera when they're not looking.

Cleaning and Maintenance

At a fundamental level, all cameras are the same: A lens focuses light onto a recording medium. Because the recording medium is light-sensitive, it must be kept in a lightproof box. A shutter in front of the recording medium allows for control of when the sensor is exposed and how long the exposure will last. Cameras have worked this way since the beginning of photography in the 1850s, and although all sorts of new technologies have come along—everything from light meters to stabilized lenses to self-timers, color film, and autofocus—the basic

principles of a lens that focuses light onto a light-sensitive medium held in a light-proof box have remained the same.

Of course, the significant change in a digital camera is the recording medium that's being exposed. Rather than a piece of celluloid covered with light-sensitive chemicals, a digital camera employs a silicon chip covered with light-sensitive bits of metal. And, where a film camera needs a bunch of mechanics to move the film in and out of the roll, a digital camera needs an onboard computer and storage device to process and store the images that it captures.

Other than this change, though, your D90 is similar in design to a traditional 35mm SLR. The camera body is the lightproof box that houses the image sensor, shutter, and viewfinder. Of course, it also has lots of other things, like the shutter button, controls, LCD screen, battery, media card, tripod mount, pop-up flash, and more.

The D90 is *not* weatherproof, meaning that Nikon has not engineered it for handling harsh environments. The various openings on the camera—the lens mount and assorted doors—are not sealed against sand and moisture. So, if you're planning an extended stay in the Sahara or a float trip down the Amazon, you may want to think about taking a sturdier camera. That said, there's no reason you can't go shooting with the camera in drizzle or light rain. A little water on the body won't hurt anything; just wipe off the camera, and keep shooting.

The D90 Battery

Your camera requires a battery to power its onboard computer, light meter, image sensor, and other components. If you were following along in the previous chapter, then you've already charged and used the battery, so I'm going to cover some battery tips here:

- With a new battery, you should find that you can get about 500 shots from a single charge. As the battery ages, this number will go down, but the included battery should be good for a couple of years of shooting before you need to replace it.

- Note that, in general, you do not need to worry about completely draining the battery before recharging it. You can "top it off" at any time without harming the battery itself.

- For the first few charges, drain the battery completely, and then give it a full charge. After that, you can "top it off" any time you like.

OOPS!

THE D90 AND BAD WEATHER

Although the Nikon D90 can handle light rain, it's not going to do so well in heavy rain or submersed in water. If you accidentally submerge your camera, take it out of the water immediately, and *don't* turn it on. Remove the battery and media card, and let the camera sit for several days to dry. To speed drying, place the camera in a bowl, and cover it with dry, uncooked rice. The rice will act as a desiccant and can help speed drying.

After a few days, try powering up the camera. If it works—and the viewfinder isn't too dirty—then there's no reason not to start shooting. If it doesn't work, then you'll need to send the camera in to Nikon. You can find the Nikon repair web page at *www.nikon.com*. From the repair page, you can easily set up a mail-in repair request.

If you're shooting in extreme heat or cold, be aware that the LCD screen on the back of the camera may not work. Nikon officially rates the operating temperature of the D90 as 32 to 104°F. You can probably go a little beyond these temperatures, but if you do, you will be risking a hardware failure. At extreme temperatures, small parts and circuits expand and contract and can break.

If you're shooting in very cold, damp weather, you must be careful when returning indoors, because condensation inside the camera can cause the lens or viewfinder to fog. When shooting in cold, take a Ziplock bag with you. Before you return to a heated room, turn off the camera, and place it in the bag. Zip up the bag, and leave it zipped until the camera has had time to warm up. Once the temperature inside the bag has equalized with the temperature outside, you can open the bag without fear of condensation.

- If you plan on an extended trip away from power or if you tend to shoot a *lot* then you might want to invest in another battery. For less than $100, you can get a second battery and charge it up before you leave. You can easily swap out the battery as you need.

- You might also consider some alternate chargers, such as a charger that can work off a car cigarette lighter, or a small, inexpensive solar charger that will provide you with a way to charge your camera battery (as well as a cell phone or iPod) any time you have access to sunlight.

T I P : International Charging

The battery charger that comes with the D90 can adapt to voltages around the world, so you don't have to worry about finding a different charger for international travel. However, you will need a plug adapter to make it fit into foreign outlets. You can get these at most stores that sell cameras and electronics and in many airports.

The Media Card

As you already know, your D90 uses a Secure Digital card. The camera is also compatible with SDHC, a newer format that has the same form factor as SD but that comes in higher capacities and offers speedier transfer. Note that you'll need an SDHC reader for SDHC cards. Fortunately, an SDHC reader will read normal SD cards, so you need only one reader to read both formats.

When shopping for media cards, you'll find a wide range of capacities and vendors and a correspondingly wide range of prices. What's the difference between a 2 GB card that costs $19 and one that costs $49? Nothing at all, in terms of the number of images it will hold. However, that $49 card is probably much faster, which means your camera will be able to more quickly dump images to it.

As you already learned, the number on the right side of the viewfinder status display shows how many images the camera can currently fit in the camera's internal buffer. As you shoot, the buffer fills, and the number goes down. It takes time for the camera to dump these images to the card, and while the camera is performing this transfer, you may not be able to shoot at all or to shoot a full burst of images.

So, with a speedier card, the camera will be able to dump its images more quickly, freeing up buffer space for more shots. How much this will matter to you depends on the type of shooting you do. If you plan on shooting sports or other action shots, where you'll typically be shooting bursts, then you will want a speedier card.

Another way to look at it is that if you want to ensure the best chance that the camera will always be able to shoot, then get a speedier card. A 133x card (or faster) will deliver a very good level of performance in the D90. If you find that those cards cost more than you'd like to spend, then go for something less expensive, but understand that sometimes the camera might be tied up with storing images and so won't be able to shoot.

TIP: Know Your Speed Class

SDHC is a newer derivative of SD cards. Offering higher capacities and speedier transfer than regular SD, SDHC cards will work fine in your D90. However, while SD cards use a multiplier rating—133x, for example—SDHC uses a speed class rating. The multiplier used on regular SD cards indicates how much faster the card is when compared to a standard-speed CD-ROM drive. SDHC cards come in three classes, Class 2, 4, or 6. Class 2 cards can transfer 2 MB per second, while Class 4 or 6 can transfer 4 or 6 MB per second, respectively.

Body Parts

As you work through the rest of this book, you will become well-versed in all of the D90's controls. Let's take a quick look at the different interface elements on the D90 so that you understand what controls I'm referring to as you work through the rest of the book.

Camera Top

You should already be familiar with the power switch and Mode dial on the top of the camera. We'll be exploring all of the mode options throughout the rest of the book.

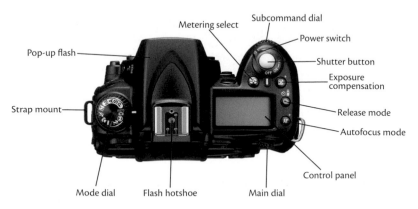

On the top of the camera you'll find several essential shooting controls.

- If you've been shooting, then you also already know where the shutter button is and understand that it has two positions, a half-press position for focusing and a full press for taking a shot.

- Just behind the control panel is a control wheel. You'll use this for changing parameters such as aperture and shutter speed.

- Scattered around the control panel are buttons for setting autofocus mode, release mode, exposure compensation, and metering mode. These buttons are used in conjunction with the Main dial. You'll learn about each of these functions later.

- On the front of the camera, just in front of the power switch, is the sub-command dial, which is used in conjunction with other controls, such as the Qual and White Balance buttons located on the back of the camera.

- Finally, just above the viewfinder is a hotshoe for mounting an external flash unit.

Camera Front

The front of the D90 has minimal controls, but the few buttons that are there are ones you'll use often.

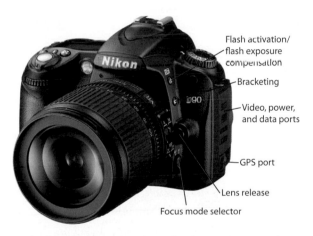

The front of the camera has a few important controls.

- The Flash button pops up the camera's internal flash and also lets you apply flash exposure compensation. In Auto mode, the flash pops up automatically whenever the camera thinks you need it. In most other modes, *you* decide when to use the flash and press this button to activate it.

- The Bracketing button is used to control the camera's autobracketing features.

- You can connect the camera to a computer, video monitor, or GPS using the ports on the side of the camera. This is also where you can plug in an optional power supply.

- You'll press the lens release button any time you want to remove the lens from your camera. Press and hold the button while twisting the lens clockwise.

- The focus mode selector lets you switch between auto and manual focus.

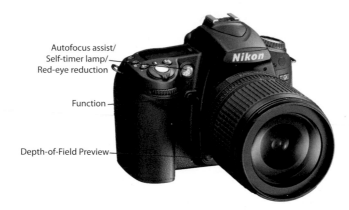

Autofocus assist/
Self-timer lamp/
Red-eye reduction

Function

Depth-of-Field Preview

The D90 has front-mounted controls on both sides of the lens.

- The light at the top of the front of the camera serves three functions. When autofocusing in low light, the camera might turn on the light to help illuminate the scene to ease focusing. When shooting with the self-timer, the lamp flashes to indicate that the camera is counting down to firing. When shooting with the flash in red-eye reduction mode, this lamp flashes to try to reduce red eye.

- The Function button is a customizable, programmable button that you can tailor to your particular taste. You'll learn how in Chapter 12.

- The Depth-of-Field Preview button provides a way to see the actual depth of field in your scene when looking through the viewfinder. More on this later.

WARNING: Don't Block the Lamp

If you're using the red-eye reduction flash, be sure your fingers don't block the red-eye reduction lamp when you're holding the camera.

Camera Sides

The left side of the camera (if you're looking at it from behind) holds a rubber door that covers three ports.

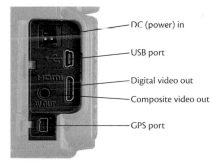

The left side of the camera holds the USB port, which is used for transferring images to your computer, a connector for an optional external power supply, analog and digital video out ports for connecting the camera to a TV, and a connection for an optional GPS unit.

These ports are used for connecting your camera to a TV to play back images, for connecting an external power supply, for attaching your camera to a computer, and for attaching an external GPS unit. We'll look at all of these options in more detail later.

The port covers don't snap closed; instead, you kind of have to mash them into their receptacles until they stay.

On the right side of the camera is the media slot cover, which you should already have used when inserting your media card.

Note that on the rear of the camera, there's a small, green light. Any time the camera is reading or writing data to its storage card, this light will illuminate.

WARNING: Do Not Remove Card When the Light Is Lit

Wait until the camera is completely finished writing before removing the card. If you remove the card before the write is completed, not only will you lose the images that are being written, but you might also corrupt images that have already been stored on the card. So, if you shoot a bunch of shots in quick succession and the camera's buffer is full, remember that it might take a while to completely empty the buffer. If you need to change cards, make sure to wait until the green light goes out.

Camera Back

The rest of the camera's controls are housed on the back of the camera, around the LCD screen.

To the immediate left of the screen is the Playback button, which you use to review your images. Below that is the Menu button, which you use to access the camera's menu system, where you'll find additional controls and settings.

The White Balance button has additional functions when you're reviewing your images. When in playback mode, the White Balance button lets you access the camera's help system, as well as protect images so that they can't be accidentally deleted.

Below the White Balance button is the ISO button, which also does double duty. When in playback mode, the ISO button lets you zoom in and out of your images to assess fine detail.

The bottom button allows you to choose the size and quality parameters that you want for your images. Above the LCD screen are the Delete and Exposure and focus lock buttons, which are used to delete files and lock the exposure from one shot to the next.

To the right of the LCD screen is a circular array of controls, which you'll use for navigating the camera's menu system. Below this is a switch that allows you to manually select the focus point that you want to use. The Info button below the focus selector activates a status display on the camera's LCD screen.

Earlier, I covered the diopter control, which sits next to the viewfinder and allows you to adjust the viewfinder to compensate for your glasses prescription.

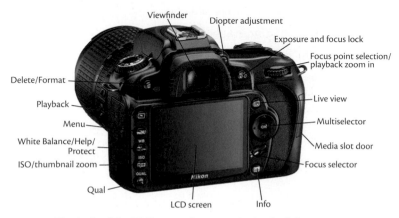

The bulk of the D90's controls are on the back of the camera.

Finally, the sub-command dial on the back of the camera lets you select focus points, zoom during playback mode, and is used in concert with other controls to change settings.

Camera Bottom

The bottom of the camera doesn't have any controls, but it does have two important features. There's the battery compartment, which you've already used, and there's the tripod mount.

The Nikon D90 Menu System

Many of the D90's features and parameters are accessed through the camera's menu system. When shooting in a rapidly changing environment, such as a sporting event, busy street, or birthday party, you'll want to be able to quickly change camera settings, so it's important to be able to use the camera's menus speedily and efficiently. Fortunately, the D90 has a very good menu layout, so with just a little practice, you should find that you can get to any that you want very quickly.

Some shooting modes don't allow you to change certain parameters, so depending on what mode you're in, some menu items may be grayed out. For example, when you're in Auto mode, menu items such as White Balance and Active D-Lighting are grayed out, because Auto mode does not allow you to change these. In other modes, these items will be available.

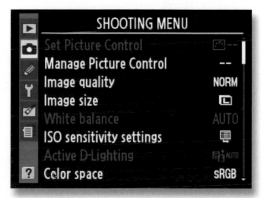

In some modes, like Auto, some menu items will be grayed out, because not all modes allow you to change all parameters of the camera.

In this section, we're going to look at menu navigation so that you'll know how to go to a particular menu item—something you'll be doing a lot of throughout the rest of the book.

For the sake of this example, change the camera's mode to P so that all menu items are available.

To activate the menu, press the Menu button on the back of the camera. You can do this whether you're currently shooting or viewing images.

The D90's menu system offers six menus, represented by tabs stacked along the left side of the screen. The most recently visited menu and menu item are always highlighted when you enter the menu system.

The menus are grouped by function, making it easy to zero in on which menu contains the feature you're looking for.

Playback

Shooting

Custom Setting

Setup

Retouch

Recent

The D90's menu tabs, which are stacked on the left side of the menu screen.

When you activate the menu system, the four semicircular buttons on the back of the camera function as arrow keys. When one of the menu tabs is highlighted, pressing the up and down arrows lets you switch from one menu to another. Using the left and right arrows, you can navigate from the menu tabs to the contents of the menu. When navigating a menu itself, use the up and down arrow keys to select a menu item. Note that you can also use the Main dial to scroll up and down a menu, and you can use the subcommand dial in place of the left and right arrow keys.

Once you've selected the menu item that you want to access, press the OK button. What happens next will depend on the feature you've chosen, which we'll be covering throughout the book.

So, if I tell you to access the "ISO sensitivity settings" feature in the Shooting menu, you'd press the Menu button to activate the menu, then navigate to the Shooting menu, then use the up and down arrow keys to select ISO Sensitivity Settings, and then press the OK button to execute the feature. In the case of ISO sensitivity settings, a submenu will appear, which offers additional options.

Info

At any time, you can press the Info button on the back of the D90 to see a readout that's very similar to the control panel on the top of the camera but with a few additional displays.

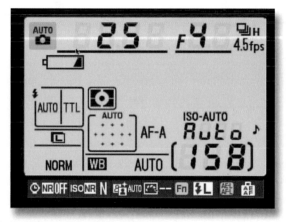

Pressing the Info button at any time gives you a status readout of the camera's current settings.

This display can be very handy when you have the camera mounted on a tripod, especially if the camera is up very high. With the Info display, you don't have to crane your neck or stand on your tiptoes to see camera status. For regular handheld shooting, you probably won't use this feature.

In low light, the D90 displays an inverse version of this display, which will be less bright. This will help you preserve your night vision. As you work through this book, you'll learn more about what each of these settings and readouts means.

Getting Help

The D90 menu system has a help facility built in. Any time you see a help icon at the bottom of the menu display, you can press the **?/⊶** button on the back of the camera to view a help screen about that particular feature. For example, if I highlight Active D-Lighting in the Shooting menu and then press **?/⊶**, I will see the following help screen.

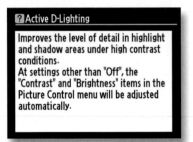

This help screen appears when I highlight the Active D-Lighting command and press and hold the **?/⊶** *button.*

The help screen remains until you release the **?/⊶** button. You can use the up and down arrow keys to scroll, if the content is longer than one screen.

Holding the Camera

Holding the D90 might seem like a fairly obvious procedure, but good photographic "form" can mean the difference between a sharp image and one that's blurred from camera shake. Observing a few simple guidelines about camera grip and posture will improve your chances of getting stable, sharp images.

The Grip

Obviously, your right hand goes around the camera's grip, with your forefinger positioned on the shutter button. To guarantee the most stable hold, your left hand should go underneath the lens barrel, where it connects to the camera.

Cradling the camera this way makes it easier to hold the camera for long periods of time and will help you hold the camera steady. With your forefinger on the shutter release, you should be able to easily reach the control buttons on the back of the camera with your thumb.

Support the lens with your left hand to ensure a more stable hold on the camera.

Feet, Elbows, and Neck

When standing, your most solid, secure stance is to have both feet firmly planted on the ground, about shoulder-width apart. Obviously, depending on the terrain, this may or may not be possible. The best way to ensure a stable hold is to always remember to *keep your elbows touching your sides.*

Elbow position is critical to achieving a stable, shake-free camera hold. Remember: your elbows should always be touching your sides.

"Elbows in" gives you a very sturdy platform for holding the camera. If you get in the habit of keeping your elbows against your sides, eventually it will simply feel

wrong to not have them pressed against you when shooting. In most cases, even if you're on uneven terrain and having to change your foot position, you can still keep your elbows at your sides. Elbows in also holds true when you're seated.

When switching from landscape to portrait orientation, you *still* want to keep your elbows at your sides to ensure a more stable position.

The elbow rule holds for vertical shooting, as well. The image on the right shows a much more stable position than the image on the left.

Finally, lift the camera all the way to your face. This may sound strange because you probably think you are, but many people lift the camera partway to their face and then push their neck forward to close the gap. In addition to giving you bad posture (and probably contributing as much to back pain after a day's shooting as that heavy camera bag on your shoulder), it's a much less stable position.

QUESTION: Does Stability Really Matter?

When your camera is shooting at 1/1000th of a second (or faster), you may think stability doesn't really matter. If you're a stickler for sharpness, though, even a tiny bit of motion can make a difference. If you blow things up a lot or if you're shooting with a long telephoto lens, trying to shoot more stably is very important. Besides, there's nothing difficult about these techniques, so there's no reason not to learn them.

You'll get a more stable shot, and have less neck pain, if you bring the camera all the way to your eye, rather than pushing your neck forward.

The Lens

One of the great things about an SLR like the D90 is that you can remove the lens and replace it with another. Interchangeable lenses allow you to build a lens collection tailored to the way you like to shoot. For example, if you're a nature shooter who likes a long reach, you can invest in telephoto lenses; if you're a landscape shooter, you might want to weight your collection toward wide-angle lenses. Because you can remove the lens, you can choose to upgrade lenses later and improve the quality of your images without having to replace the entire camera. Removable lenses also give you the option to add specialty lenses such as fish-eye lenses for creating stylized pictures or tilt/shift lenses for architectural work.

Depending on the configuration you purchased, your D90 may or may not have come with a lens. If you bought the Nikon D90 kit, then you probably have an 18-105mm zoom lens. You should already be practiced at mounting and unmounting a lens, as detailed on pages 25–26 of your Nikon D90 manual.

Ideally, you want to leave the camera body open for as little time as possible. As you learned in the previous section, just inside the body is the mirror that reflects light up into the viewfinder, and behind that is the shutter and image sensor. You

don't want to get dust or dirt on the image sensor, because any type of debris on the sensor will show up on your images as dark splotches. The less time you leave the camera body open, the less chance dust will get inside.

If you have more than one lens, you'll find that, over time, you will work out a coordination that allows you to remove one lens, hold it, and get the other lens on with minimal exposure of the camera body. Obviously, you have to be careful not to drop anything. Keeping the camera around your neck with the included strap will free up your hands enough to manage a lens change.

WARNING: Manage Those Body Caps

Every lens has a body cap that covers the end of the lens that attaches to the camera. Unfortunately, a lot of people stick these caps in their pocket, where they get covered with lint, and then put the cap directly onto the lens when they're changing lenses. This is a great way to get dust and lint on your lens, and that debris can get transferred directly to your image sensor when you mount the lens on your camera. So, clean those body caps before you put them back on your lens!

Understanding Focal Length

If you wear glasses, you are probably already familiar with the idea that a thicker lens provides more magnification. The same is true for your camera lenses—a longer lens provides more magnification.

The image on the left was shot with a short lens, while the image in the center was shot with a very long lens. Obviously, the image on the right is more magnified.

35MM EQUIVALENCY

If you're coming from a 35mm film camera background, then you might already have certain ideas about focal length. For example, you probably think of a 50mm lens as a "normal" lens, that is, a lens with a field of view that's roughly equivalent to the human eye.

In turn, you probably think of anything longer than 50mm as being telephoto and anything shorter as being wide-angle. To you, a 16mm lens is probably a super-wide angle, while a 400mm is a long telephoto.

The image sensor in the Nikon D90 is smaller than a piece of 35mm film. All lenses project a circular image onto the focal plane, and a rectangular crop is taken from that to create the final image. But because its sensor is smaller, the D90 cuts a smaller crop out of that circle.

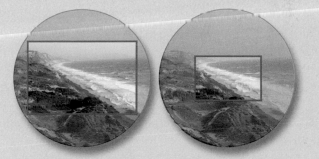

On the left, you can see what a piece of 35mm film cuts out of the image projected by a lens. On the right, you can see the image that the D90 captures. It has a much narrower field of view, as if you had been shooting with a more telephoto lens.

In practical terms, this means that, for any given focal length, the field of view of a lens on the D90 will be narrower than that same focal length on a 35mm camera.

To put it another way, on the Nikon D90, a 50mm lens has the same field of view as a 75mm lens on a 35mm film camera.

To calculate the 35mm equivalency of any lens you put on the D90, simply multiply the focal length of your lens by 1.5. So, if you have an 18-105 mm lens—a lens that would be an ultrawide to normal lens on a 35mm film camera—you can think of it as a 27 to 157mm lens in 35mm terms.

Another way of thinking about magnification is to pay attention to the field of view. In the figure on the previous page, the center image has a much narrower field of view than the left image. As focal length increases, the field of view captured—that is, the distance from left to right—gets narrower.

On lenses, the "thickness," or length of a lens, is measured in millimeters and is referred to as the lens *focal length*. A longer focal length means a more telephoto lens, which means more magnification and less field of view. So, a 300mm lens will be more telephoto than an 80mm lens. I'll be speaking about focal length a lot throughout the rest of this book.

Types of Lenses

In general, lenses fall into two categories: *prime lenses* and *zoom lenses*. A prime lens has a single, fixed focus length. A zoom lens lets you change the focal length so that the lens can go from wide-angle to telephoto.

The advantage of prime lenses is that they're sometimes sharper than the same focal length in a zoom lens. The advantage of a zoom lens is that a single lens can provide the focal lengths of a bunch of prime lenses. As you'll see, choice of focal length is one of your most important decisions when composing a shot.

Twenty years ago, it was safe to say that zoom lenses were of markedly inferior quality to prime lenses. Nowadays, the difference is not nearly so great, and a good zoom lens can yield excellent image quality, especially when paired with a camera as good as the D90.

Lens Controls

On most zoom lenses you'll find three controls: a *zoom ring*, which lets you zoom in and out (which is the same thing as choosing a different focal length); a small switch for changing between autofocus and manual focus; and a *focus ring*, which lets you manually focus the lens.

On a prime lens you'll have only a focus ring and an AF switch. You might possibly have an image stabilization control. I'll be covering all of these controls later in this book.

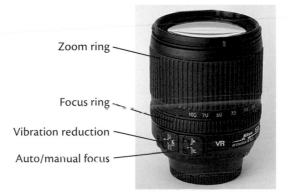

Zoom ring

Focus ring

Vibration reduction

Auto/manual focus

Here you can see the zoom ring (outer), focus ring (inner), and focus switch

Lens Care

Obviously, with a big expensive piece of glass like a camera lens, dropping it is not a good idea. Your other concern with a lens, though, is keeping it clean and scratch-free. In the previous section, I mentioned the possibility of dust getting in the mirror chamber of the camera. If the dust alights on the sensor, then you'll see visible smudges and smears in your image. Most sensor dust is actually delivered to the inside of the camera by the end of the lens, so one of the best things you can do for your camera *and* lens is to keep the lens clean.

> **WARNING:** I Repeat
>
> When you remove a lens, put the end cap on immediately!

Don't put a lens in a pocket or bag without an end cap. The end of the lens will trap a lot of dirt, and when you next mount the lens on the camera, you'll transfer a lot of this dirt and debris to the inside of your camera. To keep the ends of your lens clean, use a blower brush to blow any visible dust off the glass at either end. You can get a blower brush at any camera store.

If there's something on either end of the lens that you can't get off with a blower brush, then you can resort to lens paper of some kind. Lens paper is also available at a camera store. Don't ever try to clean your lens with your shirt or a piece of "found" cloth. Although the cloth may look clean, you never know whether there's some small abrasive particle that could scratch your lens.

Use a blower brush for cleaning dust off the ends of your lenses.

One of the best things you can do to ensure the long-term health of a lens is to put a protective filter on the end. A skylight or UV filter will not alter the light that passes through the lens but will provide a significant amount of protection. If the filter gets scratched, you can simply replace it. Even in the event of a drop, a filter can absorb a lot of the impact that would normally smash up the front of the lens.

When shopping for a filter, spend a little more money and buy a *multicoated* filter. Multicoated filters have special chemicals on them that reduce flare and other reflections and other image-damaging phenomena. If you've spent a lot of money on a lens, don't hobble it with a cheap, low-quality filter.

Sensor Cleaning

Because you can remove the lens on the D90, the sensor chamber is exposed to the outside world in a way that it never is on a point-and-shoot camera. This means it's possible for dust and other fine debris to get on the image sensor. And, because you don't ever remove the sensor and replace it with another one—as you do with the film in a film camera—once there's dust on the sensor, it's there to stay unless you take action.

Pixels on your sensor are very, very tiny. Remember, more than 12 *million* of them are crammed into a space that's smaller than a piece of 35mm film. Because they're so small, it doesn't take a very large piece of dust to obscure thousands of them. Sensor dust will appear in your images as dark spots or smudges.

Fortunately, the D90 has a built-in sensor-cleaning mechanism that can greatly reduce the chance of sensor dust problems.

Sensor dust will appear in your image as smudges, smears, or specs—as if there were something on your lens.

Sitting in front of the image sensor is a clear filter So, "sensor dust" Is actually dust that's accumulated on this filter. By default, any time you turn the camera on or off, it vibrates this filter to shake any dust off. A piece of sticky material just below the filter traps the dust so that it doesn't float around the sensor chamber

You can also force the camera to clean the sensor at any time, using the Clean image sensor command in the Setup menu. From this menu you can also disable automatic sensor cleaning or set the D90 so that it cleans only at power on *or* down instead of both.

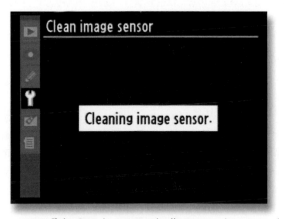

When you turn off the D90, it automatically engages its sensor-cleaning mechanism.

If you absolutely want to be sure that your camera is ready to shoot as quickly as possible after you turn it on, then you might want to disable the Power Up at

Cleaning command, just to speed up the camera's power-up. Cleaning takes only a fraction of a second, though, so the cleaning cycle should not noticeably slow down the D90 boot-up process.

Although the built-in sensor cleaning is very good, you should still take precautions to keep your sensor clean. Try to avoid changing lenses in windy locations, especially if there's sand or dirt nearby. Keep the camera end of your lenses clean—most sensor dust is delivered to the sensor by the camera lens. When you change lenses, have both lenses in hand *before* you start the change so that you can swap them as quickly as possible.

If you get some dust on the sensor that the built-in cleaning can't handle, then you can take your D90 to a Nikon service center for cleaning or attempt it yourself using special cleaning products, such as those made by VisibleDust. The VisibleDust website, at *www.visibledust.com*, includes a full selection of sensor-cleaning products and accessories, as well as instructions on how to clean specific cameras. Additional cleaning instructions can be found on page 246 of the D90 manual.

WARNING: Sensor Cleaning

Never spray compressed air into the sensor chamber! Compressed air uses a liquid propellant that can sometimes come out of the nozzle. If this gets on your sensor, you'll have a much *worse* sensor problem. Use only those cleaning materials designed for sensor cleaning, or have your camera professionally cleaned.

More Auto Practice

In this chapter, I've covered a lot of technical and practical details that are essential to understand if you want to be able to use your camera quickly and effectively. Often, quick use of the camera is what makes the difference between capturing a "decisive moment" and getting a boring shot.

Later, I'm going to start getting more technical about basic photographic theory, but before you go there, you might want to take some time to do a little more practice in Auto mode. Shooting in Auto does not mean you're a photo wimp. The D90 in Auto mode is a very powerful instrument, and having the camera decide technical details for you can free you up to focus on composition and

content. While I'll be discussing composition in more detail in Chapter 8, here are some exercises to try right now, before moving on to the next chapter.

Work with Fixed Focal Length

Zoom lenses can make you lazy. They tend to encourage you to stay in one place and compose from there. As we'll see later, there can be a great difference in images shot from different locations. But zoom lenses also keep you from having to visualize a scene for a particular framing. Here are three quick exercises that will get you seeing and thinking in a different way:

Full wide Zoom your lens out to full wide, and *leave it there!* Spend a few hours shooting with it at full wide. Don't zoom the lens. Instead, reposition yourself if you need to frame the shot differently. Be aware that you may not be able to visualize or recognize potential scenes when limited to this one focal length. So, if you think you see something even remotely interesting, look at it through the camera. You don't have to shoot it, but often when you look through the camera, you'll see a potential shot that you didn't recognize when you were looking with the naked eye.

Full tele Now do the same thing as the previous exercise, but this time zoom your lens to its longest focal length. In other words, zoom in all the way. Spend some time shooting as before. No zooming!

35mm On the Nikon D90, a 35mm lens has the same field of view as a 50mm lens on a 35mm camera. This also happens to be roughly the same field of view as your eye. Consequently, a 50mm equivalent lens is considered a "normal" lens. Some of the most famous, celebrated photos of all time have been shot with a 50mm lens. The great French photographer Henri Cartier-Bresson worked exclusively with a 50. If it's good enough for him, the rest of us should be able to manage.

Set the focal length of your lens to 35mm, and spend a few hours shooting. (The zoom ring has markings indicating focal length.) Again, don't zoom! Some Nikon lenses show a dot on the zoom ring to indicate where normal is.

Obviously, with prime lenses—that is, lenses that don't zoom—you get this type of shooting experience all the time. These exercises are a way for you to learn some of the advantages (and disadvantages) of shooting with a fixed focal length lens.

Playing Back Images

REVIEWING AND ANALYZING IMAGES
ON YOUR NIKON D90

One of the great advantages of a digital camera is the ability to see your images right away. While the compositional advantage of instant review is obvious, you can also perform many types of analysis using your camera's LCD screen. However, it's important to understand what the screen does and does not tell you about your shots. In this chapter, you'll look at all of the Nikon D90's playback features and learn how they can help you take better pictures and help improve your chances of getting the shots you need.

Image Review

By default, any time you take a picture with the D90, it automatically shows the image on the camera's LCD screen for two seconds, which is usually enough time to tell whether you've composed it properly.

If you want to delete the image while it's being shown during image review, follow these steps:

- Press the Delete 🗑 button, located to the left of the viewfinder.
- The camera will ask you to confirm the delete. Press the Delete button again to delete the image or the Playback button to save the image.

You can easily turn image review off; follow these steps:

1. Press the Menu button.
2. Navigate to the Playback menu (if it's not already active).
3. Select Image Review.
4. Press OK.
5. Select On or Off, and press OK again.

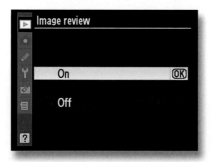

You can easily turn the image review feature on or off.

6. Press the Menu button, or half-press the shutter button to dismiss the menu.

You might also want to turn off image review if you're shooting in a low-light situation like a concert. Because the screen can cast an obtrusive light, you'll have a lower profile if you deactivate image review. If you're shooting in a situation where there's no time to review images while you shoot—a fast-moving sporting event, for example—then you might as well turn off image review to conserve battery power.

There are some additional features available during image review. We'll look at these when we explore Display Mode later in this chapter.

REMINDER: All Reviewing in Moderation

Immediate image review is one of the great advantages of digital photography. However, the instant image review can also be a distraction if you obsessively look at every image after you shoot it. When you're out shooting, you want to be concentrating on the world around you, not on the back of your camera. Image review is great when you want to review a composition you've just shot, and it can be essential when you're in a tricky exposure situation and need to double-check your exposure decisions. We'll discuss exposure evaluation in more detail later.

Image Playback

While image review is a great way to quickly assess a shot you've just taken, playback mode is what you'll want to use when you're ready to review a whole batch of shots:

1. To enter playback mode, press the Playback button ▶.

 The last image you shot will be shown on the screen. By default, the D90 will superimpose some data about the image.

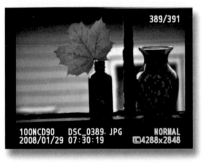

The default image review display.

At the top of the screen, you'll see the number of images and the current image number. A the bottom you'll see the folder and filename for the image. Like your computer, the D90 creates folders on its media card, each with a separate number, and stores the images you shoot in those folders. You'll learn more about folder and filename options later. A date and time stamp, as well as the size and image quality settings, are shown at the bottom of the screen.

2. To scroll through the images stored on the card, press the left and right arrow buttons, or rotate the Main dial.

 Note that the images "wrap around." If you go past the last image, the camera will show you the first, and vice versa.

Playback Zoom

When reviewing an image, you can zoom in to view fine details and assess focus. To zoom in to an image during image playback, press the Zoom In button Q. The D90 can zoom in up to 27 times. As you zoom in, notice the navigation panel that appears superimposed over your image.

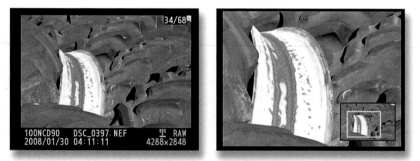

Using the zoom buttons, you can get a closer view of your image and pan around to examine details.

This navigation box shows a relative illustration of which part of the image you're viewing. The yellow box shows you which part of your image is currently being displayed.

- To scroll around an image that you've zoomed into, use the four arrow buttons.
- To change to another image but maintain your current zoom level, use the Main dial. This is a great way of comparing focus between two images.
- To zoom out of an image, use the Zoom Out button.

WARNING: Don't Judge Sharpness on the D90 LCD

When you've zoomed in to an image to check focus, be aware that the LCD screen on the D90 is a little soft. So, you can't always use the screen as a measure of actual sharpness. If your image looks wildly out of focus, then it probably is, but if it looks a little soft, there's a good chance that it's actually OK.

You can easily perform a quick experiment to learn more about how sharpness on the D90's LCD screen relates to the sharpness in your final image:

1. Shoot an image with some fine detail, and then copy the image to your computer (see Chapter 4 for details on image transfer). Don't delete the image after transfer.

2. Put the card back in your camera, and compare what you see on the camera's screen to what you see on your computer. This should give you a better idea of what on-camera sharpness really means.

Exiting Playback

The easiest way to exit playback mode is to give the shutter button a half-press, just as if you were autofocusing. You can also exit playback by pressing the Playback button.

THE SETUP

CHANGING THE BRIGHTNESS OF THE LCD SCREEN

If you're in bright sunlight, it may be hard to see the camera's LCD screen clearly when viewing images. You can change the brightness of the screen by using the LCD Brightness command in the Setup menu.

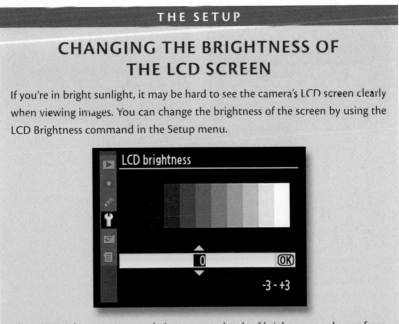

The LCD Brightness command gives you ten levels of brightness to choose from. If you're shooting in a dark location, you might want to turn the brightness of the screen *down*, since a very bright screen can be hard on your eyes if they're already adjusted to low light.

Viewing Image Thumbnails

In addition to zooming *in* to an image to view fine detail, you can also zoom *out* from an image to view more than one image on the screen at a time. This thumbnail view makes it easier to navigate quickly to a specific image on the card.

To zoom out to a thumbnail display of all the images on the card, follow these steps:

- Press the Zoom Out button.

- Note that if you were zoomed in to an image, you'll have to zoom back out first so that the image fills the entire screen.

- A single press of the Zoom Out button will take you to a four-up view of thumbnails. Additional presses will show you 9 or 72 thumbnails.

Using the Zoom Out button in playback mode, you can change the number of thumbnails that are displayed on the camera's LCD screen.

- When viewing thumbnails, you can navigate from one image to another using the four arrow buttons. Turning the Main dial will move the selection left and right, while the subcommand dial will move the selection up and down. This means you can quickly use the subcommand dial to scroll up or down the selection of images and then zero in on the image you want with the Main dial.

- To zoom in to the selected image, press the OK button. If you press the Zoom In button, you'll return to the previous size thumbnail screen.

Using these two simple controls, Zoom In and Zoom Out, you can easily move from up-close views of your images to thumbnail views that provide speedier navigation.

In theory, when you're zoomed in to an image in playback mode, the D90 should automatically put a box around the first face that it recognizes in the image. If you turn the subcommand dial, it will automatically shift your view to the next face in the image. By continuing to turn the dial, you can automatically jump to a zoomed-in view of every face in the image. This should be a great way to check the focus of faces in your shot.

I say "in theory" and "should be" because on my D90, this feature rarely works. Give it a try, but don't spend too much time with it if you find that it doesn't work.

> **TIP:** Persistent Playback Display
>
> The D90 remembers the last view you used in playback mode. So, if you were viewing individual images, the next time you enter playback mode, the camera will show you individual images. If you were viewing thumbnails, then you will see thumbnail view the next time you enter playback mode.

Calendar View

From the 72-up thumbnail display, if you press the Zoom Out button one more time, you'll see the D90's Calendar display.

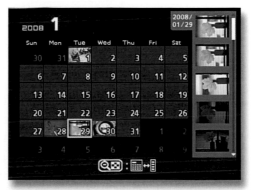

The D90's Calendar display automatically sorts the images on the card according to the date they were shot.

In Calendar view, the D90 automatically sorts the images on the card by date. Here I've selected January 29, and all of the images shot on that day are displayed as thumbnails in a scrolling list on the right side of the screen.

Use the arrow buttons to select the date you want to view; the thumbnail list will update automatically.

If you press the Zoom Out button, then the arrow keys will let you select a thumbnail from the scrolling list.

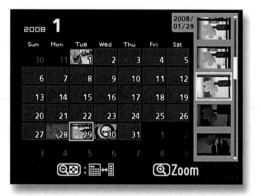

Select an image you want to view from the list, and then press the OK button to view that image at full size.

Viewing Image Info

Like most digital cameras, the D90 automatically stores a fair amount of information with every image you shoot. This information, commonly referred to as *metadata*, is embedded in the image file, so it travels with the image as you copy and move files around.

In addition to the date and time you take an image, the D90 stores all essential exposure information—aperture, shutter speed, ISO, white balance setting, exposure compensation, and much more. Because this metadata conforms to an accepted standard called EXIF, most any image editor can read the data. Having access to your shooting parameters while editing can make certain corrections much easier and help you learn what you did right or wrong while shooting.

You can also view EXIF metadata on the camera itself, and you've already seen a small example of it when viewing your images. The date and time stamps that have appeared in your image playback are two bits of EXIF metadata.

To change the image metadata that's displayed, follow these steps:

1. Go into playback mode by pressing the Playback button. The last image display mode you used will still be active. If you're viewing a thumbnail display, zoom in to view a single image.

2. Press the up or down arrow button to activate the information display.

Your image will be shrunk down to a small thumbnail, and a lot of data will be displayed around it.

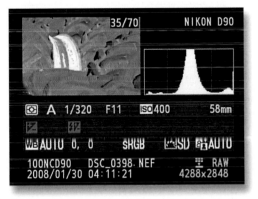

The image info display shows you essential shooting data that's stored alongside each image.

Beneath the image is a line of data that shows which light meter setting was used to take the shot, as well as the shooting mode. After that you can see the shutter speed, aperture, and ISO setting, as well as the focal length of the lens.

The next two lines include other parameters such as exposure compensation, flash exposure compensation, white balance, color mode, and more. Fortunately, each of these parameters is displayed with an icon that matches its camera control. As you learn about these features later in the book, you'll understand what these displays mean.

In the upper-right corner of the display is a *histogram*, and as you'll learn, the histogram can be an essential shooting tool that can help you choose an exposure.

Finally, at the bottom of the screen you'll find all of the date, time, and filename information that you saw in the original playback screen.

Note that, no matter what extra data the D90 displays, you can still always use the zoom buttons to zoom in and out of your image.

Viewing Additional info

Although the default data display shows all of the essential shooting information that you might need, the D90 also includes some additional data displays.

To activate these other displays, go to the Playback menu, and choose Display Mode. From the Display Mode screen, you can choose to activate three different additional information displays.

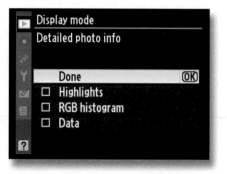

From the Display Mode menu, you can choose extra information screens that you can view in playback mode.

For now, activate them all so that you can see what they do. When you have multiple displays enabled, pressing the up and down arrows, or turning the sub-command dial, will cycle through all of the various displays.

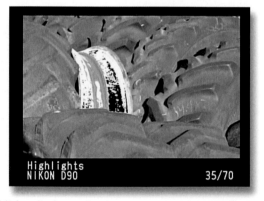

The D90's Highlights display makes it easy to spot overexposed areas in an image.

The Highlights display shows you a full-size thumbnail and flashes any bright pixels that are overexposed. If overexposed areas are revealed, you can shoot again with a slight underexposure. You'll learn how to do this later in this book.

The RGB histogram display shows a different kind of histogram readout, one that can give you a little more insight into overexposure and white balance problems, as you'll learn later.

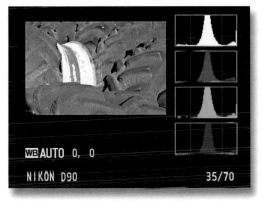

The three-channel histogram can help identify white balance issues and certain types of overexposure problems.

Finally, if you activate the data information screen, then the D90 will show several screens full of data, detailing just about every parameter and setting that the camera has.

```
WHITE BALANCE :AUTO, 0, 0
COLOR SPACE   :sRGB
PICTURE CTRL  :STANDARD
QUICK ADJUST  :0
SHARPENING    :3
CONTRAST      :ACT. D-LIGHT.
BRIGHTNESS    :ACT. D-LIGHT.
SATURATION    :0
HUE           :0

NIKON D90                    35/70
```

The data displays let you analyze exactly how your camera was configured when you took the shot.

You probably won't regularly use this readout, but if there's a problem in an image and you can't figure out why it happened, reviewing the camera's settings can often lead to a solution. It may not help you fix that particular image, but it can keep you from making the same mistake again.

> **TIP:** Image Info in Image Review
>
> The D90 always remembers the last info display you used and presents that display the next time you go into playback mode. However, it also uses that screen during the image review that happens after you shoot. Also, note that you can change the info display during image review, just as you do in playback mode.

The metadata that the D90 displays can be an invaluable aid in difficult shooting situations. However, you don't have to look at it all the time. When you're out in the field shooting, you want the bulk of your attention focused on shooting, not on reviewing your images. In later chapters we'll revisit these modes, and you'll gain a better understanding of what they're for and when to use them.

For a detailed reckoning of exactly what is shown on each data screen, consult pages 131 to 134 of the D90 manual.

OPTIONS

DISPLAYING YOUR IMAGES ON A TV

You can connect your D90 to a TV using the included S-video cable. Your TV must have an S-video input jack on it. See page 146 of the D90 manual for details on connecting the camera to a TV.

Note that though you may find another cable that appears to have the same connectors as the one included with your camera, it may not display your images properly when connected to a TV. For best results, use the included cable.

You can also connect the camera to a high-definition television using an optional HDMI cable, available at most stores that sell high-def televisions. You need a Type C mini-pin HDMI cable, as shown on page 147 of the D90 manual.

Viewing your image on a TV is a great way of showing your images to other people as a slide show, but it can also be handy for shooting in a studio. If you're working with a model or shooting product shots, put your camera on a tripod, and connect it to a TV while you're shooting. The same image review that displays on your camera's LCD screen will be shown on the attached TV. Your model, client, makeup crew, or anyone else in the room can see the shots right away and adjust their work accordingly.

Image Rotation

Your camera contains an orientation sensor that it uses to determine whether you're shooting in portrait or landscape orientation (that is, vertically or horizontally). The orientation you use is automatically stored in the metadata of each image. Your image editor can most likely read this data and will automatically rotate the image appropriately.

You can also tell the camera to automatically rotate the images so that they always display at the largest size possible. By default, this feature is turned on, but if you want to turn it off (perhaps because you're working with the camera mounted on a tripod or because you have the camera connected to a TV), then go to the Playback menu and select Rotate Tall. Turn the feature off to prevent the D90 from rotating the images.

Note that this does *not* change the rotation tag that's stored with the image. It simply changes how the camera itself chooses to display each picture.

Slide Shows

The D90 can automatically play a slide show of the images on its card. You can view the slide show on the camera's LCD screen or connect the camera to a television, as described in the previous section.

The D90 offers two different methods for creating slide shows: the basic Slide Show function, which simply displays each image on the card for a specified time, and the Pictmotion function, which lets you select specific images and choose music and transition effects.

Basic Slide Show

To start a slide show, follow these steps:

1. Go to the Playback menu.

2. Select Slide Show.

3. By default, the slide show will put a two-second pause between each slide; you can change this by altering the Frame Interval parameter in the Slide Show menu.

4. When you're ready to start the slide show, select the Start item.

Once it's running, you can pause the slide show by pressing the OK button or stop it by pressing the Menu or Playback button.

Pictmotion Slide Show

To run a Pictmotion slide show, follow these steps:

1. Go to the Playback menu.

2. Select Pictmotion. The Pictmotion menu screen will appear.

The Pictmotion controls let you create slide shows that include background music and transitions.

3. If you don't want the slide show to include every image on the card, choose the Select Pictures option to select a smaller set of images.

4. Pictmotion slide shows can include a background song. Choose the Background Music option to select from a menu of five different tunes. If you're viewing the slide show on the D90 itself, then the sound will play out the camera's speaker. If you've connected the camera to a TV, then the music will play out the TV's sound system. You cannot add songs.

5. Pictmotion slide shows can also include a transition effect between slides. Choose one of these from the Effects menu.

6. Press OK to start the slide show. Once the slide show is playing, the OK button will let you pause and unpause the show. Press Menu to end the slide show and return to the Pictmotion menu, or press the Playback button to end the slide show and return to image playback.

Note that you can change the volume of the music during playback by pressing the Zoom In and Zoom Out buttons.

Erasing Images

You can erase images from the D90's card using some simple menu commands. Erasing images gives you a way to free up space on your card, if you find that you need

more room for shooting. Deleting extraneous shots can also help speed up your post-production workflow. If you *know* a shot was bad—your finger was in front of the lens, you accidentally took a shot of the lens cap, your model sneezed right when you pressed the shutter button—it's not a bad idea to just delete the image so that you don't have it cluttering up your post-production sorting and editing. Obviously, if you're in a situation that demands speedy shooting, you shouldn't waste time sorting and deleting images, but if you have the time, excising those images that aren't keepers can speed up the later parts of your photographic process.

Deleting an Image During Image Review

If your camera is set to show an image review (a quick view of your image immediately after you shoot), you can delete the image when it appears on your screen.

To delete an image during image review, follow these steps:

1. When the image appears onscreen, press the Delete 🗑 button.

2. The camera will prompt you to confirm that you want to delete the image. Press Delete again, or press Playback to cancel.

Deleting an Image During Image Playback

When in playback mode, you can delete an image simply by pressing the Delete button, just as you do during image review. As in image review, the camera will give you one chance to cancel the operation.

If you want to erase lots of images, follow these steps:

1. Choose Delete from the Playback menu.

2. From the Delete menu, choose Selected, and press the OK button. The camera will present you with a scrolling thumbnail display.

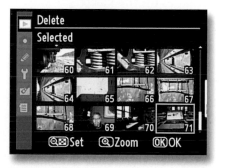

Navigate to an image you want to erase.

3. Use the four arrow buttons to navigate to an image you want to delete, and then press the Zoom Out button to mark that image for deleting. A small trash can will appear on the thumbnail.

4. When you've marked all the images that you want to delete, press the OK button. The camera will ask you to confirm that you want to delete the images.

5. Navigate to any other images you want to erase, and press the up button on each.

6. When you've selected all the images you want to erase, press the Delete button.

The camera will give you a chance to cancel. Select and press OK to delete the checked images.

Deleting All the Images Shot on a Particular Date

You can also use the Delete command in the Playback menu to delete all the images on the card that were shot on a specific date.

To delete all images shot on a particular date, follow these steps:

1. Choose Delete from the Playback menu.

2. From the Delete menu, choose Select Date. The camera will present you with a list of all the dates that are represented in the images that are currently on the card.

3. Use the up and down arrow buttons to select a particular date. Press the right arrow to check the box next to that date.

4. When you've selected the date(s) that you want to delete, press the Zoom Out button to delete those images, or press OK to cancel.

Deleting All the Images on the Card

After you've transferred your images to your computer, you'll want to erase the card.

In the Delete menu that you saw in the previous section, there was an option called All, which lets you delete all images on the card. While this works, it's not the best option for erasing a card. A much better option is to choose Format Memory Card from the Setup menu. Formatting executes a more thorough rebuilding of the media card, which will make the card more reliable.

You can also format the card by pressing and holding both the Delete button and the metering button ◼◼ for two seconds.

OOPS!

RECOVERING DELETED IMAGES

No matter how careful you are, there will probably come a day when you will accidentally delete an image or even accidentally format your camera's media card. Just as files on your computer's hard drive can be recovered after deleting, you might be able to recover deleted images from your camera's media card.

The reason it's possible to recover files that have been erased is that when you delete a file, the camera doesn't actually erase the image data. Instead, it removes that image's entry from the directory of contents on the card and marks that image's space as available. Even if you have already shot more images, the image data for a deleted image probably hasn't been overwritten. Special recovery software can construct a new directory to your deleted files.

When you realize you've deleted an image that you want to recover, *immediately* stop shooting with that card. Take it out of the camera, and use a different card until you get back to your computer.

Normal file recovery software (the type you use with your computer) won't work for your camera's media cards. My favorite media card recovery software is PhotoRescue from Data Rescue. You can download a fully functional version of PhotoRescue for free from *www.datarescue.com/photorescue*. The free download lets you analyze your card and shows you which pictures, if any, it thinks it can recover. If you see images you want to recover, you can then pay the $29 purchase price to unlock the software and perform the recovery.

What's great about PhotoRescue is that you don't have to spend anything to determine whether you can recover your lost images.

To guard against accidental deleting, you might want to consider using the D90's protect feature, which is described next.

Protecting Images

If you've shot a once-in-a-lifetime, keeper image that you absolutely *don't* want to lose, then you might consider protecting the image. This locks the file on the card so that it can't be deleted. If you're on a long trip and won't have the time or opportunity to clear off your media cards, protecting images provides a way of guaranteeing that an image won't be deleted by most normal erase options.

To protect images, follow these steps:

1. In playback mode, navigate to the image you want to protect.

2. Press the Help/Protect button ?/o-. A key icon will be superimposed over your image.

When you protect an image, a key icon is displayed over the image thumbnail.

3. Navigate to the next image you want to protect, and press the Help/Protect button again.

To stop protecting images, press the Menu button. The protect feature is a toggle. Press the Help/Protect button to remove the protection from an already-protected image.

A protected image cannot be deleted using the Delete button or using the Erase All Images command. However, formatting the card *will* erase protected images. Now, if you choose Erase All Images, only unprotected images will be deleted. Your protected images will remain untouched.

In addition to keeping you from accidentally deleting images, protecting images provides an easy way to bulk delete some of the images on your card.

For example, say you stick a card in your camera and shoot a dozen or so images before you realize you hadn't erased the card first. Because you hadn't erased the card, a bunch of images that you'd already transferred to your computer are still there. You don't want to choose Format, because you want to keep the 12 images you've already shot, but going through and deleting the 100 or so images that are also on the card would take forever.

Instead, you can protect the few new images that you've shot and then use the Erase All Images command. This will erase all the other images, leaving your new images intact. You can then shoot as normal, transfer the images to your computer, and then format the card, which will erase even the protected images.

Image Transfer

COPYING IMAGES TO YOUR COMPUTER

In the old days, you pulled the film out of your camera and dunked it in toxic chemicals, or you hired someone else to do that for you. With a digital camera, of course, you don't need chemistry or lightproof rooms. Instead, after your shoot, you'll transfer your images to your computer where you can edit and correct them. You can perform this transfer in many ways, and lots of software exists that you can use for editing. In this chapter, you'll take a look at your transfer options and explore Nikon's bundled software. Before getting started, let's consider your camera's media card.

Media Cards

Film is an amazing invention because it's a single material that can both capture an image *and* store it. With a digital camera, the image sensor does the capture, but it doesn't have any capability to store an image. For that, a digital camera employs a memory card of some kind. As you've already learned, the D90 uses Secure Digital cards (or SDHC cards, a faster, higher-capacity version of SD).

Flash memory cards are similar to the RAM that's in your computer but with one important difference: They don't require power to remember what's stored on them. So, after you turn the camera off, the images remain on the card, even if you remove it. Consequently, it's perfectly safe to take out a full card and replace it with another.

Your camera treats the card just the way your computer treats your hard drive. The camera creates folders on the card and stores files in those folders, each with a different name.

Because cards are so small and because they can pack *huge* capacities, it's possible to shoot a tremendous number of images with just one or two cards. In fact, because the D90's battery is good for "only" about 500 shots, if you're carrying a couple of high-capacity cards, you'll probably run out of battery power before you run out of storage.

One Big Card? Or Lots of Small Ones?

With the range of capacities available, you can carry storage in several ways. You can get a few high-capacity cards or more lower-capacity cards. The advantage of a high-capacity card is that your shooting won't be interrupted with a card change. The risk, though, is that if something happens to the card, all your images will be lost.

Though it's rare, a Secure Digital card *can* be corrupted. Sometimes static electricity can do it; sometimes a glitch in your computer or in your camera can mess up a card. Although the card probably won't be permanently damaged, its contents can be rendered unusable. So, you might want to consider using more, smaller cards so that if one goes bad, you won't lose as many images.

For maximum flexibility, you might want a combination: a big card that you can use when you're shooting events such as a performance or sporting event and don't want to miss shots because of a card change, and smaller cards that you use for everyday shooting. You may have to change them more often, but your images will be safer in the event of a card failure.

Card Management

When you're in the field, you'll need to keep track of which cards you've used and which are available for shooting. If you're shooting on the go, you don't want to have to worry about whether the card you're about to use already has images on it. You can ease your card management hassles when shooting in a few ways.

First, after you transfer your images to your computer, erase the card. We'll look at how to do this later in this chapter. After you've transferred images, if you just throw the cards back in your camera bag with the idea of erasing them when you're ready to use them, you can easily end up confused as to whether the card has already been transferred. If you become uncertain, you might be less willing to use the card, and then you can end up short on storage. Also, if you erase beforehand, when you put the card in the camera, it's ready to use, right away.

Second, if you have a camera bag with a lot of pouches and compartments, consider using one pouch for unused cards and another for used cards. This makes it simple to keep track of which media is ready for use.

I carry my cards in a small holder. When I fill up a card, I place it back in the holder, facedown. That way, I can easily see how many cards are remaining and be certain that I'm grabbing a card that's ready for use. I use a holder made by Lowepro (*www.lowepro.com*).

A card holder can make it much easier to manage your cards while shooting.
Upside-down cards are full; face-up cards are ready for use.

At some point, though, your cards will be full, and you'll be ready to transfer your images to your computer.

Transferring from Your Camera

Every image you shoot is stored on your camera's media card as an individual file. The file is a document just like you might create on your computer. Before

you can do any editing of your images using your computer, you have to copy those image documents from your camera's media card onto your computer's hard drive.

You can transfer images from your camera in two ways. You can plug the camera directly into your computer, or you can remove its media card and place it in a media reader that is connected to your computer.

The advantage of a card reader is that it doesn't consume any of your camera's battery power. Also, most card readers support lots of different formats, so if you have multiple cameras (say, the D90 and a small point-and-shoot) and they use different formats, then you need to carry only one card reader and a cable.

Depending on the type you get, a card reader might provide faster transfer than the D90. You should be able to find card readers that connect to your computer's USB 2 or FireWire port.

If you have a laptop with a PC Card slot or a CardBus 34 slot, then you can get card readers that will fit in those slots. These are typically the fastest readers of all, but they rarely support multiple formats.

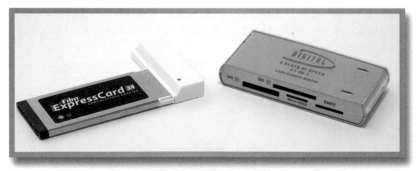

On the left is a CardBus card reader that can plug directly into a CardBus slot on a laptop. On the right is a card reader that plugs into a USB 2 slot. Note the huge number of card formats that it supports.

REMINDER: Don't Forget SDHC

If you're shopping for an SD card reader, be sure to get one that also supports SDHC. Since the D90 supports SDHC, you might end up buying SDHC cards at some point, so you might as well have a reader that can handle them as well as regular SD.

The D90 ships with a USB cable that you can plug directly into your computer. This allows you to use your camera as a card reader, saving you the hassle of keeping track of an extra piece of gear. However, if you have an especially speedy reader, transferring from the camera might be slower, and as mentioned before, camera transfer will use up battery power.

QUESTION: What If the Reader Can't Read My Card?

Sometimes you might find that a card that has always worked fine in your card reader suddenly won't read. If this happens, put the card back in the camera, and see whether you can view images on the camera's screen. If you can, then you know that the camera can read the card just fine. Plug the camera into your computer, and try transferring the images that way. It will usually work. When you're done, perform a low-level format (explained in Chapter 3). This will usually get the card working with your card reader again.

What happens on your computer when you plug in a card reader or camera will vary depending on the operating system that you're using. In the next two sections I'll go over the separate options available for Windows and Mac users.

Installing the Nikon Software

Even if you plan on using some other software for editing, it's worth taking a look at the bundled Nikon software. Although you may not ultimately use it in your workflow, it's worth knowing what it's capable of, and I'll be using it for some of the examples in this book, so it will be good for you to be able to follow along.

The Nikon Software Suite Disk that's included in the D90 box is a hybrid disc that works with the Mac or Windows. To install the software, insert the CD in your computer, and run the installer. The disc puts a number of applications on your computer, with some slight variations between the Mac and Windows.

I'll cover how you might use this software in the following sections.

Transferring Images to a Windows Computer

If you're using Microsoft Windows XP or Vista, you'll find that Windows will take care of a lot of image transfer hassles for you. If want to customize your transfer experience, you can easily do that to build the type of workflow that you like.

When you plug a card reader or camera into Vista or XP for the first time, Windows might make some kind of mention of installing a new driver.

When plugging in a card reader for the first time, Windows might tell you it's installing a new driver.

Follow any necessary onscreen instructions to get the camera or card reader working. Once the card reader or camera is configured, Windows will show you a simple window that lets you specify what you want done with the images on the card.

Windows lets you choose what you want to have happen when you plug in a card reader or camera.

Import Pictures lets you copy the images on your card to a specific directory on your hard drive. By default, Import Pictures copies images into your Pictures directory. When you first choose Import Pictures, Windows will show you a simple dialog box, which gives you an Import button and an option to add a text tag to your images. Tags make it easier to sort and filter your images later.

If you click the Options button, you'll see a more advanced dialog box that offers additional options:

Using these controls, you can specify which directory you want the pictures imported into, and you can define naming conventions.

Once your images have been imported, Windows will show them to you in Windows Photo Gallery.

View Pictures Using Windows will open Windows Photo Gallery, which lets you thumb through large views of your images. Using the menu items at the top, you can choose to import the images, print them, or even perform simple image edits.

Windows Photo Gallery lets you browse your images as thumbnails, making it easier to sort, rate, and organize them.

View Pictures Using Windows Media Center lets you view the images on the card using Windows Media Center, which offers a full-screen interface, with easy navigation to other images on your system.

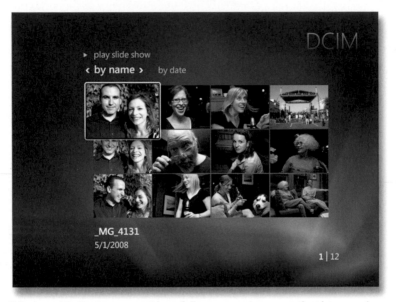

Windows Media Center provides a full-screen environment that lets you view images on your computer, present slide shows, and more.

Finally, notice the Always Do This for Pictures check box at the top of the dialog box. This allows you to specify default behavior for a card insertion.

Which option is right for you depends largely on the rest of your workflow. If you think you can manage your entire postproduction workflow in Windows Photo Gallery or Windows Media Center, then these are all good options. If you plan on using some different image-editing software, then you can still use the Import Pictures command to copy your images to a directory.

Alternatively, you might want to use the Open Folder to View Files Using Windows Explorer option, which gives you the chance to manually copy the files using Windows Explorer. Depending on what software you have installed, the menu might contain other options, such as Adobe Bridge. Once you've copied your images, you can work with them using your choice of programs.

I'll outline some other options in the following sections.

TIP: Changing Your Media Card Preferences

If you select the Always Do This for Pictures check box, configure an option, and then decide later that you'd like something else to happen when you insert a card, you can change Windows' behavior using Control Panel.

From the Start menu, choose Control Panel, and then select Hardware and Sound. On the following screen, find the AutoPlay section, and click Change Default Settings for Media or Devices. Here, you can edit the Pictures category to select a different option, or you can choose Ask Me Every Time to get Windows to present you with a dialog box of choices.

Using Adobe Photoshop Elements for Windows

If you've installed Adobe Photoshop Elements, then when you attach a media card reader or camera to your computer, the Elements Photo Downloader will automatically launch.

The Photo Downloader lets you choose a location to store your files and can create subfolders within that location based on the date and time stamp on each image. Photo Downloader can also rename your images from the nonsensical camera names to something more meaningful.

If you click the Advanced Dialog button at the bottom of the screen, you'll get an interface that lets you select which images you want to download as well as use some more advanced options such as the ability to add metadata to each image. Metadata consists of notes and tags—such as your name, copyright info, or organizational keywords—that get added to the image.

Photoshop Elements Photo Downloader.

Photoshop Elements is a great image editor with all the features you'll need for almost any image-editing task, so if you plan on using Elements for your image editing, you might want to explore Photo Downloader for your image transfers, simply because of its Elements integration.

Using Adobe Photoshop

The full version of Photoshop provides all the features of Photoshop Elements, along with some more high-end features that you may or may not need. If you think you might need the ability to prepare images for offset printing or if you routinely work with high-end 3D imaging, scientific, or video/film production software, then Photoshop will be a welcome addition to your toolbox. Otherwise, it's probably overkill for your photo-editing needs, and the money you'd spend on the full-blown version of Photoshop would easily pay for Elements *and* a new lens for your D90.

If you do install Photoshop CS3 or CS4 (or Photoshop Elements on the Macintosh), you'll also get Adobe Bridge, an excellent image browser that has its own image transfer features.

Transferring Images to a Macintosh Computer

Whether you use a card reader or plug directly into your camera, transferring images to your Mac is very simple, and you have a number of options for determining what happens when you attach the camera or card reader.

Depending on what kind of Mac you have and when you bought it, you might have a copy of iPhoto, Apple's image-organizing and editing program. iPhoto is very good and can handle the transfer of images from your media card, as well as help you with the rest of your photographic workflow, from organizing to editing to output.

iPhoto is part of Apple's iLife suite, and it comes bundled on many new Macs. If your Mac doesn't have it, you can buy the latest version from any vendor that sells Apple products.

Whether or not you have iPhoto, every Mac ships with a copy of Image Capture, a small utility that helps manage the transfer of images into your computer. Image Capture has no editing or organization features—its sole purpose is to

get images copied onto your hard drive. Once they're there, you can decide what to do with them.

If you installed the software from the Nikon Software Suite Disk, then you'll have some additional software on your Mac, which I'll cover later. You might also have other editing software that you want to use, such as Adobe Photoshop or Photoshop Elements. These programs can also manage the transfer of images to your computer.

Configuring Your Mac for Image Transfer

You can tell your Mac what you want to have happen when you plug in a camera or media card reader. This makes it simple to choose what software you want to use to transfer your images.

In your Applications folder there should be a program called Image Capture. By default, Image Capture will open automatically any time you plug in a camera or card reader and will present a window for managing the transfer of images.

Image Capture is included on all Macs and provides a simple way to manage the transfer of images from a camera or media card reader.

Image Capture lets you choose where you want your images downloaded and what to do after the images have been copied, and if you click the Download Some button, you can even select specific images to copy.

Image Capture also lets you specify what you want your Mac to do when you plug in a card reader or camera. If you go to the Capture menu and choose Preferences, you'll see a pop-up menu that lets you select which application you want to have launched whenever a camera or media card reader is plugged in to your Mac. When you installed the Nikon software, you were probably given the option of having Nikon Transfer open anytime a camera or card reader is plugged in. We'll look at Nikon Transfer later in this section.

Using the preferences in Image Capture, you can control what should happen when a camera or media card reader is connected to your Mac.

By default, the menu will list iPhoto (if you have it), Image Capture, and possibly other applications, including Nikon Transfer, if you have them installed. If you have a program installed that you'd like to use but you don't see it listed, choose Other. Image Capture will present you with a dialog box that allows you to pick the program you'd like to use.

Finally, if you'd like complete manual control, you can choose No Application.

You can change this menu at any time if you later want to change your image transfer preference. We'll go over a few image transfer options in the following sections.

Using Nikon Transfer for Mac or Windows

If you installed the Nikon Software Suite Disk, then you'll also have a copy of Nikon Transfer, Nikon's software for managing the copying of images from media cards to your computer.

If you have Nikon Transfer installed on Windows, then Windows will provide an additional option when you insert a media card. Copy Pictures to a Folder on My Computer Using Nikon Transfer will let you transfer images using Nikon Transfer.

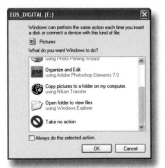

If you've installed the Nikon Software Suite Disk, then copying images using Nikon Transfer will be an additional import option. If you decide you like Nikon Transfer, select Always Do the Selected Action to make Nikon Transfer your default choice.

If you're a Mac user, then you can configure the OS to automatically launch Nikon Transfer when you insert a media card. See the previous section for details.

Choosing a Source and Destination for Transfer

Nikon Transfer provides a single dialog box with five different tabs for configuring the specifics of your transfer operation.

When the program launches, the Source tab should automatically configure itself to point to the card that you inserted. If it doesn't, open the Search For menu, and you should see a listing for the card you inserted.

By default, Nikon Transfer will copy all the images on your card. If you prefer to copy only a selection of images, then open the Thumbnails section of the Source tab (if it isn't open already), and select the images you'd like to transfer.

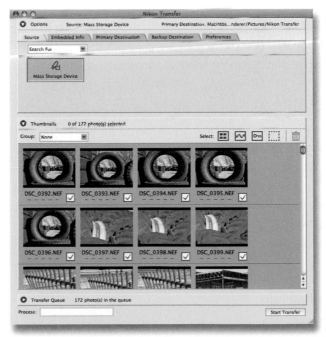

To transfer selected images, in the Source tab, select the box beneath the thumbnail of each image you want to copy.

The buttons at the top of the Thumbnails section allow you to select and deselect all the images or to select images that you marked or protected in the camera.

You can even delete selected images by clicking the trash icon. Hold the mouse over each button to see a tool tip that describes its function.

Once you've selected the images you want to copy, you need to tell Nikon Transfer where to put the images. Choose the Primary Destination tab to select a folder to copy the images into.

Open the Primary Destination Folder pop-up menu to select a destination. If you would like to create a subfolder within that folder, click the Create Subfolder for Each Transfer box, and enter a folder name.

Use the Primary Destination tab to select the location you want your images copied to.

If you'd like, you can have Nikon Transfer automatically rename your images when it copies them. Check the Rename Photos During Transfer box, and then click the Edit button beneath it to define a naming convention.

You can also have Nikon Transfer automatically make a *second* copy of your images to a second, backup location. Click the Backup Destination tab, and you'll find controls for selecting an additional folder. Nikon Transfer will copy the contents of your card to both locations.

On the Preferences tab, you'll find a number of useful, self-explanatory settings that you can configure.

Embedding Info

As you've seen, when you take a picture with the D90, it automatically embeds all of your exposure settings in the *metadata* of the image. Metadata is simply extra data that's stored alongside the image data in the file that the camera creates.

You can add metadata to your image file, such as a description, title, copyright info, and more. You can add this info at any time, using any number of different tools. Nikon Transfer also lets you add metadata when you import.

Metadata is often image-specific—for example, you might include keywords that describe the image content. But there are some metadata tags that will apply to all of your images, such as your name and copyright information. If all of the images on the card were shot in the same location, then you might want to fill in some of that data before you transfer.

To have Nikon Transfer automatically embed metadata info, follow these steps:

1. Click the Embedded Info tab. There are several different types of metadata. Your camera embeds EXIF metadata in your image when you shoot—this is the exposure data. XMP and IPTC metadata are additional metadata standards. Using Nikon Transfer, you can define templates containing specific metadata. This allows you to keep a library of commonly used sets of metadata.

2. Click the Edit button to open the metadata template editor.

The template editor lets you create a predefined set of metadata tags that Nikon Transfer will automatically add to images when you copy them. You can save multiple templates, in addition to the default ones that Nikon provides.

3. On the left side of the window are three presets. Click the New button to create a new preset, and give it any name you like.

4. Fill in any fields that you like. For example, if you want your copyright information added to all the images, fill in the Copyright Notice field. If you want your name added, then fill in the Creator field. When you're finished, click OK. Your preset will now appear in the XMP/IPTC Preset pop-up menu on the Embedded Info tab.

Starting the Transfer

When you've configured all of the transfer settings to your liking, click the Start Transfer button at the bottom of the dialog box. The progress bar will show the progress of your copy.

Transferring Images Manually Using Windows or the Mac

If you want complete manual control of your image transfers, configure your computer to do nothing when a camera or card reader is plugged in. This will simply mount the camera or card reader on your desktop, just as if it were a hard drive, leaving you free to copy files as you please.

The advantage of taking a manual approach is that you can completely control where files are placed and create a folder structure on your drive that makes the most sense to you.

The downside to importing using this approach is that, depending on which version of your operating system you're using, you won't necessarily be able to see thumbnail previews of your images before you transfer, which means you won't be able to pick and choose which images to copy. Obviously, you can always sort through them later.

To transfer images manually, simply plug in the camera or card reader. When the camera or card reader icon appears on your desktop, open it. You should see a folder inside called DCIM. There might be some other folders, but DCIM is the only one you need to worry about. It is the standard location that camera vendors have agreed upon for storing images.

Inside the DCIM folder you will find additional folders, usually named with some combination of numbers and "D90" (i.e., "100NCD90"). Depending on how many

images you've shot, there may be more. Open each folder, and copy its contents to your desired location.

Using the Camera to Select Images for Transfer

While reviewing images in your camera, you can specify which images you want to transfer to your computer. Of course, you could also just delete the images that you don't want, which would free up more storage on your card. However, if you've shot a bunch of images and need to quickly process and deliver just a few, then marking only those images for transfer will let you quickly get those images to your computer for processing. You can transfer the rest later.

Of course, you can also select images for transfer using your transfer software, but marking images in the camera can be convenient, both because it's something you can do in the field, when you have spare time, and because you can mark a "keeper" image as soon as you shoot it.

To mark an image for transfer, view the image on the D90's screen; then hit the Menu button. Choose Transfer Order from the Playback menu. On the resulting menu, choose Sel. Image.

Using the Transfer Order page, you can control what images will be transferred to your computer.

ImageBrowser and ZoomBrowser both let you choose to download only images that have been marked in the camera, providing you with a one-button method for getting your order into your computer.

> **QUESTION:** What If I'm Using Photo Management Software?
>
> If you're using Apple's iPhoto or Aperture, or Adobe Lightroom (on either a Windows or Mac machine), then those programs can take care of image transfer for you. As with any other application, you'll need to specify that you want those applications to take over image downloading. Consult the documentation for your program for more information, and be aware that these applications all copy your images into their own library systems, so you don't need to worry about where the images should be stored. Each program will take care of putting the files in a location that's right for them.

Organizing Your Images

No matter which method you use to transfer images to your computer, if you're managing your image organization yourself (as opposed to having a program such as iPhoto, Aperture, or Lightroom do it for you), then you will want to think about how to organize your files.

You'll be best served in your organizational chores by making good use of folders. How to organize these folders is entirely a matter of personal preference; just find a scheme that makes sense to you. You can create folders by subject—"Arizona vacation," "Winter holidays," "Family reunion"—or by date. You'll probably find that some combination of both works best, especially if you find yourself shooting a lot of similar events.

As you accumulate more vacation folders, you can group these into other folders. With well-named folders, you can easily rearrange your taxonomy later, creating new branches of your naming "tree" and then rearranging photos as needed.

What you probably won't need to do is rename files. Yes, the images that come out of your camera have pretty meaningless names, but with a browser program such as the one that came with your camera, or programs such as Adobe Bridge or Camera Bits Photo Mechanic, you can search and sort your images by viewing thumbnails, rather than by digging through lists of arcane filenames.

If you do feel compelled to rename your images, renaming by hand is probably not the way to go, unless you're talking about only a handful of images. Programs like Bridge, Photo Mechanic, and most image browsers provide tools for automatically renaming batches of files. If you think you need to have your individual image files named, then consider using such a utility.

FILE NUMBERING OPTIONS

As you may have already noticed, image files that come out of the D90 have meaningless names. The D90 usually labels its images DSC_ and then a sequential number and a file extension, either JPG or NEF.

By default, every time you start shooting, the camera picks up with the next number in the series, even if you change media cards. It will continue this numbering scheme up to 9999, at which point it will start over at 0001.

If you'd rather, you can configure the camera so that it starts with new numbers every time you format the card or insert a new card. With this scheme, though, you have to be careful when transferring new images into a folder that contains previously transferred images, because many images will have the same name.

If you think you'll always be putting new images in their own folders, then having the numbers reset might be a good choice, because each folder will have its own numbering scheme that starts at 1. If you want to be able to throw new images into existing folders that already have images, then you'll probably want to stick with continuous numbering so that you don't have to worry about new files overwriting old.

To change the file numbering preference, go to the Custom Setting menu, and choose Shooting/Display and then File Number Sequence. Selecting On tells the D90 to continuously number. Off causes it to restart numbering with a new card, or card format. Reset works the same as On but resets the count to 1 more than the highest number in the current folder.

The Off option can be handy when used in conjunction with the D90's folder creation commands. In the Shooting menu, you'll find a command called Active Folder. Here, you can create, rename, and delete folders on the camera's media card and select which folder the camera should store new images in. By creating folders and resetting the file number sequence, you can keep your images organized while you shoot. However, because of the interface limitations of the camera, you'll probably find it easier to do this type of organization later, on your computer.

After You've Transferred Your Images

Once you've transferred your images, you'll be ready to start the rest of your postproduction workflow—correcting, editing, adjusting, and outputting your images. With these first four chapters, you should know how to shoot in Auto mode and transfer your results to your computer. This means you can continue to practice while we cover some new topics.

Although modern image-editing software can do some amazing things, how much editing you can perform is limited by the quality of your original shot. So, I'm going to now delve more deeply into some photographic theory so that you can learn to use the more advanced features on the D90. These features will allow you to shoot images that can withstand a much greater level of editing and adjustment.

Photography 101

THE FUNDAMENTAL THEORY OF EXPOSURE

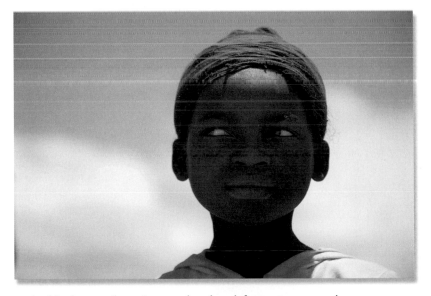

In this chapter, I'm going to take a break from cameras and computers and focus on basic photo theory. In the old days of manual cameras, you couldn't learn to shoot without certain fundamental knowledge. With today's automatic cameras, it's possible to take great photos without having the slightest notion of how different parameters affect your image. However, you'll most likely find that shooters who do understand the basics have a broader creative palette to work with and can push their photography further. You'll be using the concepts covered in this chapter through the rest of the book.

In Chapter 2 you took a quick look at the anatomy of your D90, and you learned something about the architecture of an SLR camera. In that discussion I mentioned the image sensor in your camera. As you already know, in a digital camera, the image sensor takes the place of a piece of film and is the mechanism by which the camera can "see" an image.

The image sensor is a chip that is mounted parallel to the back of the camera so that the light focused by the lens hits it head-on. In the D90, the image sensor is smaller than a piece of 35mm film; it's the same size as a piece of APS film.

The image sensor in your D90 is a large silicon chip with an imaging area that's the same size as a piece of APS film. It is this area that is sensitive to light.

The D90 image sensor is based on a technology called *complementary metal-oxide semiconductor*, or CMOS. Nikon's higher-end SLRs use CMOS image sensors, while many of their less expensive SLRs and most point-and-shoots use charge coupled device, or CCD, image sensors. You will often see people praise the merits of one sensor over another, and although these can be interesting engineering discussions, as a photographer, the only thing you need to worry about is final image quality. If your image sensor delivers excellent images in a range of lighting

situations—which the D90 does—then the relative merits of sensor technology are fairly moot.

Whether CMOS or CCD, most image sensors employ the same basic design. A rectangular area on the sensor is sensitive to light. This area is divided into a grid with one cell for each pixel that the sensor can capture. So, the D90's 10-megapixel sensor is divided into a grid with 10 million cells (for those of you who are sticklers for accuracy, it's actually closer to 10.10 million cells).

So you can understand what happens in each cell, we have to talk about a major figure in digital photography. While photographers will often throw important names around—Elliott Erwitt, Ansel Adams, Henri Cartier-Bresson—they don't often mention Albert Einstein. Albert Einstein might have fundamentally changed our idea of space and time, ushered in the nuclear age, and laid the groundwork for some of the most important, radical thinking in the entire history of the human species, but he also did some important work that turned out to be essential for digital cameras.

Everyone associates Einstein with relativity, but it was his investigation of the photoelectric effect that won him his one and only Nobel Prize, and the photoelectric effect is what makes a digital image sensor work.

In simplest terms (which is probably about as far as us non-Einsteinian, non-computer engineers can understand), the photoelectric effect causes certain types of metal to emit a number of electrons when struck by light. The number of electrons is directly proportional to the amount of light.

Each cell on your image sensor contains a piece of metal that is sensitive to the photoelectric effect. After the exposure, the sensor measures the voltage at each location and thus understands how much light struck each pixel.

Since it knows how bright each pixel should be and since it has so many pixels on its sensor, the image sensor can build up a very detailed image.

Obviously, all of this happens in a fraction of a second, and in practice, you don't have to worry about what the image sensor is doing at the individual pixel level. However, you do have to think about the amount of light that you expose the sensor to, because if there's too much or too little, your shot will be ruined. What's more, you can change the method by which the sensor is exposed and achieve very different results.

FOOD FOR THOUGHT

WHERE COLOR COMES FROM

If you haven't noticed already, the process I just described does not actually describe anything about the color of an individual pixel. In other words, the only thing the image sensor can determine from the photoelectric effect is how *much* light struck an individual pixel. It can't actually tell anything about the *color* of the light that struck each pixel. A digital image sensor is inherently a *luminance* or *brightness* sensor. In other words, it sees in black and white.

To achieve a color image, each pixel on the sensor is covered with a colored filter. On the D90, the filters are either red, green, or blue. As you may already know, red, green, and blue are the primary colors of light. Those three colors can be mixed together to form every other color.

The filters allow the image sensor to know how much of a particular color struck each pixel at the time of exposure. Using complex algorithms, the camera is able to analyze all of this information to interpolate the color of each individual pixel. This interpolation process is called *demosaicing*, because the mosaic of primary colors on the image sensor gets converted back into a full-color image.

If this sounds difficult and complicated, that's because it is, and demosaicing algorithms are some of the most important trade secrets in the camera industry.

Over- and Underexposure

At its most basic level, exposure is pretty easy to understand. If you turn out the light in your room at midnight, your eye won't be able to gather enough light for you to be able to see anything. In other words, your room is underexposed.

Conversely, if someone shines a bright light in your eyes, you may not be able to see because the sensors in your eyes will get overdriven. In other words, your field of view will be overexposed.

The image sensor in your camera (or a piece of film in a film camera) works the same way. If you underexpose a scene—either because there's simply not enough light or because you use bad exposure settings—then the scene will be too dark. If you overexpose a scene, then the image will be too bright.

The left image is underexposed: It's too dark overall, and shadow areas have plunged into complete black. The center image is overexposed. It's too bright, and highlight areas have blown out to complete white. The right image is properly exposed, revealing good detail from shadows to highlights.

Even within an individual shot, some areas can be overexposed, and some areas can be underexposed.

This image has highlights that are overexposed and shadows that are underexposed. There's no way to capture the full range within the camera, but if you expose properly, you can restore highlight and shadow detail later using an image editor.

So, one of your primary concerns as a photographer is to make sure that you're choosing settings that expose the camera's sensor to an amount of light that will render a scene that is neither too bright nor too dark.

Exposure Mechanisms

Your camera gives you two mechanisms for controlling the amount of light that hits the image sensor. Using these mechanisms, you can ensure that you don't end up with images that are too bright or too dark.

In Chapter 2, you learned about the shutter, a curtain that opens and closes in front of the sensor to expose it to the light that is focused through the lens. By using a faster shutter speed, the shutter will open for less time and thus expose the sensor to less light.

The second mechanism that the camera uses to control light is the iris or aperture. This concept should be somewhat familiar because your eyes have irises in them, and if you've ever walked out of a dark movie theater in the middle of the afternoon, you know what it's like to wait for your pupils to close down so that your field of view ceases to be overexposed.

The iris in your camera is built from a series of interlocking leaves that, when rotated, create an expanding or shrinking opening, or *aperture*. The wider the aperture, the more light that gets let through to the sensor.

The aperture is positioned at the very end of the lens, just before the mount that attaches the lens to the camera body. As mentioned in Chapter 2, the shutter is positioned just in front of the image sensor.

DEFINITION: It's Curtains!

The shutter in your camera is composed of two curtains that pass in front of the lens. As the first one passes, the sensor is exposed. The second one then passes to close off the sensor. At a high shutter speed, there's a good chance that there will be very little time between when the two curtains start moving. This means that the actual opening created by the shutter is just a thin slit that passes in front of the sensor.

ISO: The Third Exposure Parameter

In a digital camera, you have one additional parameter that you can change to control exposure.

As you just learned, your image sensor measures voltages on the sensor's surface to determine how much light struck each pixel. These voltages must be amplified before they can be measured. If you amplify the voltages more, then the sensor will effectively be more light-sensitive, because dimmer light levels will be boosted.

ISO is a standard for measuring the sensitivity of film. Digital vendors have adopted the standard for specifying the sensitivity of a digital image sensor. When you increase the ISO setting on the D90, you're essentially making the sensor more light-sensitive. As the sensor becomes more sensitive, it will require shorter exposures to be able to "see" a scene. We'll discuss ISO in more detail later.

DEFINITION: Stops

To a photographer, a *stop* is a measure of light. More specifically, a stop represents a doubling of light. So, any time there's a doubling of light—whether we're talking about the light in a scene or the light hitting your sensor—you can say that the amount of light has increased by one stop. Conversely, a halving of light means that the light has decreased by one stop. I will be using this term extensively throughout the rest of the book. Experienced photographers are often able to recognize one or two stops of light by eye. Although that can take years of practice, it's not a necessary skill to use your camera well. However, you will need to understand the term and how it applies to the different exposure settings.

Shutter Speed

As you've learned, the shutter sits just in front of the image sensor and opens and closes to expose the sensor to light. The shutter speed that you (or the camera) chooses determines how long the shutter will stay open.

Shutter speeds are measured in seconds, and a longer shutter speed exposes the sensor to light for a longer period of time than a shorter shutter speed. The D90 has a shutter speed range of 1/4000th of a second on the fast end to 30 seconds on the slow end. The D90 also provides a Bulb mode, which lets you keep the shutter open indefinitely.

In the Auto shooting that you've been doing, the camera has been calculating an appropriate shutter speed for you, automatically, and you can see its decision in the camera viewfinder status display.

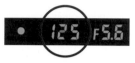

Here, the camera is indicating that it has chosen a shutter speed of 1/125th of a second.

On the status display shown on the top LCD, shutter speed is the number in the upper-left corner.

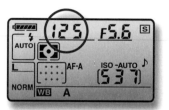

Shutter speed is also shown on the top LCD screen.

In later chapters, you'll learn how to control shutter speed manually.

Aperture

Like shutter speed, the size of the aperture (which we discussed earlier) can be controlled automatically by the camera or manually by you. Aperture size is measured in f-stops, and an f-stop number is often fractional, so you'll see f-stops with values such as f5.6, f8, or f11.

> **QUESTION:** What Do Those Numbers Mean?
>
> An f-stop is a measure of the ratio of the focal length of the lens to the size of the aperture. Many of the numbers are fractional because you're dealing with the area of a circle, and the math quickly gets complex. Don't worry about trying to understand that ratio; you don't have to understand the math to effectively use f-stop values.

Unfortunately, f-stops can be a little unintuitive at first, because the way they're measured can seem backward. A larger f-stop number, say 16, indicates a smaller opening.

Let's try a little experiment that will make all of this a little clearer.

1. Take your D90 and set the Mode dial to M, for manual. You'll be looking at Manual mode in detail in Chapter 9, but for now you're going to use it so that you can see your lens's actual aperture.

2. Press the shutter button halfway to meter and then turn the Main dial to the left until the shutter speed readout on the rear LCD says Bulb.

3. Now turn the subcommand dial on the front of the camera This allows you to change the aperture. Turn the wheel until the aperture readout says F16. The status display should look something like this:

When shutter speed is set to Bulb, the shutter will stay open for as long as you hold down the shutter button.

4. With the shutter speed set to Bulb, the shutter will stay open for as long as you hold down the shutter button.

5. Set the camera lens to manual focus by changing the focus switch on the lens from AF to MF.

6. Orient the camera so that you can see the front of the lens, and watch what happens when you press and hold the shutter button. You should see the iris close.

f16 aperture

If you look closely at your lens while the shutter button is down in Bulb mode, you can see the aperture close down to your current aperture setting.

7. Take a closer look, and you'll be able to see the interlocking metal leaves that make up the iris.

8. Now release the shutter button, and the iris will open again.

It's pretty easy to see that when the aperture is smaller, it blocks (or stops) a lot of light. For this reason, when the shutter button is not pressed, the aperture opens as wide as it can go to ensure that as much light as possible makes it to the viewfinder so that you can more easily see and frame your shot. When you press the shutter button, the camera closes the aperture down to your chosen aperture setting, opens the shutter to make the exposure, closes the shutter, and then opens the aperture back up all the way so that you have a clear view out the viewfinder.

Now press and hold the Exposure Compensation button, and dial the aperture to f8. Again, look at the front of the camera, and press and hold the shutter button. The iris will close, but it should be obvious that it's not closing as far as it did when the aperture was set to f16.

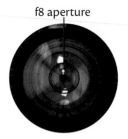

At f8, the aperture will be slightly larger than at f16.

Dial up some other apertures, and take a look at them. When you're finished, be sure to set your lens back to autofocus by moving the focus switch to AF.

What you should have seen is that when you choose a higher f-stop number, you're electing to stop more light with the aperture. That is, you're selecting a smaller opening.

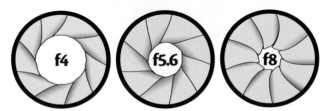

As aperture size increases, less light strikes the sensor.

In this book, I'll use a few aperture-related terms that you'll regularly hear photographers employ. When I speak of stopping down a lens, I mean choosing a smaller aperture (larger f-number). Opening up the lens means to choose a larger aperture (smaller f-number). Shooting full wide means choosing the largest possible aperture (the one with the smallest number).

This last term can be a little tricky because, on a zoom lens, the largest possible aperture can vary depending on your current focal length. For example, if you're using the 18-105mm lens that Nikon bundles with the D90, then you have a large aperture of f3.5 when shooting with the lens at full wide but a large aperture of f5.6 when shooting with the camera at full telephoto. In other words, the aperture can't open as wide when you zoom the lens in all the way. This is simply because of the nature of engineering a lens. (If you look at the front of the lens, you'll see that it says "1:3.5-5.6." This tells you the aperture range, from full wide to full telephoto.)

Why There Are Two Ways to Control Light

So, you can limit the amount of light that hits the sensor by changing the amount of time that the shutter is open, and you can limit the amount of light that hits the sensor by changing the size of the aperture in the lens. But why do you need two mechanisms for controlling light? If your concern is just to ensure that the image is neither too bright nor too dark, wouldn't one mechanism be enough?

If brightness were your only concern, then yes, one mechanism would be enough, but because of the way the physics of light works, there can be a big difference in your final image depending on whether you try to control exposure using shutter speed or aperture. In fact, after compositional choices, the bulk of your creative power as a photographer comes from how you choose to manipulate these two controls.

How Shutter Speed Choice Affects Your Image

This next bit should be pretty intuitive. As you choose a faster shutter speed, you will have more ability to freeze motion in a scene. That is, when the shutter is open for a very short time, a moving subject will be frozen. When the shutter is open for a longer time, a moving subject will be blurry and smeared.

With a slower shutter speed, you can blur your subject to create a more dynamic image.

You may think that blurry and smeared is inherently bad and that you would always want your images sharp and clear. But consider the following two images:

In this image, the slower shutter speed lets us see the movement of the rides.

In this image, the faster speed makes the rides look like they're sitting still.

If we shoot this scene with a fast shutter speed so that it is completely frozen, then we no longer see this as a moving Ferris wheel. In fact, it looks stopped. Blurred motion is often a way to introduce a dynamic feel to your images. When shooting a dynamic scene, you'll want to think about what best conveys the sense of dynamism that you feel there. Is it a perfectly frozen, fast shutter speed choice? Or a blurred, slow shutter speed choice?

There's another concern with shutter speed, which is the fact that your hands and body aren't always steady. You don't want to choose a shutter speed that's so slow that the natural shakiness of your hands will cause the image to be soft or blurry. In Chapter 6, we'll discuss how to calculate the slowest possible shutter speed for handholding in any given situation.

How Aperture Choice Affects Your Image

As you saw when you looked at the front of your lens with the shutter button held down, when you choose a higher f-number, the aperture in your lens is closed off more and blocks more light. Obviously, this will make your final exposure darker. But changing aperture has another effect on your image.

As you go to a smaller aperture, the depth of field in your image gets deeper. Depth of field is simply a measure of how much of your image is in focus.

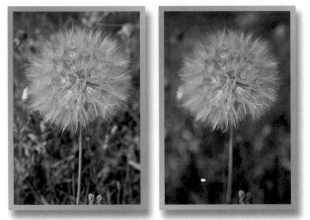

The image on the left has deep depth of field, while the image on the right has a very shallow depth of field.

Here, the figure on the right has a very shallow depth of field. Notice that the background is out of focus, and even some parts on the front and back of the dandelion are slightly out of focus. The image on the left has very deep depth of field, with everything in the image in focus.

Depth of field is measured around your point of focus. So, if you've chosen an aperture that gives you, say, 10 feet of depth of field, then an area 10-feet deep will be in focus centered around the distance you focused at. What's more, about a third of that depth will be in front of the point of focus, and the other two-thirds will be behind.

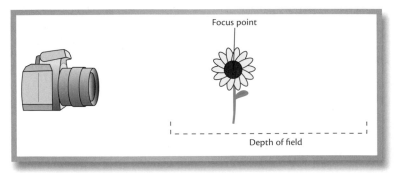

About a third of the depth of field in your scene will be in front of your subject, with the remaining two-thirds falling behind your subject.

Isn't it usually best to have everything in your image in focus? Not necessarily. Sometimes, having a sharply focused background can distract the viewer from your foreground subject. Portraits are the most common example of a shallow depth of field application. If you choose a larger aperture for a portrait, you'll create a softer background that will bring more attention to the subject of your portrait.

Just as you'll make shutter speed choices to control motion stopping, sometimes you'll need to consider how depth of field can be used to better express the subject or scene you're shooting.

Also, be aware that every lens has an aperture "sweet spot." On most lenses, if you stop down too far, you might suffer a sharpness penalty. Depending on how big you intend to print your final image, this penalty may be irrelevant.

Shutter Speed/Aperture Balance

So, you can control how sharp or blurry a subject is by choosing a slower or faster shutter speed and you can control how deep the focus is by choosing a larger or smaller aperture.

However, each of these choices will also render your scene brighter or darker. For example, if you decide you want to use a very fast shutter speed to stop a fast-moving object, then your scene might end up underexposed. The faster speed will allow less light to hit the image sensor, and your final image might end up dark.

You can compensate for a faster shutter speed, though, by using a wider aperture. A wider aperture will allow more light to pass through the lens and will restore a good level of brightness to your scene. Of course, a wider aperture might mean less depth of field. So, if you want to stop motion and have deep depth of field and a scene that is properly bright, you might have a problem. Balancing all of these factors is one of the tricky things about photography.

To better understand this balance, you need to learn a new term.

Reciprocity

Let's go back to the subject of stops for a moment. As discussed earlier, a *stop* is a measure of light. When you double the amount of light that hits the sensor, you

say that you have increased the amount of light exposure by one stop. Conversely, if you halve the light, you decrease the exposure by one stop.

Consider these shutter speeds:

1/60 1/120 1/250 1/500 1/1000 1/2000 1/4000

Each one is double the previous shutter speed. In other words, there is a one-stop difference in the amount of light exposure generated by each of these speeds.

Now consider these apertures:

f4 f5.6 f8 f11 f16 f22

This one is not so obvious because most of us aren't too familiar with calculations of circular area. But, trust me when I say that each one of these apertures represents an opening that's twice as big as the previous aperture. In other words, there's a difference of one stop of light exposure between each of these apertures.

When it comes time to balance motion-stopping power with depth of field with overall illumination, you can take advantage of the fact that both shutter speed and aperture can be adjusted by the same amount in opposite directions. In other words, the two values have a reciprocal relationship.

For example, let's say your light meter recommends an exposure of 1/500th of a second at f8. It doesn't know how much motion stopping you might want or how much depth of field, so it's simply trying to recommend a shutter speed and aperture that will give you a good level of illumination.

But if you decide that you want more motion stopping power and so increase shutter speed from 1/500 to 1/1000 (one stop), you'll run the risk of darkening your image. But, you can open your aperture from f8 to f5.6 (one stop) to compensate for that one stop of darkening that you introduced with the shutter speed change.

Because of this reciprocal relationship, many different shutter speed/aperture combinations yield the same overall exposure. That is, many combinations produce an image of equal brightness. However, some of those combinations might produce an image with more depth of field than others, or some might produce an image that has blurrier motion than others.

These two images have reciprocal exposures. That is, they have the same overall illumination, but the left one was shot with a combination that had a slower shutter speed than the right image.

For the moment, don't worry about how you manage all of this on your camera. In this chapter, the goal is to understand the concepts. We'll get to the application and the actual controls in the next chapter.

TIP: Reading Shutter Speed

On the status display on top of the camera and in the viewfinder, the D90 displays only the denominator portion of the shutter speed. So, a shutter speed of 1/60 of a second is shown as 60. When you get to shutter speeds that are longer than a second, the D90 will use a quote mark to denote seconds. So, 1.3" denotes one-and-one-third seconds, while 2" would be 2 seconds.

ISO: The Third Exposure Parameter

Earlier in this chapter, you learned about ISO. The D90 offers these ISO settings:

200 200 400 800 1600 3200

You can probably already see where this is going. Each ISO setting is double the previous, meaning there's a one-stop difference between each ISO. So, if you end up in a situation where your shutter speed and aperture choices have left your scene underexposed by a stop, you can increase your ISO setting by one stop to compensate.

Fractional Stops

In the days of manual cameras, shutter speed and aperture controls used the progression of settings that you've looked at here, with one stop of exposure difference between each setting (however, they provided a wider range than what I've shown).

However, it's possible to adjust shutter speed and aperture by intervals that are smaller than a whole stop, and by default the D90 will use values that are fractions of stops. So, as you adjust the shutter speed control on the D90, you might see a progression that goes like this:

1/15 1/20 1/25 **1/30** 1/40 1/50 **1/60** 1/80 1/100 **1/125** 1/160 1/200

I've put the traditional one-stop increments in bold. The other values are increases of a third of a stop. All the same reciprocal rules apply when dealing with fractional stops. These fractional stops simply give you a more granular, finer level of aperture control.

FOOD FOR THOUGHT

IMAGE ANATOMY

You need to learn an additional bit of theory if you want to get the most of out your image-editing software. Just as good film shooters needed to have a certain understanding of film and paper chemistry, as a digital shooter, you need to know something about how a digital image is constructed.

Pixel is a pretty common term these days, and I've been using it off and on already, but just in case there's any confusion about it, here's a definition: Pixel stands for *picture el*ement, and a pixel is used to refer to any individual unit of information in a raster image. A *raster* image is simply an image that's made up of colored dots. So, the image on your computer screen is a raster image made up of pixels.

Similarly, your digital camera produces a raster image of different-colored pixels.

A pixel's color is simply a numerical value, with a different number representing each color that the pixel can be. The range of color that any individual pixel can be is limited only by the amount of memory that your imaging device devotes to that pixel. For example, your computer monitor probably uses 24 bits of data for each pixel. With 24 bits you can count from 0 to roughly 16 million, which means that any pixel on your screen can be one of roughly 16 million colors. Your D90 uses 14-bit pixels, which means it can record a huge variation of color.

FOOD FOR THOUGHT

When you were a kid, you probably learned about the color wheel and learned you can mix the primary colors of ink together to create other colors. You probably also learned that as you mix colors together, they get darker until they eventually turn black.

Light works mostly the same way. The primary colors of light—red, green, and blue—can be mixed together to form every other color of light. But, as you mix the primaries of light, they get brighter until they eventually turn white.

A digital image is actually composed of three separate *channels*. One contains all of the red information in the image, the second contains all of the blue, and the third contains all of the green.

I'll be referring to this three-channel color process at various places in this book.

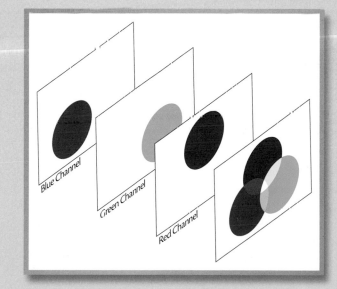

Unlike ink, when the primary colors of light (red, green, and blue) are mixed together, they get lighter and lighter until they become white.

Thinking Again About Auto Mode

Now that I've identified all the mechanisms that go into making an exposure, let's look again at the Auto mode that you've been shooting with. As you learned in Chapter 1, when you press the D90 shutter button halfway down, the camera

focuses and calculates an exposure. That exposure is a shutter speed setting, aperture setting, and ISO choice. The camera has determined that these settings will yield an image that is neither too bright nor too dark.

When the camera has calculated these values and autofocused, it displays its choices in both the viewfinder and rear LCD status displays. These numbers should make a little more sense to you now.

As you just learned, many combinations of shutter speed and aperture settings yield the same overall exposure. So, how does the camera choose? Its algorithms are designed to take the "safest" possible combination, that is, a shutter speed and aperture that will yield a good overall exposure, without risking handheld shake from a slow shutter speed or image softness from an extreme aperture.

Summing Up

I've thrown a lot of theory at you in this chapter, and it's worth spending a little time studying it. However, the rest of this book will reinforce these concepts with actual practice.

To sum up, it takes a certain amount of light to yield an image that is neither too bright nor too dark. Your camera offers two ways to control this light: shutter speed and aperture. Shutter speed allows you to control how still or blurry a subject is, while aperture lets you control how deep the depth of field in your image is. In addition, ISO lets you control how light-sensitive the sensor is.

All these controls are measured in stops, with a change of one stop representing a doubling or halving of light. These three parameters have a reciprocal relationship, which means that if you change one, you can alter one of the others to make up for that change and ensure that your overall exposure remains the same.

Program Mode

TAKING CONTROL AND
UNDERSTANDING MORE ABOUT EXPOSURE

So far, you've been using your camera in its fully automatic mode. In Auto mode, the D90 makes all critical decisions for you. Program mode, on the other hand, provides a great balance of automatic and manual modes, letting you continue to shoot snapshot-style but with additional manual control when you need it. Because of this and because of the ease with which the D90 lets you take manual control when you need it, you'll probably use Program mode more than any other mode on the camera.

However, no algorithm can know what's right for every situation or know what your particular taste is. Some photographic situations require more complicated decision making than the camera can perform, and some pictures that you see in your head simply can't be captured by the camera. They require additional image editing. For all these situations, you'll need to take some additional control. In this chapter, we'll explore all of the manual overrides available in Program mode, as well as some of the other creative choices you make when shooting.

Switching to Program Mode

In Chapter 1, I showed you the Mode dial, the dial on the left side of the top of the camera that you use to select a shooting mode. Each mode specifies a different set of parameters that the camera will handle automatically. For this chapter, change the shooting mode to P, which is for Program mode.

Program mode is a lot like Auto mode in that your camera will automatically determine shutter speed and aperture for you, as well as white balance and focus. However, Program mode does *not* automatically pop up the flash if the camera determines that your scene is too dark, and it *does* offer you some important manual overrides. Here's a table that shows the basic feature comparison between the two modes:

Feature	Program Mode	Auto Mode
Flexible program	✓	
Manual ISO selection	✓	✓
Manual white balance selection	✓	
Exposure compensation	✓	
Autofocus mode selection	✓	
Picture control	✓	
Release mode	✓	✓
Focus point selection	✓	✓
Exposure lock	✓	✓
Image format	✓	✓
Auto flash activation		✓

The additional manual control that you get in Program mode means you're going to have more creative control—the control to stop or blur motion, to change depth

of field, to better handle difficult lighting situations, and to choose exposures that change the way light and dark tones are represented in your final image.

Focusing Revisited

With your work shooting in Auto mode, you should now be comfortable with the autofocus mechanism of the D90, and prefocusing—the process of pressing the shutter button halfway down to autofocus—should be second nature. Although the D90's autofocus system is very good, no autofocus system can work perfectly in every situation, and sometimes you'll need to override, or take manual control of, the D90's focus. Fortunately, the camera provides a number of autofocus control mechanisms.

Understanding Focus Points

You've already experienced the D90's eleven autofocus points in the work you've done in Auto mode. So, you know that when you half-press the shutter button to autofocus, the camera assesses your scene and tries to determine what the subject is. It then focuses on that subject.

To let you know what it has focused on, the D90 will make any of the autofocus points that are on the chosen subject flash red and then outline them with a solid black border. When focusing, it's important to keep an eye on which points light up so that you know exactly where the camera has focused.

However, sometimes the camera chooses the wrong subject, especially if you're framing a scene with different subjects at different depths or a subject on the edge of the frame. Here's an example:

Here, I wanted to focus on the woman in the foreground, but the camera chose the wrong focus points and focused on the wall.

In this example, the camera chose to focus on the wall behind the woman, leaving her silhouette slightly out of focus. Fortunately, for situations like these, the D90 lets you select exactly which focus point you want to use.

Manually Selecting a Focus Point

Before you can manually choose a focus point, you have to change a setting to allow manual focus point selection.

To enable manual focus point selection, follow these steps

1. Go to the Custom Setting menu, and select Autofocus.

2. You'll see the full Custom Setting menu. All items in this menu that start with an *a* (a1 through a7) are items that affect the camera's autofocus mechanism.

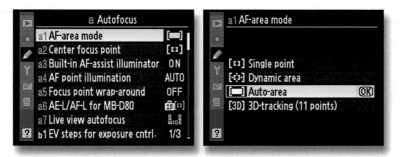

Choosing AF-Area Mode lets you change how the camera selects a focus point.

3. Using the arrow buttons and OK button, select Single Point.

4. Half-press the shutter button to return to shooting mode.

5. Set the focus selector lock switch on the back of the camera to •.

6. Frame a shot, and half-press the shutter button to autofocus.

7. Use the four arrow buttons on the back of the camera to manually select a focus point. As you press the buttons, you'll see the appropriate focus point light up both in the viewfinder and on the control panel on top of the camera.

8. When you've selected your focus point of choice, half-press the shutter again to refocus on the subject beneath your chosen point.

By manually selecting a focus point, I can ensure that the camera focuses on the flower, rather than the background.

Manual focus point selection lets you compose shots in any way yet still ensure that the camera understands what *you* think the subject is. Select the focus point that sits on the area you want to ensure is in focus, and the camera will focus there. However, if you've been finding that the D90's automatic focus point selection is working well for you, then you may need to switch to manual selection only in situations where the camera's auto mechanism fails.

Other Focus Point Selection Modes

As you probably noticed in the AF-Area Mode menu, the D90 includes a few options for focus point selection. Auto-Area is the default mode that you've been using. In Auto-Area mode, the camera automatically assesses what it thinks the subject of your image is and focuses on that subject. The focus points that it chose to use are highlighted so that you can keep track of what it has decided.

Note that if you're using Nikon G- or D-series lenses, the D90 will do an especially good job of identifying people.

Dynamic Area Dynamic Area mode is like the Single Point mode that you just learned but with an important difference. In Dynamic Area mode, you manually select a point, but the camera will still pay attention to surrounding focus points. Dynamic Area is used when you're shooting a subject that might move a little bit, such as a tree blowing in the wind or a person who's fidgety. As long as the subject doesn't move too far from your selected focus point, the camera will still be able to keep it in focus.

3D-Tracking In the manual focus point selection modes, if you select a focus point and then reframe your shot, the focus point may no longer be sitting on top of your desired subject. 3D-Tracking mode lets you manually select a focus point. However, if you recompose your shot, the D90 will likely be able to figure out where the subject is in your new framing and keep it in focus.

To use the 3D-Tracking feature, select the option, just as you did earlier with Single Point mode, to activate 3D-Tracking mode from the Custom Setting menu. Now select your focus point manually, then press the shutter button halfway down to autofocus. As long as you keep the shutter button held down, you can recompose, and the camera will keep your subject in focus.

If your subject leaves your frame altogether, you'll have to release the shutter button and start over. You'll want to practice with this feature before you go into any kind of once-in-a-lifetime shooting situation with it.

When to Manually Choose a Focus Point

As I mentioned earlier, when using Auto-Area focus point selection (which is the default setting in the Auto and Program modes), you must pay attention to what the camera says it's focusing on. Any time it decides to focus on the wrong subject in a scene, you'll want to manually select a focus point.

Certain types of scenes might consistently confuse the camera's ability to automatically select a focus point. Landscape scenes can often yield wrong focus point choices, as can shots of still lifes, such as a picture of a product that you want to post on eBay. Manual focus point selection can quickly solve all of these problems. Scenes that have lots of fine details, such as a field of flowers, can confuse the Auto-Area mode, as can regular geometric patterns, such as buildings. You don't have to remember all of these possible contingencies; just pay attention to where the camera is focusing when it automatically selects a point, and make sure it's the point you want.

Focus Modes

Nikon calls the type of focusing we've been doing so far *Single Servo autofocus*. No matter which focus point you're using, you set focus once for your shot and then take the picture.

USING ONLY THE CENTER FOCUS POINT

Some people like to set the focus point on the center point to gain better control of the camera's autofocus mechanism. The technique works like this: Set the D90 to the center focus point, and from now on you'll know that the camera will *always* focus on the center. If you're shooting a tricky composition, you can place the center focus point on your subject, press the shutter button down halfway to lock focus, and then reframe *while continuing to hold down the shutter button*.

To guarantee that the gravestone was in focus, I switched to center-point focusing, focused on the stone, and, with the button held down, reframed my shot to get the composition I wanted.

As you know, once you've locked focus, the camera will hold it until you release the shutter button or press it the rest of the way to take a picture. So, once you've locked focus, you can reframe as much as you want without losing that focus. When you have the image composed the way you want, press the button the rest of the way to take the picture.

The advantage to this technique is that you don't have to pay attention to where the camera is focusing. Instead, because you've made the decision, you always know what the camera is focusing on. One caveat when using this technique is that it's best to change the camera's light meter from its default of 3D color matrix II.

If you're shooting a moving subject, though, especially one that's moving toward you, then you might have to refocus several times. Remember, when you focus, you're focusing on an object that's at a specified distance. If that object moves closer or farther, then your focus will no longer be accurate. If it moves side to side but stays at the same distance, your focus should be fine.

Continuous Servo AF

For moving objects, you have two choices. As the object moves, you can reframe and refocus. To refocus, you'll have to let go of the shutter button and then give it another half-press. If you're using autofocus point selection, then you need to ensure that the camera is focusing in the right place. If you're using a single focus point, then you'll need to ensure that it stays on your moving subject as you refocus. Another option is to use Continuous Servo autofocus. This is an autofocus mode that automatically tracks a moving subject and keeps it in focus.

To activate Continuous Servo autofocus, press and hold the AF button on the top of the camera, and turn the Main dial until AF-C is selected in the control panel.

Press the AF button and turn the Main dial to change the autofocus mode from AF-A to AF-C.

To use Continuous Servo, focus on your subject as you normally would, and then continue to hold the shutter button down halfway. The camera will continuously refocus and adjust its exposure as your subject moves and you reframe.

Because the camera is continuously focusing, it will never beep or show its ready light, as it does in normal autofocus modes. So, you can simply take the shot whenever you want. If the camera has not managed to lock focus or is currently changing focus, then there might be a slight lag before the shutter is actually tripped. In general, though, you should find that Continuous Servo focus does a very good job of keeping your subject in focus in a timely manner.

Continuous Servo focus will keep your image in focus even as your subject moves and your framing changes.

Auto Select Autofocus

If you're in a dynamic situation where you sometimes want to shoot with Single Servo autofocus but also need to be able to shoot moving objects, then you might want to use Auto Select mode, which automatically switches between Single Servo behavior and Continuous Servo mode. With Auto Select autofocus, your D90 will default to one-shot focusing but automatically engage continuous focusing when your subject moves.

If this mode is truly the best of both worlds, why even have the other modes? Well, sometimes you'll want one-shot focus behavior but will be shooting a scene with moving objects in it. For these instances, you'll want to switch to Auto Select autofocus mode.

Conversely, there might be other times where you're trying to get a shot of a moving object that occasionally stands still. You don't want the camera switching into Single Servo mode and so might choose to lock it into Continuous Servo mode. Practicing with all three modes will help you better understand when to use each one.

> **REMINDER:** It's Always in the Eyes
>
> When shooting people, remember that the most important thing to consider in a portrait is the eyes. As long as the eyes are in focus, it probably won't matter if there's a little softness in the rest of the image. So, if you're using autofocus point selection, make sure the D90 indicates that it has the eyes in focus. Or, switch to center-point autofocus, put the center focus point on the subject's eyes, autofocus, and then reframe. This will ensure that the eyes are sharp.

What to Do When Autofocus Doesn't

The autofocus mechanism in the D90 is dependent on contrast; the sharp edges in an image are composed of high-contrast lines.

A crop of this image shows how much contrast there is. The lower crop shows an unfocused version of the image. As you can see, there is very little contrast in the image, since it is out of focus.

When you half-press the shutter button, the camera measures the contrast in your scene; then it zooms in a little and measures the contrast again. If the contrast has increased, it zooms in more until there's no additional contrast improvement. If the camera zooms in and the scene's contrast *de*creases, then it zooms back out. If you see the lens zoom in and out and back in before it beeps to tell you it's found focus, then you've just experienced it searching and zeroing in on the most contrasty focus distance.

However, if you're shooting a scene that *lacks* contrast, then you may have a hard time getting the camera to focus. You'll hear the lens search back and forth, and you'll see the image in the viewfinder alternate between focused and blurry, but you'll never hear the beep of the focus lock. This usually happens for two reasons: Either the camera's focus points are all on a contrastless part of the scene, such as the sky, or they're pointed at a textureless object.

In these situations, you must use a focus and reframe technique. Reframe your shot so that the camera's focus points are positioned on an object that's at the same distance as your desired focus, and then press the shutter button halfway. After the camera has locked focus, keep holding the button halfway down as you reframe to your desired composition; then press the button the rest of the way to take the shot.

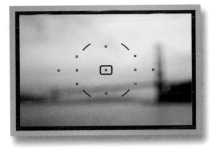

When all the focus points land on contrastless fog, the camera can't set focus.

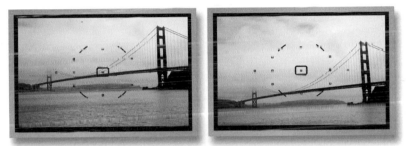

Tilt down so that the camera's focus spots are on the contrasty bridge. Press the shutter button halfway to lock focus; then reframe and take the focused shot.

WARNING: Use Something at the Same Distance to Set Focus

Remember, though, for this to work, you must focus on something that's at the appropriate distance. Don't lock focus on something in the foreground or way in the distance. When you reframe, your camera will be focused at the wrong point.

Low-Light Autofocus Problems

Sometimes your scene lacks contrast because it's too dark. When this happens, the camera may have trouble locking focus. If you hear the camera focus in and out for a while and it still doesn't lock focus, then probably the scene is too dark for the autofocus mechanism to work. In these instances, the camera will light up its autofocus-assist lamp, the light on the camera body that sits just to the left of the hand-grip. This extra light can help the camera lock focus.

The focus-assist feature, like the flash, has limited range, so it won't help if you're shooting a landscape shot or something very far away. But if you're taking a portrait or snapshot, it will probably be fine. You might want to warn your subject

that the camera is going to shine a light at them, although these days most people are used to weird lights coming out of cameras.

If the focus-assist light doesn't solve your focus problem, try the focus-and-reframe trick. Very often, you can find a bright highlight or reflection in a dark scene and focus on that, if it's at the right distance.

If you're shooting in a situation where the autofocus-assist lamp would be disruptive, you can disable it. You'll see how in Chapter 12.

> **T I P :** Autofocus Assist
>
> In Auto mode, the camera automatically pops up the flash if it needs to use the focus-assist lamp.

Manual Focus

Although the D90 packs a great autofocus system, don't give short shrift to manual focus. By switching the focus switch on your lens from AF to MF, you get full manual control of focus.

Most D90 lenses will have a manual focus ring, though different lenses will put the focus ring on different sides of the zoom ring. Simply turn the ring to focus the lens. On some lenses, you must first switch the lens to manual focus before the manual focus ring will work. On other lenses, manual focus will automatically work as soon as you turn the ring. So, if autofocus focuses and you don't like the results, you can simply turn the focus ring to refocus, and the camera will leave it alone.

Manual focus is great for those times when autofocus isn't working because your scene is too dark or you're shooting a subject that lacks contrast. Manual focus is also great for times when your subject isn't moving or changing. For example, you can autofocus on your subject and then switch to manual and know that your lens is locked on the right focus. With the lens set to manual focus, you'll be able to shoot much faster because you won't ever have to wait for the camera to focus. This is also great for shooting still life and product shots.

When shooting an object that's moving in a predictable fashion, many people think manual focus allows them to track faster than Continuous Servo focus. Quickly focusing manually requires practice, though, and the D90 Continuous Servo focus is very good, so you should experiment with it before you switch over to manual.

When using manual focus, it can sometimes be difficult to see whether you've achieved correct focus, especially if you're working in low light. Manual focus can be a little easier if you zoom in to the subject you want to focus on and perform your focus at that focal length. You can then zoom out and frame your shot. Note that you should *not* use this zooming in technique with autofocus, because you'll risk confusing your light meter.

FOOD FOR THOUGHT

PANNING WITH A SLOW SHUTTER SPEED

When you shoot with a slow shutter speed to try to introduce blur into your shot, you have two choices: You can hold the camera still and let the object move through your scene to create a blurred subject, or you can pan the camera to follow your subject and create a blurred background.

When shooting with a slow shutter speed, you can pan the camera to follow a moving subject, rendering the background a blur.

To create a blurred background, you pan the camera while the shutter is open. It can take some practice to do this well, without too much camera shake and without blurring your subject too much, but give it a try.

Press the shutter button halfway to meter your scene, and then spin the Main dial to dial in a slower shutter speed. Then, press the button all the way to open the shutter, and pan to follow your subject as it passes through your scene.

With a really fast-moving object, you don't need a super-long shutter speed. On a bright day, even a 50th of a second might be enough. Try different shutter speeds and pans until you get the amount of background blur that you like.

Getting Creative with Flexible Program

In the previous chapter, you learned about the effects that different shutter speed and aperture choices have on your final image. You saw that by controlling shutter speed, you can choose how much you want to freeze or blur motion, and that by controlling aperture, you can choose how much you want to blur out the background. You also learned that these parameters have a reciprocal relationship. If you change one, you can change the other to compensate.

The Nikon D90 has a lot of different ways to change shutter speed and aperture, allowing you to take complete creative control of motion stopping and depth of field.

If you've shot already in Program mode, then you've seen that it works just like Auto mode. When you half-press the shutter, the camera autofocuses and meters. Once it has determined a shutter speed and aperture that's appropriate for the scene, it displays those values on the status display inside the viewfinder and on the back of the camera.

As I mentioned in the previous chapter, the camera's built-in meter aims for a shutter speed that is appropriate for handheld shooting and an aperture that's not too extreme. But as you've learned, many different combinations of shutter speed and aperture yield the same exposure. Some of these combinations will have a faster or slower shutter speed and, conversely, a larger or smaller aperture.

In Program mode, you can automatically change from the current exposure to any equivalent, reciprocal exposure by turning the Main dial (the rear dial) after the camera has metered.

So, for example, if I press the shutter halfway to meter and the camera yields a reading of 1/125th at f7.1, and I then rotate the Main dial to the right, the meter reading changes to 1/200th at f6.3. Another turn to the right gives me 1/250th at f5, and so on. Each of these exposures is equivalent, but as I spin the dial to the right, my shutter speed is getting faster, which gives me more motion-stopping power. The aperture is also getting wider, which might yield a shallower depth of field.

Here's a real-world example: These two images have the same exposure, but they achieve it through different exposure settings. In the left image, I metered and then turned the Main dial until the aperture read 5.6, the widest aperture available for the focal length I was using. The wide aperture gave me a shallow depth of field. For the second image, I turned the Main dial until the aperture read 11. This yielded the same overall exposure but gave me a deeper depth of field.

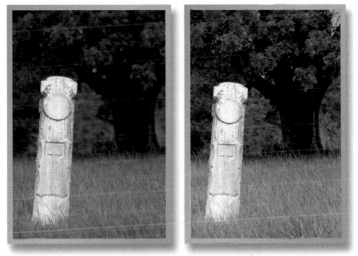

By using program shift, I was able to shoot the same scene with different depths of field.

Flexible program is a very powerful function. With it, you have the ability to manually select a shutter speed or aperture while ensuring that your exposure is correct, but you don't have to leave the automatic features of Program mode. This makes it easy to grab a little manual control when you need it.

In Chapter 5 you learned about the handheld shutter speed rule and about how you have to consider whether a given shutter speed is appropriate for handheld shooting at your current focal length. As you use flexible program, you'll want to be sure that you don't end up with a shutter speed that will be too slow for sharp handheld shooting. So, as you cycle through the reciprocal combinations that are available, be sure that you don't choose a combination that slows the shutter speed down more than is appropriate.

TIP: Assessing Exposure with Your Ears

By now, you should have a good idea of what your D90's shutter sounds like. As shutter speed gets slower, the shutter sound changes fairly significantly. You can hear the delay between when the shutter opens and closes. Listening to the sound of your shutter can be an easy way to keep track of when your shutter speed might have dropped too low for handheld shooting. If you hear a slow shutter speed, you'll want to consider reshooting the shot with more appropriate settings. I'll get to what those settings might be later in this chapter.

Vibration Reduction: Help with Handheld Shooting

If you have a lens with vibration reduction (or VR), then you have some more handheld shooting latitude. For example, the 18-105mm lens that Nikon bundles with the D90 includes built-in stabilization, as do many other Nikon lenses, as well as several third-party lenses.

Vibration reduction is a seemingly magical technology. When activated, the system detects tiny movements of the camera and adjusts its optics on the fly to counteract those movements, resulting in a more stable image. Vibration reduction is not a substitute for a tripod—it won't render the camera perfectly still. It also can't smooth out extreme jarrings of the camera. If you're shooting from a Jeep in rough terrain, vibration reduction isn't going to render your camera still. But for ordinary vibration and shake caused by handholding, it can mean the difference between getting a usable shot and getting a shot that's soft and blurry.

If you have a VR lens, like the 18-105mm that's bundled with the D90, try this: Zoom the lens to full telephoto, press the shutter button halfway down to autofocus, and activate the vibration reduction. Now move the VR switch on the lens to Off.

Keep your finger on the VR switch while you look through the viewfinder. Pay close attention to one edge of the frame, and notice how much it's moving. Now, without moving your eye from the viewfinder, flip the VR switch to On. You should see that the image stops jittering, and the edge of the frame is much steadier. (Obviously, the whole image is steadier; it's just easier to see the motion when you look at the edge of the frame, because you have the frame edge to use as a reference.)

With the image stabilized, you can use longer shutter speeds when shooting handheld. How much longer depends on the quality of the stabilizer in your lens. The 18-105mm bundled with the D90 has a system that provides three to four stops of vibration reduction, depending on who you believe. To be safe, let's assume three.

Remember, a stop is one doubling of exposure. If we're shooting with the 18-105mm at full telephoto, then we're shooting at an equivalent focal length of 157mm. This means that we shouldn't try to handhold with a shutter speed below 1/150th of a second (technically, 1/157th of a second, but to ease the math, I'll round down to 1/150th). With three stops of stabilization, that works down from 1/150th to 1/75th to 1/37th. So, in theory, you can shoot with that lens at 1/37th

of a second when shooting at full telephoto. Whether you really can depends on how steady you are at holding the camera.

Why would you want to shoot this slow? Well, sometimes you'll be shooting in situations that are so dark that you'll have no choice. You'll need to open the lens all the way and shoot at a very slow shutter speed. So, the slower you can manage, the better the chance of getting the shot. I'll discuss low-light shooting in more detail in Chapter 9.

Objects in your scene that are moving might still be blurry when shooting with such a slow speed, but you shouldn't see an overall softening of your image because of camera shake.

REMINDER: Steady As She Goes

When trying to hold the camera steady—which is especially important when using a slow shutter speed—remember to gently squeeze the trigger. Use the posture tips we discussed in Chapter 1, and *don't* hold your breath. Holding your breath actually makes you shakier. If possible, try to find something to lean against or that you can use to steady the camera.

Changing ISO

In the previous chapter you learned that the ISO setting controls how light sensitive the D90's sensor is. A higher ISO number means the camera's sensor is more sensitive. This means it can gather light more quickly, which allows you to use shorter shutter speeds and smaller apertures. For times when you need lots of motion-stopping power or deep depth of field, the ability to increase your ISO can make the difference between getting and missing the shot. Increasing ISO is also a great option when your camera has chosen a shutter speed that's too slow for steady handheld shooting.

But in addition to creative latitude, increasing the ISO also means you can shoot in much lower light. In fact, the image sensor in the D90 is so sensitive that you can shoot effectively in much lower light than you could ever manage with film.

As discussed in Chapter 5, ISOs are measured using a standard scale. The D90 offers a default ISO range from 200 to 3200 in 1/3-stop increments. So, the entire range of ISO settings goes like this:

200 250 320 **400** 500 640 **800** 1000 1250 **1600** 2000 2500 **3200**

Values shown in bold indicate one-stop increments (and, as you can see, each is the double of the previous bold value).

When you're shooting in Auto mode, or in any of the D90's scene modes, then you'll also have an Auto ISO option that will select an ISO for you.

So, if a faster ISO offers better low-light performance and the ability to shoot with really fast shutter speeds and narrow apertures whenever you need them, why shouldn't you just leave the camera on ISO 1600 all the time?

In Chapter 5, you learned that the camera increases the sensitivity of the sensor by boosting the amplification of the voltages that are read off the sensor after an image is shot. Unfortunately, any time you amplify any type of electrical signal, you increase any noise in the signal along with the data you're trying to read. Noise is just what you think it is—the extraneous, static-type signals that you hear on a radio. Noise is generated by components in the camera, by other electrical sources in the room, and even by the stray cosmic ray that might be passing through you and the rest of the planet. The practical upshot of this is that as you increase the ISO of the camera, you also increase the *noise* (grainy patterns that sometimes look a lot like film grain) in your image.

This image was shot at ISO 1600 and suffers from a tiny bit of noise—a speckly pattern that occurs predominantly in shadowy areas.

So, in general, you always want to shoot at the lowest ISO that you can to ensure that you don't introduce extraneous noise. But, on the D90, you'll probably find that there's very little difference in the amount of noise you see in an ISO 200 to 400 image. So, you can safely choose these ISOs and see no discernible noise increase. And, although you may be able to see a noise increase at ISO 800 and 1600, the D90 produces so little noise, and it's such a nice quality, that you probably won't mind. Sometimes a bit of texture can add a lot of atmosphere to an

image. Most importantly, just because noise is visible onscreen doesn't mean it will show up in print. By the time you've scaled your image to your desired output size and the printer has processed it, the noise might be far less visible.

Tip: As you'll see in Chapter 12, you can also expand the D90's ISO sensitivity to range from 50 to 6400.

Setting ISO

There are many occasions when you'll want to change the camera's ISO setting. In fact, the ability to change ISO on a shot-by-shot basis is one of the greatest advantages that digital photography has over film.

For example, if you're shooting in low light, then you'll want to increase the ISO setting to allow for a shorter shutter speed (with a higher ISO, the D90's sensor will be more sensitive to light and so won't require a long shutter speed to get a good exposure). Or, perhaps you're shooting a very fast-moving subject in daylight and are having trouble getting a shutter speed that's fast enough to freeze the subject's motion. With a faster ISO, you'll be able to opt for a slower shutter speed.

To change the ISO, press and hold the ISO button while you rotate the Main dial. You can see your ISO choice in the lower-right corner of the control panel.

As you change the ISO setting, you'll see the new value on the D90's control panel.

A Real-World ISO Change

Let's say you're trying to shoot a close-up of a flower on a windy day. Your meter has recommended 1/125th of a second at f3.5. This is great because it gives you the shallow depth of field that you want, but it's so windy that 1/125th of a second is resulting in an image that's too blurry. If you increase the shutter speed by two stops to 1/1000, the image will be underexposed, because the camera's aperture can't be opened any further.

But, if you increase the ISO from 100 to 400 (a two-stop difference), you'll have enough exposure latitude to make your shutter speed change and get your shot.

> **TIP:** Remember to change back!
>
> One of the most important things to remember about changing ISO is to remember when you've done it. If you're shooting in a dark environment at ISO 1600 and then move into bright daylight, it's essential to change ISO back to something relevant. If you don't, your images will have extra noise. So, try to get in the habit of always thinking about what ISO you're set for when you enter a new lighting environment.

White Balance

Although your D90 is an incredibly sophisticated imaging instrument, it still pales in comparison to the human eye. Your eye has better autofocus, can perceive a much wider range of tones and colors, and has the amazing ability to autocorrect color under different types of light.

That last one may not sound that difficult, but think for a moment about a street corner. During the daytime, it's covered with sunshine (unless it's a cloudy day), but at night, it's lit up by a street light. The street light is very yellow, while sunshine is much "cooler"—closer to the blue end of the spectrum—and cloudy light cooler still.

Similarly, the light you're sitting in right now might be an entirely different color. It will vary if you're sitting under a fluorescent light or a tungsten light. Or maybe you have the book under a tungsten desk lamp, with fluorescent overhead lighting while sunshine streams through a nearby window.

Throughout all of this, your eyes still register the pages of this book as white. For the most part, no matter what light you move the book into, you'll still perceive the pages as white—they might be brighter or darker, but your sense of color will remain consistent, until the light level drops below a certain threshold, at which point your ability to perceive any color will be compromised.

We have yet to develop a technology that is as good as your eyes are when it comes to correctly rendering color under any type of light. Different types of film have to be specially formulated for different kinds of light, which is why you buy special "daylight" film when you're shooting outside.

Similarly, your D90 must be calibrated to the type of light you're shooting in, a process called *white balancing*.

To understand the fundamental principles of white balance, you need to think back to elementary school. At some point, you probably learned how a rainbow works—how the droplets of water act like tiny little prisms that scatter the light that passes through them. And from this you learned that the light we see is actually made up of a bunch of independent color components, the Roy G. Biv collection of red, orange, yellow, green, blue, indigo, and violet. These colors combine to create the white light that we normally see.

So, the idea with white balancing is that if you can accurately represent the color white, then you get an accurate representation of every other color, since all other colors combine to make white.

White Balance Presets

By default, your D90 is set up to use the Auto White Balance feature, which uses complex algorithms to analyze the color in your scene and then calibrate itself to those white values. This is the only white balance option that's available in Auto mode, but in Program mode, you can override the Auto White Balance and opt for some more manual control. Why would you ever want to do this? Because as good as the Auto White Balance is, it can be confused. Consider this image:

This image was shot under shade, using the camera's Auto White Balance feature.

This was shot in nearly complete shade, and although the color doesn't look wildly bad, it's rather cool and unflattering. The woman is too blue, and the image's overall cast is too cold.

In this case, the Auto White Balance was not able to properly calibrate the camera for the light I was shooting in. To correct for this, you would need to change to a white balance preset that has been designed for a specific type of light.

To select a white balance preset, press the White Balance button on the back of the camera. The camera will display the White Balance menu. Turn the Main dial to select the setting you want.

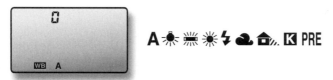

The white balance display in the control panel shows your current white balance settings. From left to right: Auto White Balance, Tungsten, Fluorescent, Direct Sunlight, Flash, Cloudy, Shade, Temperature, or Preset.

As you can see, there are different white balance presets for five different types of light, as well as an Auto White Balance and two full manual white balances (**K** and **PRE**).

Shade is the best white balance choice for our previous example. It's similar to the Cloudy white balance, and it's often worth trying both. Since our subject is in the shade, I decided to go with that.

With Shade white balance, our image looks much more color accurate.

While the Auto White Balance shot you saw before didn't look terrible, the Shade white balance shot makes the weakness of the previous shot a little more apparent.

In general, with the D90, you'll probably find that Auto White Balance works very well. However, it's best to get in the habit of noticing whenever you enter a cloudy or shady area or an area that's predominantly lit by tungsten lights or by fluorescent lights. In these instances, you'll probably get better results with manual white balance.

If you're unsure what the best setting is, when you get into a new lighting environment, take a quick test shot with the Auto White Balance and another with an appropriate manual setting; then review them both and see which looks best. The screen on the D90 is not terrifically color accurate, but it is good enough for you to see the difference between white balance settings.

> **R E M I N D E R : Don't Forget to Change Back!**
>
> Like ISO, one of the trickiest things about white balance is that you must remember to change it when the light changes. So, if you move into shade and switch to Cloudy white balance and then move back into daylight, you *must* remember to switch back to Auto White Balance or daylight white balance. Correcting a bad white balance in an image editor is extremely difficult—and often impossible—so it's important to get white balance right.

Choosing a Color Temperature

The color of a light is measured using a temperature scale, in degrees Kelvin. Although measuring color by temperature may sound a little strange, the reasoning for it is something you may already be familiar with.

If you heat a black object, as it gets warmer, it will eventually change color. If you've ever left a fire poker in a fireplace, then you've seen this happen. First it gets red, and then it turns more orange, and if you leave it in long enough, you might start seeing blue shades and eventually white. A specific temperature corresponds to each color that you see.

If you know the exact color temperature of the lights you're using, then you can dial that value in by hand by setting white balance to the **K** setting. When white balance is set to **K**, continue to hold the WB button while you turn the sub-command dial. This will allow you to dial in a specific temperature.

In reality, this is probably not a feature you will use very often, if ever.

Custom White Balance

For the most accurate color, you'll want to define a custom white balance preset. A custom white balance is also the best choice when you're in a lighting situation for which there is no stock preset, such as a mixed lighting situation (sunlight shining into a fluorescent-lit room, for example). Auto White Balance works by identifying something in your image that's probably white, usually a bright highlight. This area is then used as the basis for the camera's white balance analysis. The white balance presets (tungsten, daylight, and so on) don't analyze the current scene at all. Instead, they're simply preset values that Nikon has determined are good for each specific lighting type.

When you define a custom white balance preset, you point the camera at something white and tell it to use that as the reference for its white balance calculations. Because you're in control of what the camera is using as a reference and because that reference is reflecting the actual light in your scene, you get a very accurate white balance calculation.

To create a custom white balance preset, you first need something white, like a piece of paper or a white T-shirt. It's very important that the white object be in the same light as your subject. For example, if you're standing in shade and your subject is 10 feet away in bright sunlight, don't hold the white object directly in front of the lens, because the camera is in very different light from the subject.

Next, press and hold the White Balance button on the back of the camera, and select **PRE**.

This tells the D90 that you want to use a predefined white balance setting. However, we haven't yet *defined* a white balance setting. We'll do that next.

Press and hold the White Balance button until **PRE** begins to flash on the control panel.

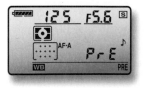

Frame a shot of the white object that you're using as a white balance target. Try to fill the frame with as much of the white object as you can. At the very least, it needs to fill the circle that appears in the middle of the viewfinder.

A white or gray object defines a manual white balance that produces very accurate color. Here, we're simply using a piece of copier paper.

Now take a picture. No review image will appear on the screen, but if the camera successfully records a white balance, then **Good** will appear in the control panel and in the viewfinder. If the white balance fails, then **no Gd** will appear.

The D90 lets you store up to five white balance presets, labeled d-0 through d-4. The most recent preset is stored in d-4.

To select a particular custom white balance preset, press and hold the White Balance button while you turn the subcommand dial. To use the preset that you just created, dial in d-0.

Alternatively, you can go to the Shooting menu and choose White Balance. From there, select Preset Manual. You'll see thumbnails of all the custom white balance images you've shot. Use the arrow buttons to select the correct one, and press OK. On the adjustment screen that follows, press OK again.

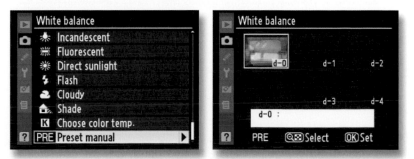

You can select a specific custom white balance preset from the Preset manual menu.

Now when you shoot, the camera will use the white balance that it calculated off of the white object in your scene.

After manual white balance, the same shady scene has more accurate color and a nice touch of warmth.

If you regularly shoot in the same lighting conditions—the same school gymnasium or auditorium, for example—then the ability to store and access several custom white balance settings can be very valuable.

Unfortunately, it's difficult to make any hard and fast rules about which white balance setting will work best for you. In a tricky lighting situation like shade or clouds, you'll probably want to try Auto White Balance, the appropriate preset, and manual, just as we have here. The human eye is very sensitive to changes in flesh tone color, so it's very important to get white balance correct when shooting portraits.

> **TIP:** Gray Is Even Better Than White
>
> Although custom white balance works fine with a white object, it works even better with a gray object. However, it needs to be a spectrally neutral gray object, meaning it needs to be a true gray with no hint of other hues in it. It's best to use a white object unless you have a gray card designed specifically for white balance, like the WhiBal card from *www.whibal.com*. It's spectrally neutral and is gray all the way through, so if it gets scratched, you can just sand it off and still have a usable gray. What's more, it floats if you accidentally drop it in a stream. If you use custom white balance a lot, the WhiBal card is a very good investment.

White Balance Fine-Tuning

Sometimes neither Auto White Balance nor the white balance preset is quite right for your situation. If custom white balance is not an option (perhaps you don't have a white reference available), then you can always use the D90's white balance fine-tuning feature.

You can fine-tune any white balance setting by selecting it in the White Balance menu that you saw earlier and then pressing the right arrow button:

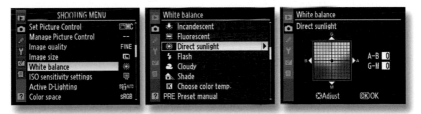

To fine-tune the Direct Sunlight white balance, navigate to the Direct Sunlight preset and then press the right arrow button.

This is a fairly advanced option that is intended for shooters who are used to balancing light using colored filters. Such a topic is beyond the scope of this book, but even without an understanding of filter use, or *mireds* (a unit of measure used for specifying color filter density), white balance fine-tuning might still be handy.

The white balance tuning page shows a color display with a grid over it. The two axes of the grid represent two different types of color shift. By default, the display shows no color adjustment at all—the control point on the grid is in the very center. Using the arrow buttons you can shift the control point around. As you move it up, your image will get more green, down will yield more magenta, right will shift to amber, and left will shift to blue. A diagonal movement will introduce a combination of shifts.

Note that these adjustments are very subtle—too subtle to show up in the printing process used in this book. But they can still serve to improve the overall color tone of your image if you're printing on a photo printer. Use the arrow buttons to set the correction you want; then press the OK button.

To deactivate the white balance shift correction, move the control point back to the center of the grid. If you've spent any time using an image editor, you might think "Why would I do this here when I can make this adjustment much easier in my image editor?" If you were just shooting a single shot, then you'd be right. Using the white balance shift feature wouldn't make a lot of sense.

But let's say you were shooting an event. When you got to the location, you might take a couple test shots to determine what white balance looks best in that lighting. If you determine that all the images are a little too cool, are too warm, or have a weird color shift of some kind, then you could dial in a white balance shift and all of your images would be correct when you shot them, saving you a tremendous amount of time in your image editor later. To be honest, this is not a feature you will use very often, if it all, but it's worth knowing about.

Release Mode and the Self-Timer

By default, the D90 shoots in single-frame mode. When you press the button, it takes only one picture. But, you can change the camera to a continuous mode, which will cause it to keep shooting frames as long as you have the button held down.

The obvious application for Continuous mode is when you're shooting action scenes such as sporting events or wild animals or any moment where you're concerned that your reflexes won't be fast enough to grab the decisive moment. With Continuous mode you can shoot a burst of images and pick out the best one later.

Continuous mode is great for shooting action sequences, since it allows you to shoot a burst of images to capture a specific moment.

But Continuous mode can also be useful for more everyday events, especially shooting candid shots of people. People's expressions can change very subtly from one moment to the next, and with a burst of images you can capture a range of expression and pull out exactly the right shot later.

With groups of people, it can be difficult to know the precise moment when everyone's eyes will be open, when everyone will have a good expression, and so on. Continuous mode can ease this by letting you quickly gather a burst of images.

To activate Continuous mode, press the Release mode button on the top of the camera, and turn the Main dial to select the release mode that you want. The current release mode is shown in the upper-right corner of the control panel.

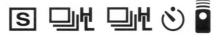

There are five different release modes to choose from: single-frame, two speeds of continuous shooting, the self-timer, and an optional remote control.

There are two different continuous modes on the D90. Low speed (which is denoted with an L) can shoot one to four frames per second. In Chapter 12, you'll learn how to set the speed. In High speed (denoted with an H) the camera can shoot 4.5 frames per second. When either is selected, you do all the same things you do for ordinary, single-mode shooting. Press the shutter button halfway to autofocus, make sure the camera is focused properly, and then press the button the rest of the way to take the shot. As long as you hold the shutter button down, the camera will continue to shoot, bursting away at your selected speed. In the viewfinder status display, you'll see a number that counts down as you continue to shoot.

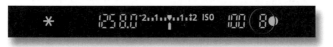

On the right side of the viewfinder status display is a number showing how many shots are available in the camera's buffer.

When this number reaches zero, you have filled the camera's buffer, and it will have to pause as it writes data out to the card. The camera does not wait until the buffer is full before it starts writing. It is continuously writing as you shoot, but when the counter hits zero, you've overrun the buffer. As soon as some space is available and the counter returns to one, you can shoot again, but you'll get only one shot before you experience another pause.

In practice, this won't be a huge problem, because we don't tend to shoot really long bursts. But, it's still a good idea to keep an eye on this number and to shoot small bursts with breaks in between. If the "big play" is about to unfold, don't just start bursting with the idea that you'll get the whole thing. Wait until the critical moment is as close as possible, and then begin your burst. Not only will

this improve your chances of getting the shot you want without incurring a pause, you'll have fewer images to wade through later, when you start processing your images.

When shooting in Drive mode, the camera does *not* display each image on the LCD screen. Instead, it waits until you're done with the burst and then displays the last image you shot.

This buffering process is why you might not always want to shoot at the fastest burst speed possible. If you're shooting at high speed, then you'll fill up the buffer very quickly and possibly miss the critical moment you were hoping to capture. A slower burst speed will spread your shots over a longer span of time.

If you're aiming to catch a very specific moment in the middle of some rapidly changing action—a hand releasing a football, say—then you'll want to use the faster continuous mode. If you're shooting a situation that unfolds more slowly —changing facial expressions in a casual social environment—then a slower burst speed might be a better choice, as you'll see more variation from shot to shot.

Using the Self-Timer

Cameras have had self-timers for years, and we've probably all experienced the process of setting the timer of a camera teetering on the edge of a car hood and then scrambling into the shot before the camera fires. The D90 also includes this feature, allowing you to bring your hasty scrambles into the digital age.

You access the self-timer using the release mode button, just as you used it to select continuous shooting: Select the self-timer setting.

Once you've set a self-timer, frame your shot, and half-press to focus; then press the shutter the rest of the way. After you fully press the shutter, the camera will *not* take the picture. Instead, it will begin the timer. The D90 will beep and flash the self-timer lamp on the front of the camera. The shutter will fire 10 seconds later. Two seconds before it's fires, the beeping and flashing will speed up.

There are some things you should consider when using the self-timer. If you won't be looking through the viewfinder when the camera finally fires, you should use the eyepiece cover. Without your face in front of the viewfinder, light can enter the viewfinder and interfere with the camera's exposure calculations.

As we'll see in Chapter 12, it's possible to change the duration of the timer from 2 seconds to 20.

Although using a 10-second time is fairly obvious—with 10 seconds, you have plenty of time to get into position in front of the camera—the 2-second timer may seem less practical.

A very short timer is not for self-portraits but for when you want to take a shot with minimal camera contact. Any time you handle the camera, you risk introducing shake that can cause your images to be soft, especially pronounced with long exposures. So, with a longer exposure, you'll get the sharpest image if you put the camera on a tripod and use the two-second self-timer.

That way, your hands will be completely off the camera while the shutter is open. This approach is good for low-light photos, astro photography, or photos where you're using a small aperture for a deep depth of field and so must use a long shutter speed.

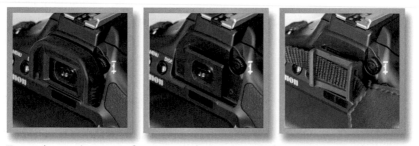

To use the eyepiece cover, first remove the eyepiece. Fit the eyepiece cover (attached to the strap) over the eyepiece mount. When you're done, replace the eyepiece.

If you want to shoot a solo self-portrait, bear in mind that focus can be tricky. If your goal is to stand in an open area, then you have a focus concern. When you half-press the shutter button, the camera will focus on whatever might be behind you, which could be a long way away. After you press the shutter button down all the way and run in front of the camera, the focus won't change—focus is locked with the half-press.

To compensate for this, tilt the camera down, and focus on the spot on the ground where you plan to stand. In fact, you might want to mark the spot beforehand. Press the shutter halfway to lock focus; then frame your shot, and press the rest of the way to start the timer.

Now run to the marked spot, and you should get good focus. To improve your chances, select a small aperture to increase depth of field. That way, if the focus is off by a foot or two, your image will still most likely be in focus.

To shoot this self-portrait, I first focused on the spot on the ground where I would be standing. Then I switched the camera to manual focus and set the self-timer.

Choosing an Image Size and Format

The D90's image sensor has roughly 12.3 million pixels on it. When shooting at maximum image size, it produces an image that's 4,288 pixels wide by 2,848 pixels high.

When shooting at maximum image size, with the best quality, you will be able to fit approximately 140 JPEG images on a 1 GB card. Although this is a lot of images (equivalent to almost 4 rolls of 36-exposure film), there will be times when you need to save space, so you might want to shoot images that don't take up as much space. The D90 provides two options for controlling the size of the images it captures.

First, you can choose to shoot images with smaller dimensions. The D90 supports three different images sizes. In addition to the default, large size of 4,288 x 2,848, there's also a medium size of 3,216 x 2,136 and a small size 2,144 x 1,424. The smaller the pixel count, the less space an image will take up on the camera's media card.

Second, you can change the amount of compression applied to the image when it's saved. The D90 provides three levels of JPEG compression: Basic, Normal, and Fine. Basic creates smaller files than Normal, which creates smaller files than Fine. Remember, though, that smaller JPEG files are lower quality. As JPEG compression increases, it introduces visible degradation in your image.

You can also choose to shoot raw. Raw format offers a number of advantages over JPEG modes, and I'll cover it in detail in Chapter 11. For now, it's best to stick with one of the JPEG options because this will allow a speedier workflow when you take your images into your computer.

To change the image size and compression, follow these steps:

1. Press and hold the Qual button on the back of the camera.

2. Rotate the subcommand dial (the one on the front) to change image size. You can choose between L, M, and S. The current size is shown in the lower-left corner of the control panel.

3. Rotate the Main dial to change compression level (often referred to as *quality*). You can choose from Basic, Normal, Fine, and Raw.

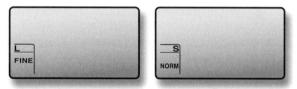

Using the Qual button and the command dials, you can set both image size and quality. Both are displayed in the lower-left corner of the control panel.

The D90 also lets you shoot a combination of Raw + JPEG. When you hold the Qual button and turn the rear command dial to set JPEG compression, you'll eventually cycle through to Raw and then Raw+. From there you can also select a JPEG quality level.

When you shoot in a Raw + JPEG mode, the camera stores both a raw and a JPEG file every time you take a shot. You'll learn more about Raw + JPEG in Chapter 11.

You can also change either or both of these parameters by selecting Image Quality or Image Size from the Shooting menu. From the resulting screens, select your desired option.

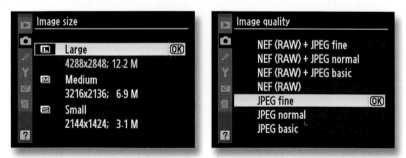

The Image Size and Image Quality menus provide you with another way to set these two parameters.

WHAT IS JPEG COMPRESSION?

To help fit more images onto your storage card, your D90 offers three levels of *JPEG compression*. JPEG compression is a computational process that compresses the data that makes up your image so that it takes up less space. JPEG is a *lossy* compression scheme, meaning that it *does* degrade your image quality. However, the highest-quality JPEG setting on the D90, Fine, is *very* good, and you'll be hard-pressed to spot any image degradation.

Your eye is more sensitive to changes in brightness than it is to changes in color. So, a JPEG compressor first separates the color data in your image from the luminance data. It then takes all of the color data and divides it into a grid of 8 x 8 pixel chunks. The color in each of these 8 x 8 grids is then averaged so that the values of each pixel in the grid are the same. This averaging means that the color data can be very effectively compressed using a compression algorithm that is similar to the ZIP compressor that you might use on a personal computer. Finally, the color and luminance data are put back together. Because the luminance data—the stuff your eye is most sensitive to—has been left untouched, you most likely won't notice any loss of quality. However, if an extreme amount of JPEG compression is applied, you may be able to see an 8 x 8 pixel blocky pattern in your image.

Too much JPEG compression can leave boxy artifacts in your image. So, be very careful about saving and resaving your images as JPEGs.

Why Choose a Different Size?

The size of the image impacts two things: how large a print you can make and how much you can blow up a detail in an image.

To print a large image, you want to have as many pixels as possible. Although an image-editing program can do a good job of enlarging an image, there's no substitute for actual pixel data, and the D90 can capture a lot of pixels.

Usually, the only reason you would choose to shoot at a smaller size is if you're running out of space on your card or you *know* that you will only ever print an image at a certain size. For example, if you've never printed an image larger than 4 x 6, then you might argue that you won't ever need more than the smallest size, because that's more than enough data to print a 4 x 6.

Shooting at a smaller size will afford you more space, but can you be absolutely *certain* that you'd never want to print at a larger size? Storage is cheap now, so it's not unreasonable to keep full-res images, and having access to the maximum size will ensure that you can repurpose your images for any use that you may come across.

So, if you're really in a crunch for space, you might want to increase the level of compression rather than reducing the image size. The D90's low-quality compression is still very good, but if you're planning on enlarging your images, then the resulting JPEG artifacts might be visible once you've blown up your image.

However, if you're sure that the only thing you'll ever use your images for is low-res output—a web page, for example—then shooting with a smaller image size will allow you to fit far more images on your card.

Summing Up Program Mode

Program mode is probably the mode you'll use most often on the D90, and the reasons why should be becoming clear to you. Like Auto mode, Program mode can automatically focus and choose an exposure, white balance, and ISO for you. But, unlike Auto mode, you can take some control yourself and override the camera's decisions to choose a shutter speed, aperture, and ISO that's better suited to your creative goals.

You can override the camera's autofocus mechanism to ensure that the subject you want is in focus and even tell the camera to track moving objects.

You can control white balance to a very refined degree, allowing you to shoot better, more accurate color in a broader range of lighting conditions, and you can maximize the use of your storage card by adjusting image size and compression settings.

As you've been playing with the camera, I hope you've begun to get a better feel for the D90's interface and for Nikon's clever design. In Program mode, using just the Main dial and ISO button, you can easily select a shutter speed, aperture, and ISO, all without ever taking your eye from the viewfinder.

We'll be staying in Program mode for another couple of chapters, because there are still more features for you to learn about. However, with what I've covered here, you should now have a little more creative latitude, so you should experiment with shutter speed, aperture, and ISO control, as well as the different focusing options.

> **REMINDER: Don't Forget to Reset Your Camera Settings!**
>
> The D90 remembers many of the settings you make, even after you turn off the camera. So, if you select a white balance preset or a high ISO, shoot a bunch, and then turn off the camera, when you come back, you'll still be using that white balance and ISO. So, it's *very* important to check your settings when you turn on the camera. You don't want to head out into bright daylight after a late night of shooting in a dimly lit club with weird white balance. Ideally, you should set each setting back to something more normal after you use it, but this can be hard to remember to do. Instead, get in the habit of double-checking your settings every time you turn the camera on. Look over the status screen on the back of the camera, then press Menu and then Disp to view additional status information.

Some Things to Try

Put what you've learned in this chapter to work by trying some of the following shots:

- Shoot some moving objects, such as cars or flying birds, and experiment with your ability to freeze or blur motion, as well as panning to blur the background.

- Shoot some portraits or still-life shots, and experiment with depth of field.

- Try some low-light shooting by heading out at night with a high ISO setting. Remember your handheld shutter speed rule, and if you find your shutter speeds are going very slow, take pains to stabilize the camera.

Also, you should be beginning to develop some "second-nature" habits around shutter speed. After half-pressing the shutter, you should be well-accustomed to noting the speed and thinking "Is this fast enough to get a sharp image?" If not, you can boost ISO. In the next chapter, you'll learn about additional exposure options.

Advanced Exposure

LEARNING MORE ABOUT THE D90 LIGHT METER
AND EXPOSURE CONTROLS

There's more to exposure than what we've seen so far. In addition to motion and depth of field control, exposure control also lets you control tonality in your image. Your exposure control is very dependent on your light meter, though, so to really understand exposure, you have to learn about some of the workings of the D90's light meter. In this chapter, you'll go deeper into metering and exposure and explore some of the D90's image-processing options.

The Light Meter Revisited

In Chapter 1, you looked at the D90's light meter, which analyzes the light in your scene to determine an exposure that will yield an image that's neither too light nor too dark.

The light meter is activated every time you half-press the shutter button, and although the automatic metering in the D90 is very good, it *can* be confused and won't always calculate the best exposure for every scene. For example, consider this image:

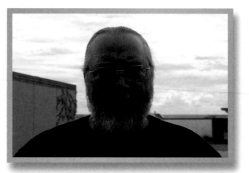

*This image suffers from bad backlighting, which is leaving
the subject's face in shadow.*

You've seen a bad backlighting problem before in this book. Because of the bright background, the camera is biasing its metering toward the brighter portion of the image, and the resulting exposure leaves the person underexposed. But you'll find that other problems can also crop up from mismetering, most notably, an inability to render black tones as real black. I'll cover both of these problems and show how they can be easily addressed using a few simple tricks and controls. Let's start with the backlighting problem.

Metering Modes

By default, the D90 uses a *matrix meter* system for its light metering. The D90's matrix meter divides your scene into a grid of zones and measures a tremendous number of parameters from each zone. In addition to the brightness of the zone, it measures the contrast between zones, the size of your subject, the brightness of your subject, the contrast between your subject and the other zones in the grid, the color of your subject, and more. (It determines what is "your subject"

by looking at which focus points were selected when the camera autofocused.) It then analyzes all this data and tries to come up with exposure settings that will properly expose your subject, without blowing out the highlights in the image and while preserving as much shadow detail as possible.

For most scenes, matrix metering works very well, and it's the most consistently accurate meter on the camera. This is why Auto mode uses matrix metering. If you just want to point the camera and shoot, matrix metering stands the best chance of giving a good result.

The metering mode you have currently selected is shown on the D90 control panel.

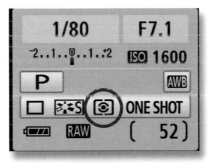

The metering mode is shown on the status display on the back of the D90. Here, matrix metering is shown.

However, matrix metering can be confused, as shown in the previous examples. So, although matrix metering will probably work well for most shots, the D90 provides a few other metering modes that you can employ in tricky situations.

Center-Weighted Metering ⊙

Although matrix metering is almost always a good choice, if you're shooting a scene that has a background that is significantly brighter than the foreground, then the matrix meter can get confused, resulting in your foreground being overexposed.

Center-weighted metering analyzes all of the zones in the frame, just like matrix metering, but adds extra statistical weight to the zones in the center of the frame. By default, the circle shown in the viewfinder receives the extra weight, though you can change the size of the weighted area, as you'll see in Chapter 12.

In center-weighted metering mode, the D90 biases its exposure decisions to the zone in the middle of the frame.

Center-weighted metering is a good solution to the backlighting problem we faced earlier. The face is better exposed, and although the background is blown out, it's not too distracting. For times when flash is not appropriate or your subject is too far away, switching to a better metering system can be your only option.

With center-weighted metering, our subject's face is better exposed.

Spot Metering

In *spot metering* mode, the camera meters off of one small 3.5mm circle in the middle of the frame. With spot metering, you can ensure that a specific area in your image will have detail. As with the center-weighted meter, other parts of your image might end up over- or underexposed. Note that the spot meter always meters around the center focus point, even if you or the camera has selected a different focus point for focusing.

Metering and Auto ISO

If you set the D90's ISO setting to Auto, then the camera will adjust the ISO as well as the shutter speed and aperture when it meters. Because there's little difference

in noise from ISO 100 to 400, Auto ISO helps ensure that you have a shutter speed that's suited to handholding and an aperture that will yield good focus.

> **WARNING:** Don't Use Matrix Metering When Focusing and Reframing
>
> Earlier, you saw the technique of using a single, centered focus spot to focus on an object and then reframing your scene. When using this technique, you might find that you get better results if you *don't* use matrix metering. If you're using matrix metering, then areas of the frame that won't be in your shot will be factored into the camera's final metering. Most of the time, this won't matter, but in a scene with high dynamic range—a dark foreground and bright sky, for example—it could get you into trouble. Instead, if you want to use evaluative metering, then after focusing, set your lens to manual focus to lock focus, and frame your shot as desired and meter.

No matter which metering mode you've chosen, the light meter still works the same way. Press the shutter button halfway down, and the camera will autofocus and meter (assuming you have your lens set to autofocus). Once it has determined focus and metering, it will beep and display a green dot in the viewfinder. This is your cue you can press the shutter the rest of the way to take the shot. In general, evaluative metering will be your best choice for almost every situation.

What Your Light Meter Actually Meters

Has this ever happened to you? It's a nice snowy day, you take a picture, and when you look at the image, the snow seems much dingier than you remember. This can also happen on a beach with really white sand.

Surprisingly, this is not the camera doing something wrong. It's actually metering exactly the way it was designed. To understand what it's up to and how to fix it, you need to understand a little more about how a light meter works.

Your light meter doesn't know anything about color; it measures only *luminance*, or brightness. Perhaps the strangest thing about your light meter is that it always assumes that everything you're pointing it at is 18 percent gray. That is, it's assuming that everything you're pointing it at is reflecting 18 percent of the light that's striking it. What's even *stranger*, though, is that most of the time, what you're pointing at *is* reflecting 18 percent of the light that hits it.

Consider these alternating black and white bars:

Although there are an equal number of black and white bars here, this image reflects only 18 percent of the light that strikes it.

There are an equal number of these bars, 10 each. Because half are black and half are white, you might assume that this pattern is reflecting 50 percent of the light that's striking it—half reflected by the white and half absorbed by the black. But, because of the physics of light, this pattern is actually reflecting only about 18 percent.

In fact, it turns out that the majority of the scenes in the world reflect 18 percent of the light that strikes them. Therefore, if your camera *assumes* that it's pointed at a scene that is reflecting 18 percent of the light that strikes it (photographers refer to this as a scene that is *18 percent gray*) and it calculates a metering that is correct for 18 percent gray, then the odds are that its calculated metering will be correct for your scene.

Most of the time this works. But, sometimes 18 percent gray assumption is incorrect. The field of white snow is a great example. Since the camera is assuming that it's pointed at something that's 18 percent gray, it calculates an exposure that will represent the field of snow as gray rather than white. Fortunately, the D90's meter is so sophisticated that it will usually recognize a strong white object as white and calculate an appropriate exposure.

Nevertheless, when subjects are bright white, you want to carefully review your images to make sure the white doesn't appear gray. If it does, then you'll need to *overexpose* your shot to render white objects as true white. You'll learn how to do this in just a bit.

> **N O T E :** Very Good Metering
>
> It's important to understand the overexposure concept I just discussed, just in case you ever end up with images with dingy whites. However, thanks to the excellent metering on the D90, you'll probably rarely encounter this problem. The matrix meter on the D90 includes a color meter that gives it a great advantage when exposing white. Keep an eye on your whites until you get some more experience how the camera meters and renders them. If they end up dingy, you'll need to overexpose.

Exposing So That Black Looks Black

Black objects are more likely to trip up the D90's meter than are white objects. Again, if you point the camera at a black object, it will assume that the object is actually 18 percent gray and so will concoct exposure settings that will properly render that object as gray. Consequently, black objects can sometimes appear ashen-looking.

Because the light meter assumes that it's pointed at something that's 18 percent gray, it calculates an exposure that renders the black tone of this car so that it looks a little gray and ashen.

In the previous shot, the blacks are not as black as they could be, because the meter assumed that the car was actually gray and so chose exposure settings that yielded an image that looked more gray than black.

By underexposing, we can accurately represent the black tones in the image as black.

As I mentioned earlier, the D90's meter is sophisticated enough that it often figures out these problems on its own. Blacks tend to trip up the camera more than whites, though, so you'll probably usually need to do some underexposure to get them to look right.

The real lesson here is that it's important that you don't become too dependent on the camera's ability to get things right. Learn to recognize when a scene might need to be over- or underexposed. If you're not sure, then review the image, and reshoot if needed.

With one stop of underexposure, the black car is rendered a true black.

WHAT'S WRONG WITH OVER- OR UNDEREXPOSING?

Of course, once you start tinkering with the camera's carefully concocted expo-sure settings, you run the risk of over- or underexposing your scene to the point where bright things blow out to complete white or where dark shadows fall to complete black. When an area in your image goes to all white or all black, it becomes an area with no detail. Detail in a photo is constructed from contrast-ing tones, and when part of an image is one color, it looks like a flat surface.

In the case of shadows, this isn't so bad. A black shadow simply looks like an area that's too dark to see. Unless there's some detail in the shadowy area that you really want to keep visible, letting a shadow darken is not too terrible. Overexposed highlights, though, are almost always distracting. An area of complete white acts like a magnet for the viewer's eye and can sometimes upstage your subject.

However, at times it's worth overexposing a highlight to get better tonality on your subject. Also, a little bit of overexposed bright spots—small bits of chrome on a car, for example—won't necessarily be noticeable. Although there are no hard and fast rules about how much over- or underexposure is too much (and many times, overexposing an image can be an effective stylistic choice), it's important to understand the risk and make an intelligent decision.

Using Exposure Compensation to Over- or Underexpose

Now that you've seen some of the occasions when you might want to over- or underexpose, I'll cover one of the ways that you can tell the camera to make such an exposure adjustment. There are many ways of controlling exposure on the D90, but the easiest method is to use exposure compensation.

These days, almost all cameras have an exposure compensation control, which simply lets you make a *relative* exposure change. That is, you can tell the camera, "I don't care how you metered the scene; I just want you to go up from there by one stop." Try using exposure compensation now:

1. Frame a shot.
2. Press the shutter button down halfway to meter your scene (the camera will also autofocus and take a white balance reading).

3. After the camera beeps, the viewfinder and status LCD will show you the shutter speed and aperture settings that it has calculated.

4. Take the shot.

5. Now frame the same shot, and again press the shutter button halfway down to meter the scene.

6. Using your forefinger, press and hold the Exposure Compensation button on the top of the camera.

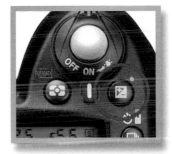

Dial in a specific amount of over- or underexposure.

7. While holding down the Exposure Compensation button, rotate the Main dial. Watch the control panel or the viewfinder, and dial in one stop of overexposure. (If you haven't changed the camera's defaults, then this will be three clicks on the dial.)

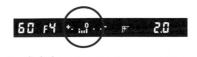

Here I've dialed a +1 stop exposure compensation.

8. Take the shot.

Now go into playback mode, and look at the two images. The second one should be much brighter than the first one. This is the image that was *over*exposed. Note that you didn't tell the camera a specific shutter speed or aperture. Instead, you simply told it to go up one stop from whatever it thought was the correct exposure. The D90 has an exposure compensation range of -2 stops to +2 stops. By default, the control moves in 1/3-stop increments.

When you use exposure compensation, you don't actually know exactly *how* the camera will achieve its over- or underexposure, but the camera does follow a predictable method. It will always try to achieve its change in a way that doesn't involve a shutter speed that might be too slow for handheld use.

Remember, a slower shutter speed means that the shutter is open longer, which means that your images are more susceptible to the blurring and softening caused by shakiness in your hand. If you have the ISO set to Auto, the D90 will often effect the change by altering the ISO setting, but it will never do this to the point of introducing noise into your image. Because there's no visible difference between ISO 100 and 400, the D90 has two stops of ISO latitude to play with, meaning it will often keep the shutter speed and aperture the same as you change exposure compensation.

The black car example that you saw earlier is a prime example of using exposure compensation. I knew that the black probably wouldn't render properly, so I set exposure compensation to underexpose by one stop to get an image that had a more accurate black tone.

> **TIP:** Changing the Exposure Compensation Interval
>
> By default, the D90 exposure compensation command goes in 1/3-stop increments. That is, each notch on the readout represents 1/3 of a stop. You'll learn how to change this later.

Exposure Compensation and Flexible Program

In Chapter 6 you learned about program shift, which lets you automatically switch between reciprocal exposure settings after the camera has metered. *Flexible* program makes it easy to quickly switch to a different shutter speed or aperture while maintaining a good exposure.

However, because flexible program always changes to a reciprocal exposure, it never gives you an over- or underexposure. But you can use the exposure compensation control for that, and you can easily use these two features in concert.

For example, you might meter and then use flexible program to switch to a faster shutter speed. But maybe you're shooting something white and want a little bit of overexposure. If you dial in +1/3 of a stop, you'll still get both your faster shutter speed *and* your overexposure. In many cases, these two controls will provide all the manual power you need, and the fact that you can drive them both while looking through the viewfinder is one of the features that makes the D90's interface so powerful.

Controlling Color Tone with Exposure Compensation

It should make sense that a slight underexposure will make black tones appear more black than gray (and vice versa for white tones). You've seen already that an underexposed image is darker than a regular exposure, so a bit of underexposure can be just what you need to restore a dark object to its true tone.

Like black and white, color has a tone also. Some reds are darker than others, for example. Consequently, it's possible to adjust the saturation of a color in your image by over- or underexposing.

For example, consider this image, which I shot using the camera's recommended metering and with a 1/3-stop underexposure:

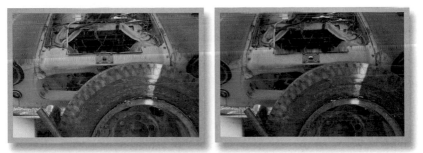

After I dialed in a 1/3-stop underexposure, the camera rendered richer colors.

Notice that the colors are a little bit more saturated and generally richer. This is because they have a slightly darker tone that needs to be underexposed to appear correct.

In general, when shooting in bright daylight, you might find that leaving your exposure compensation set to -1/3 gives you better saturation and deeper color. However, be aware that you'll run the risk of losing detail in the very darkest parts of your image, and lighter tones may render a little gray.

> **REMINDER:** Slide Shooting Techniques at Work in the Digital World
>
> If you have ever shot slide film, this last recommendation might sound familiar. In general, when shooting in JPEG mode on the D90, you should keep all of your slide film exposure habits.

Using the Histogram

One of the great things about digital photography is that you can see your images onscreen right away. In fact, we're now well into a generation of kids who've never known cameras to work any other way and for whom the idea of waiting to see an image makes about as much sense as having a guy deliver blocks of ice to the house.

And although the image on the D90's LCD *does* provide a great way to check your composition, it offers very little help when it comes to assessing your exposure choices. It's very important to understand that the color and contrast shown on the D90 screen is not very accurate. This is not because of any ineptitude on Nikon's part. Just the opposite, actually. The D90 screen needs to be visible in many different situations, including bright sunlight. To make this possible, the D90 intentionally pumps up the brightness and saturation on the image that is shown on the camera's screen. Although this makes the image easier to see in bright light, it also means you won't have an accurate view of color and contrast.

Fortunately, the camera includes an additional feature that provides a tremendous amount of information about exposure and that will repeatedly save you from returning home with poorly exposed shots.

You have already caught a glimpse of the *histogram* when you explored the D90's different playback screens. Go into playback mode on your camera, and turn the subcommand dial until you see a display that looks like this:

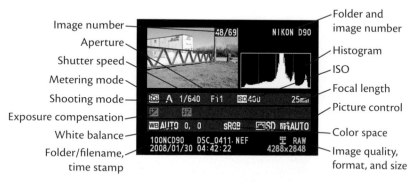

Viewing the histogram in playback mode.

This is one of two screens designed to help you better assess the exposure of an image. Scattered around the screen is a lot of status information, including shutter speed, aperture, and ISO. The camera also shows the date and time the image was shot, your white balance setting, shooting mode, metering mode, picture

control, image format, size of the final image, and color space of the image, but it's the shutter speed, aperture, ISO, and histogram display that are going to ease your exposure headaches in the field.

The histogram is that graph-looking thing in the upper-right corner. Although it may look complex and scientific, it's actually quite simple.

A histogram is nothing more than a bar chart that shows the distribution of tones in your image, with black on the left and white on the right. If there's a lot of black in your image, then there will be a lot of bars on the left side of the chart. If there's a lot of white, then there will be a lot of bars on the right side of the chart. If there's a broad range of tones, then there will be data across the histogram.

The height of each bar in the histogram simply tells you how *much* of a particular tone there is.

So, in the previous image, you can see that the image has a good range of tones from black to white, with most of the tones in the shadow and highlight areas and a smattering of tones spread across the middle.

This next part is very important: *The shape of the histogram is irrelevant!* You are not trying to get a particular shape—the histogram is simply showing you what's in your image, and two masterfully exposed images might have very different histograms, because they might contain very different subject matter.

What the histogram is good for is showing you when you've over- or underexposed and how much contrast you've captured.

Recognizing Over- and Underexposure in the Histogram

When an image is overexposed, there will be a big spike on the right side of the histogram, as in this image:

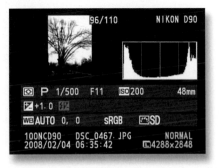

Because this image is overexposed, the histogram shows a spike on the right side.

Because of the overexposure, a lot of the bright parts in the sky have gone to complete white. That overexposure appears in the histogram as a big spike on the right side.

Underexposure shows in the histogram in just the opposite way, with a big spike on the left side of the image.

With this simple tool you can immediately determine whether you need to dial in an exposure compensation or change your exposure strategy. If you see a big spike on the right side, consider underexposing.

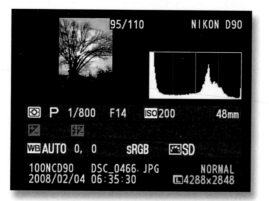

After dialing in a negative exposure compensation and reshooting, the image has color restored to the sky. Notice that the spike on the right side is much less pronounced.

DEFINITION: Clipped, Blown, and Other Terms

You'll hear photographers use several different terms to refer to a highlight that has been so overexposed that it results in a spike on the right side of the histogram. *Clipped* and *blown* are the most common.

Recognizing Contrast in the Histogram

An image with more contrast has a broader range from the darkest tone to the lightest tone. As such, it will have a histogram with data that covers a broader range.

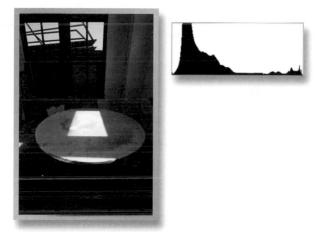

This image has a lot of contrast, with a wide tonal range from black to white.

Some images will have more contrast simply because your subject is more contrasty. A penguin, for example, is more contrasty than an emu that's a single shade of brown. At other times, though, your image will have low contrast because of your exposure choice.

For example, I shot this image with the camera's suggested metering and then looked at the histogram. (For the sake of clarity, I'm showing a histogram from Photoshop, but you'll see the same information on the D90 histogram.)

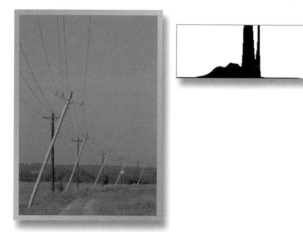

This low-contrast image sports a histogram that doesn't have a wide spread of data. There's little distance from the darkest to the lightest tones.

It appeared to me that the image should have a little more contrast, so I tried overexposing by one stop and shot again, and I got this histogram:

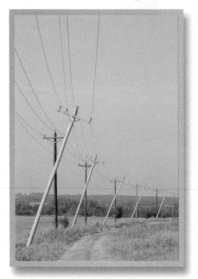
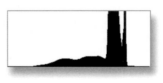

I dialed in a one-stop overexposure and shot again. The histogram of the resulting image shows more contrast. This greater amount of data means I'll have more editing latitude when I start making adjustments and corrections.

Again, there are no right or wrong histogram shapes. Nor are there right or wrong distributions across the histogram. However, the histogram can be a very useful tool for spotting over- or underexposure, as well as contrast range. An image with more contrast has more tones across the histogram that I can brighten or darken in my editing program, and that means I'll have more latitude to make changes later.

The Three-Channel Histogram

In Chapter 3, you learned how to change the display mode settings to enable an RGB histogram. With this option enabled, you can turn the subcommand dial again to see a second type of histogram.

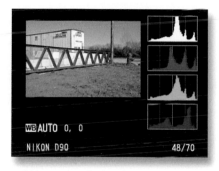

The D90's three-channel histogram display shows a separate histogram for the red, green, and blue information in your image.

This page shows the same histogram you saw before, along with an additional three-channel histogram. In Chapter 5 you learned that an image is made up of three separate channels of color information: one red, one green, and one blue. The three-channel histogram lets you see a separate histogram for each of these channels.

This can sometimes be useful for spotting white balance troubles that could otherwise be difficult to see on the camera's LCD screen. In an image with good white balance, all three channels are usually fairly "registered." That is, they're often very similar. Obviously, if you're shooting a still life of separate red, green, and blue Christmas ornaments, then the histograms for each channel will be very different. But in a typical image, the highlights in a three-channel histogram should fall mostly in the same place. If they don't, you'll want to consider switching to a white balance preset, switching to a custom white balance, or using the white balance shift to correct the image.

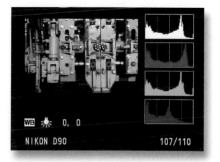

With the three-channel histogram, we can see that the white balance in this image is pretty good, as the red and green channels are fairly similar. Since our subject is mostly orange, it doesn't matter that the blue channel is shifted to the left a bit.

Using Priority Modes to Control Exposure

Although the exposure compensation and flexible program features are both great ways to adjust exposure, there will be times when you'll want more direct control. Shutter and Aperture Priority let you select specific shutter speeds or apertures. So, for example, if you're shooting landscapes and know that you're going to want a deep depth of field all day long, you can set the camera on Aperture Priority, dial in f11, and be assured that every shot will be taken with that aperture. The camera will automatically calculate an appropriate, corresponding shutter speed.

Or, if you're shooting a sporting event and know that you want lots of motion-stopping power, you can select Shutter Priority and set the shutter speed to something quick, like 1/1000th of a second. This time, the camera will automatically select an appropriate, corresponding aperture.

Aperture Priority

To use Aperture Priority, set the D90's Mode dial to A. In Aperture Priority mode, you select the aperture you want, and the camera automatically chooses an appropriate shutter speed, based on its metering.

In Aperture Priority mode, the control panel and viewfinder display the shutter speed and aperture just as it always does, but you can change the aperture by turning the subcommand dial. (You must meter to get the shutter speed/aperture readout to appear.) As you change the aperture setting, the shutter speed will automatically be recalculated and displayed.

Different lenses have different aperture ranges, and with a zoom lens, the wide end of the aperture range is often variable. For example, on the 18-105mm lens that Nikon bundles with the D90, the wide end of the aperture range varies from 3.5 to 5.6. That is, when you're zoomed out all the way to 18mm, the lens has a maximum aperture of 3.5. When you zoom in all the way to 105, the maximum aperture is a slightly smaller 5.6 aperture.

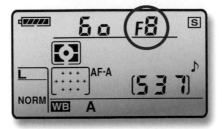

In Aperture Priority mode, the current aperture as usual on the control panel.

The maximum aperture varies in between these extremes. So, if you find that you sometimes can select a wider aperture than at other times, this is because you're probably shooting at different focal lengths.

Note that, depending on your lighting situation, you can't always pick any aperture that you want. In a low-light situation, if you pick a very small aperture, the D90 may not have a shutter speed that's fast enough to yield a good exposure. In these circumstances, the camera will display "Lo" in the control panel to indicate that your image will be underexposed. You'll need to choose a wider aperture or increase the ISO until the camera indicates that it can get a good exposure.

Depth of Field Preview

To ensure a viewfinder that's bright and clear, the D90 keeps its aperture open as wide as possible all the time. Even if you or the camera have chosen a very small aperture for your exposure, the aperture stays open all the way until you actually take the picture. Then the aperture closes down to the specified setting, and the sensor is exposed.

In addition to letting as much light into the viewfinder as possible, the fact that the aperture is always wide open means you're possibly seeing less depth of field in the viewfinder than what your final picture will actually have. Trying to shoot with a very deep depth of field can be tricky because, as you learned earlier, depth of field is centered around the point of focus, and there's more depth of field behind that point than in front.

If you want to see what the depth of field in your scene will actually look like, you can use the Depth of Field Preview button.

The Depth of Field Preview button lets you see the actual depth of field of your scene in the D90 viewfinder.

Unfortunately, as the viewfinder gets darker, it can be harder to see fine focus details. However, if you let your eyes adjust to the darker scene, you'll probably be able to get a good idea of what is in focus and what isn't. Depth of field preview will work in any mode on the D90 and is a great way to determine whether you've chosen an aperture and focus point that will yield the depth of field you want.

WARNING: Pay Attention to Shutter Speed

Just because you now have complete control of aperture, and just because the camera is choosing a shutter speed for you, doesn't mean that you don't have to think about shutter speed at all. You still need to pay attention to the handheld shutter speed rule. If you pick an aperture that yields a shutter speed that's too slow for handholding or motion stopping, then you may end up with an annoyingly blurry image. The D90 will display its selected shutter speed any time you meter.

Shutter Priority

Select Shutter Priority mode by turning the Mode dial to S. In Shutter Priority mode, you select the shutter speed you want, and the D90 will automatically choose an appropriate aperture.

In Shutter Priority mode, the D90 will display the shutter speed in the usual location on the control panel and in the viewfinder. If neither is showing, half-press the shutter button to meter. Turn the Main dial to select the speed you want; the camera will automatically select a corresponding aperture.

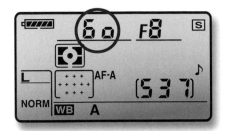

In Shutter Priority mode, the camera displays your chosen shutter speed as you turn the Main dial.

As you may have already discovered, you can choose slower and slower shutter speeds, until eventually shutter speed is measured in whole seconds.

KNOWING YOUR APERTURE SWEET SPOT

Many people assume that if they want a shallow depth of field, they should just choose the widest aperture (smallest number) that they can, and if they want deep depth of field, they should choose the smallest aperture (largest number) that they can.

Obviously, these aperture extremes can yield shutter speeds that may not be practical, but there's another price to pay for this simplified approach to depth of field. Every lens has an aperture "sweet spot." If you go outside of this sweet spot, the lens will yield slightly softer images.

On the 18-105mm lens that ships with the D90, if you go much past f11, you'll start to see a drop-off in sharpness. Depending on the size you choose to print at, this loss of sharpness may not matter, but by the time you get to f16 or f22 and beyond, you'll probably start to see a drop in sharpness at any size.

Do some tests with your camera to determine where the aperture sweet spot is, and keep these apertures in mind when shooting.

TIP: Priority Modes and Exposure Compensation

You can use exposure compensation with either Shutter Priority or Aperture Priority mode. The camera will never alter the parameter you've selected but will instead change the other exposure parameter, as well as ISO, to achieve the compensation you want. If it can't get a proper exposure, it will flash the nonpriority value to indicate that your shot will be misexposed.

Manual Mode

For the ultimate in control, you'll want to use Manual mode, which lets you adjust both aperture and shutter speed. To activate Manual mode, move the Mode dial to M.

You can change shutter speed by turning the Main dial. If you want to change aperture, press and hold the Exposure Compensation button while turning the Main dial.

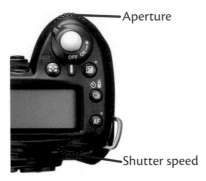

Aperture

Shutter speed

In Manual mode, the Main dial changes shutter speed, and the subcommand dial changes aperture.

If the exposure settings you choose are over- or underexposed, the camera will indicate the misexposure on the exposure compensation display in the viewfinder. If the current settings yield an underexposure, the amount of underexposure will be indicated on the minus end of the exposure compensation display. If the underexposure is two stops or greater, the entire minus section will be lit.

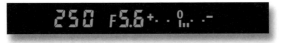

Here, the exposure compensation display in the viewfinder is showing an underexposure of -2/3 of a stop.

Overexposures will be indicated on the opposite end of the exposure compensation readout. Note that these readings are not shown on the control panel.

Obviously, if the camera is reporting an over- or underexposure, you might want to adjust your exposure setting. I say "might" because the current lighting might not allow for a proper exposure. Two stops underexposed, for example, might be the best that you can manage.

Manual mode can be handy for times when you want to ensure very specific results. Perhaps you're shooting a still life and so want a deep depth of field. You might switch to Aperture Priority to select a smaller aperture. But say it's dim lighting and the camera doesn't yield a shutter speed that's appropriate for hand-held shooting. You can switch to Manual mode and dial in both the shutter speed and the aperture you want. The results might be underexposed, but you might be able to brighten the image in your image editor later.

Exposure Bracketing

Now that I've thrown all this exposure theory at you and loaded up your head with all these facts to remember, it's time to learn the easy solution to the whole exposure thing: Rather than worry about trying to nail the exposure with one shot, just shoot the same shot a few times with different exposure settings. This process is called *bracketing*.

Bracketing is very simple. You shoot one shot at the camera's recommended metering, then another shot underexposed, and another shot overexposed. How much to over- or underexpose depends on how tricky the scene is and how cautious you are.

For example, if you're in a situation where you're not sure of the exposure—maybe there's a big mix of bright and dark tones—then you might want to bracket your shots. Or, if you're shooting a very bright or very dark object and aren't sure how to expose to properly render the tones, then bracketing can be the answer.

With exposure compensation, it's very easy to bracket. Shoot a shot, set exposure compensation down, shoot another, and then dial it up and shoot a third.

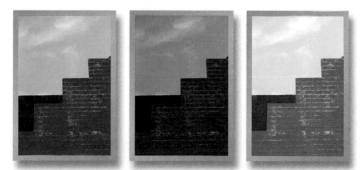

Here's a bracketed set of the same scene. The leftmost image was shot as the camera metered it, the second image is underexposed by one stop, and the third image is overexposed by one stop.

Bracketing does *not* make you a wimpy photographer! It does *not* mean you don't know what you're doing or that you're not serious. Some of the best photographers in history bracketed very heavily.

Obviously, bracketing is not viable when you're shooting action shots or any sort of fleeting moment. But for landscapes, still lifes, portraits, and other static scenes, it can mean the difference between a usable shot and one with exposure troubles.

Auto Bracketing

The D90 includes an auto bracketing feature that will perform an automatic exposure change for you, making it simple to take a bracketed set of shots.

1. To activate auto bracketing, press and hold the BKT button, which is located just above the lens release button.

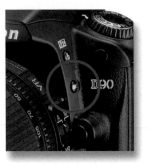

2. Turn the Main dial to select the number of shots you want in the bracket. You can select three frames, which will shoot one shot at the camera's default metering, one shot overexposed, and one shot underexposed. If you choose -2, then the camera will bracket two shots, one at the default metering and one underexposed. Choosing +2 will also bracket two shots, but the second shot will be overexposed. For this example, I'll choose a three-stop bracket.

3. Turn the subcommand dial to select the interval that you want between each shot of the bracket. You can choose up to two stops, in 1/3rd stop increments.

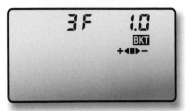

Here I've dialed in a three-stop bracket (as indicated by 3F, or three frames) with a one-stop exposure difference between each.

4. Now take a picture. That shot will be exposed as the meter recommends, and the camera will automatically be adjusted to underexpose by the amount indicated in the AEB setting.

5. As you shoot, the bracketing display on the control panel will update to show which shots in the bracket remain. For example, when you shoot a three-step bracket, the control panel indicator initially appears like this: ✚◀■▶━. After you shoot the first shot, the shot exposed normally, the bracket appears like this: ✚◀ ▶━, which indicates that the first, regular shot has been exposed. A similar indicator appears inside the viewfinder.

6. Take another picture. That shot will use your underexposed setting, and the camera will automatically be adjusted so that the next shot is overexposed by the AEB amount. The indicator will look like this: ✚◀ ━, which shows that now the regular and underexposed frames have been taken and only the overexposed frame remains. If you're shooting a two-step bracket, the display will progress accordingly.

7. Shoot a third and final shot. This will end your bracketed set.

Your next shot will be fired as metered, because now you're into a new bracketed set. In this way, you can easily fire off three shots and have a fully bracketed set.

By default, the D90 adjusts both shutter speed and aperture to achieve its bracketing. In Chapter 12, you'll learn about an option that gives the permission to also adjust ISO when bracketing.

Deactivating Auto Bracketing

To deactivate auto bracketing, press and hold the BKT button and turn the rear wheel until the bracketing setting reads 0F.

Auto Bracketing and Drive Mode

An even easier way to shoot a bracketed set is to turn on bracketing and then activate continuous release mode. Now press and hold the shutter button until it takes three shots. Because bracketing was activated, those three shots will be bracketed.

> **TIP:** Auto Bracketing and Priority Modes
>
> If you use auto bracketing in Shutter Priority mode, then the D90 will achieve its bracketing by altering aperture. By contrast, in Aperture Priority mode, the D90 will bracket by altering shutter speed.

Scene Modes Revisited

In Chapter 1 you learned about the D90's scene modes, those special automatic modes that are designed for shooting in specific circumstances. Let's take another quick look at those with your new understanding of exposure:

Portrait mode tries to choose an exposure that will blur out the background. So, you now know that what it's up to is trying to choose an exposure with a wide aperture (lower f-number), since a wider aperture produces a shallower depth of field. And, you also now know that if it's using a wider aperture, then it must use a faster shutter speed to compensate (a wider aperture lets in more light, so you need a shorter exposure time).

Landscape mode does the exact opposite from Portrait mode. It uses a smaller aperture (bigger number) to increase depth of field. This will usually result in a slower shutter speed. When the shutter speed drops below what the camera thinks is appropriate for handholding the camera at your current focal length, then it will flash the shutter speed readout as a warning.

Close-up mode opts for a shallower depth of field, just like Portrait mode. So, this means wider aperture.

Sports mode aims for motion-stopping power, which you now know means faster shutter speed. It also activates Drive mode and Servo focus.

Night Portrait mode activates the flash but also sets a shutter speed that's appropriate for exposing the scene *without the flash*. So, the flash fires to expose your subject in the foreground, but the long exposure properly exposes the background.

Scene modes offer fewer manual overrides. You cannot use exposure compensation, change white balance, or change metering mode in any scene mode. If you try, the camera will display a warning.

Picture Controls

You've now seen how changes in exposure can affect the tones in your image, as well as the saturation. But the D90 has some other ways to alter the contrast, saturation, and color in your image.

Picture controls allow you to change the way the camera processes its images. Using picture controls, you can tell the camera how you want it to process sharpness, contrast, saturation, and color tone in your image. These controls are very different

from what happens when you change exposure, and to understand how they work, you need to know a little more about how the camera makes an image.

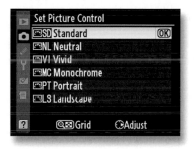

The Set Picture Control menu.

Selecting a Picture Control

A D90 picture control is a collection of image-editing directives. A picture control can contain detailed color correction instructions that affect specific hues, as well as global corrections to contrast, saturation, color tone, and sharpness settings. By default, the D90 uses the Standard picture style, which is a general-purpose style that delivers nicely balanced saturation and accuracy to deliver attractive color that's still realistic.

To change a picture control, choose Set Picture Control from the Shooting menu. Navigate to the option you want, and press the OK button.

The D90 will not display any indication that a nonstandard picture control has been set unless you choose Monochrome. When the Monochrome picture control is chosen, a B/W icon will appear in the viewfinder. Because there's no external reminder of other picture control settings, it's up to you to ensure that you're working with a picture control setting that's appropriate.

FOOD FOR THOUGHT

JPEG IMAGE PROCESSING

Earlier, you learned the basics of how the image sensor in your D90 works. You learned that the image sensor can measure the light that strikes each pixel on its surface and that to calculate color a complex interpolation process is employed. In fact, though, there's actually a lot more that goes on in the camera when you shoot in JPEG mode (which is the only type of shooting we've done so far).

–Continued

JPEG IMAGE PROCESSING (continued)

After reading the data off the sensor, amplifying it, and interpolating the color values, the D90 must do a lot of additional processing before a usable image is produced. After performing its initial color computations (which involves *demosaicing* and then performing *colorimetric interpolation*, for those of you who want some fancy terms to throw around at your next cocktail party), it then maps the data into a *color space*. Here's the trouble with color: It's *very* subjective. If you've ever gotten into an argument with someone over a color—one of those "How can you say that's mauve when it's *plainly* maroon"-type arguments—then you've experienced firsthand how different people can see colors in very different ways. Things are further compounded because different types of devices can record and interpret different ranges of colors. For example, your eyes can perceive a *much* larger range of tones and colors than the D90 can, but the D90 can capture and store *far* more colors than any printing technology can print.

So, the D90 image sensor may analyze its data and discover that one pixel is 100 percent maroon, but what does "100 percent maroon" mean? Is it a really dark maroon or a lighter maroon or a maroon that leans toward the red side? Or the magenta side?

To address this issue, scientists use something called a *color space*. You can think of a color space as simply being an agreed-upon scale that is used when measuring color.

So, for example, in the sRGB color space that the D90 defaults to, "100 percent red" is defined as being a very specific shade of red. Photo nerds will argue the merits of one color space over another, saying that some are too small—meaning that the full range of colors a camera can capture aren't represented—while others are too large—meaning that your image might suffer from some strange color problems. So, after your camera calculates color, it maps those colors into the specified color space. (Later, we'll look at how to change the color space.)

With the color stored, the camera turns to an issue of contrast. Your senses are *nonlinear* in the way that they respond to stimulus. For example, if you double the amount of light in the room, your eyes don't register a 200 percent increase in brightness. Instead, the brightness increase is *attenuated*, or rolled off. This effectively makes your eyes more sensitive to changes at the extreme bright and dark ends of their range.

JPEG IMAGE PROCESSING (continued)

The image sensor in the D90, though, is *linear* in its response to light. A doubling of brightness results in the sensor registering twice as much light. The practical upshot of all this is that your eyes see much more contrast than does your D90. For example, here's the same scene as your eye would see it and as the D90's image sensor sees it:

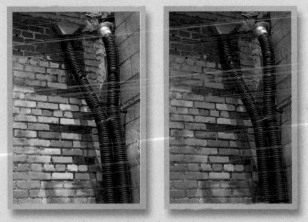

Contrast wise, the left image is fairly close to how your eyes would see this scene. The right image shows how your camera sees the scene.

Although the difference isn't huge, the linear image is definitely a little duller and lacks some of the punch of the nonlinear image.

To make the linear image more like what our eyes are used to seeing, the camera applies a mathematical curve to the values in your image to make them nonlinear. This process is called *gamma correction*.

After gamma correction, the camera corrects the color according to the white balance settings on the camera. At this point, you have a very good-looking image that is recognizable as a quality color photo (assuming you exposed well). But the camera still does more.

Using the equivalent of an in-camera image-editing program, the D90 adjusts the contrast, color saturation, and color tone in your image and then finally applies sharpening. These adjustments have nothing to do with any exposure parameters you've chosen; they're simply image-editing operations of the same kind you would apply using an image editor like Photoshop.

JPEG IMAGE PROCESSING (continued)

Earlier, you learned about pixels, and I discussed how you can represent a greater number of colors if you dedicate more bits of memory to each pixel. Basically, with more bits you can count higher, which means you can represent a greater number of colors. The D90 stores 14 bits of data per pixel, which represents a *lot* of colors. Unfortunately, the JPEG format supports only 8 bits per pixel, so after all of this image processing, the next thing the camera must do is discard a bunch of its color data. The images is converted from a 14-bit image down to an 8-bit image.

Finally, the image is JPEG compressed and stored on the media card.

Although most of this process is out of your control—it's simply a few billion calculations that the camera performs automatically in the split second after you shoot a picture—the amount of contrast, color saturation, and color tone adjustment that the camera applies *is* something you can alter.

Each picture style affects your image as follows:

Standard This is the look that you're used to if you've been shooting with the D90 already. This is the default picture control setting, and it provides excellent all-around results for most situations.

Neutral Very little processing is applied to your image with this setting, resulting in a very "natural" result. If you prefer to process your images yourself, using an image editing program, then Neutral is a good way to go. It's possible to edit any digital image too much, resulting in visible artifacts in your image. So, if you're serious about editing, you might not want the camera to "use up" too much of your editability. Images shot with Neutral will appear more subdued.

Vivid This increases the saturation and boosts primary colors to make an image with more "pop." If you want a very "glossy" look to your prints, this might be a good option.

Monochrome This converts your images to grayscale (or, *black and white*, if you prefer the more traditional term). Grayscale conversion is a very subjective process, so although this picture control is handy, if you're serious about

black and white photography, you'll be better served by shooting in color and performing your conversion by hand in an image editor.

Portrait Intended to improve the look of skin tones, this picture style can impart a warmer look to skin, as well as create smoother transitions from one skin tone to the next, resulting in a more flattering representation.

Landscape This increases sharpness to improve fine details in your landscape photos, while also making adjustments to blue and green tones, the colors you'll find most often in landscape images.

Adjusting Predefined Picture Controls

You can tweak the six predefined picture controls by adjusting five different parameters. For nonmonochrome images, you can adjust sharpening, contrast, brightness, saturation, and hue. For monochrome images, you can adjust sharpening, contrast, brightness, filter effects, and toning. These parameters give you a fair amount of adjustment latitude.

1. To edit a picture control, select Set Picture Control from the Shooting menu.

2. Navigate to the picture style you want to edit, and then press the right arrow button. The editing screen will appear.

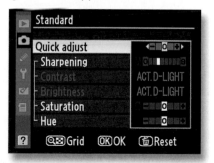

You can edit picture controls to adjust them to your specific needs.

3. Use the up and down arrow buttons to navigate to the parameter you want to adjust, and then use the left and right buttons to adjust that parameter's value. For a complete description of each parameter, see page 111 of the D90 manual.

You can also create entirely new picture controls. These can be saved to the Set Picture Control menu, and you can even share them with others. For details, see pages 113 to 118 of the D90 manual.

Obviously, I'm not choosing to devote a lot of space to picture controls, but that doesn't mean they're not useful. For example, if you shoot events, such as weddings or concerts, and tend to come home with hundreds of images that you need to turn around in a hurry, picture controls can be a boon. You can define a picture control that's right for the lighting situation that you'll be shooting in and feel confident that your images will come out of the camera adjusted close to the way you want. As long as you're careful with exposure, then you might not need to perform any additional editing at all. This will make for a very speedy postproduction workflow.

Personally, I prefer to edit my images by hand, using an image editor. I want the camera to do as little as possible so that I have as much editing latitude as I can get.

You can think of picture controls as a way of choosing a different film for the camera, and this can be a very powerful option. Personally, I choose to put my time into postproduction for maximum control.

TIP: Adjusting Brightness and Contrast in a Picture Control

If active d-lighting is activated (you'll learn about it next), then you will be unable to edit the Brightness and Contrast settings of a picture control.

Creating a Better Exposure with Fill Flash

I want to take a quick moment to introduce you to the simplest—and most often used—form of flash photography. Although most people think that a flash is for shooting in low light, flash can be just as important when shooting in direct sunlight. In fact, since the built-in flash on the D90 is not especially powerful and can't be pointed in specific directions, you may find you use it more in bright daylight than you do in low-light situations.

For example, if you're shooting someone standing under a tree, the tree will shade their face, while full sunlight brightens up the scenery behind them. This is just like the earlier example of shooting someone in front of a window. The camera will most likely meter for the background, rendering the foreground underexposed. In the window scenario, we used different metering modes to properly expose the foreground at the expense of overexposing the background. If you don't want to blow out the background and if your subject is

within range of the flash, you can use the pop-up flash to fill in the foreground to create an even exposure.

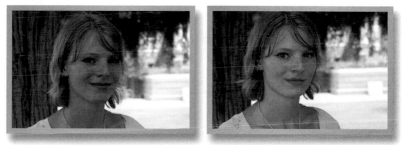

Before and after fill flash.

Similarly, someone wearing a hat can have a face cast in shadow. Fill flash can easily open up these shadows to produce a better exposure.

In the image on the left, the hat is shading the woman's face. With a fill flash, we even out the exposure, throwing more light onto her face while maintaining a natural sunlit look.

In fact, fill flash would have been a fine alternative to the bright window scene that we struggled with earlier. In Auto mode, the flash will pop up automatically if the camera thinks it's needed. In any other mode, press the flash button to pop up the flash.

Active D-Lighting: The Virtual Flash

Active d-lighting is a special Nikon image processing technology that's built in to the D90. When d-lighting is active (which it is by default), then the camera automatically makes adjustments to areas that are in shadow to brighten them. Similarly, if it finds highlight areas that are too "hot," it will try to tone them down.

It's important to understand that active d-lighting is not simply making an adjustment to the whites and blacks in the image. Rather, it's identifying areas in the image that are shadowed and is brightening them, rather than identifying an area that is a particular tone.

The practical upshot is that active d-lighting can greatly improve images shot in shadowy areas.

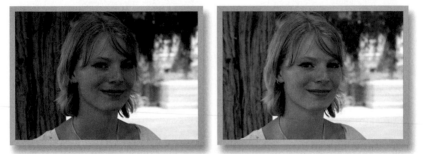

The image on the right shows the effects of active d-lighting.

By default, active d-lighting is set to Auto, meaning the D90 decides when to use it. You can change the d-lighting setting to be more or less aggressive or turn it off completely.

To change the active d-lighting setting, choose Active D-Lighting from the Shooting menu.

The downside to active d-lighting is that it's an image-editing operation, which means that, like picture controls, it "uses up" some of your image-editing latitude. Also, if applied too aggressively, it will effectively lower the contrast in your image.

But as you can see, it can make a dramatic difference when shooting in some situations. Also, if a flash is not appropriate, it can be a good, discreet alternative.

A Word About Dynamic Range

There is a range from very dark to very bright wherein your eyes can see detail. Below this range, things are too dark, and above this range, things are painfully bright. This is called *dynamic range,* and in humans, it's about 18 stops wide. That is, there are about 18 doublings of light from darkest to lightest.

Unfortunately, like all cameras, the D90 has a much smaller dynamic range than what the human eye can perceive. About half the range, actually. This means that,

with a single shot, you cannot capture some scenes in the way your eye sees them. For example:

The image on the right has such a huge dynamic range that it couldn't be captured in one shot. Instead, I had to shoot an image exposed for the shadows and one exposed for the highlights and then combine them in an image editor.

This image has a very large dynamic range. There are details in the shadows and details in the highlights. It was not actually possible to capture this in one shot. Instead, I had to take two shots, one exposed for shadows and the other exposed for highlights, and then combine them in an image editor. Unfortunately, performing this kind of combining is not always possible, either because your subject is moving, you didn't think to take multiple shots, or the postproduction work is too hard. Most of the time, when shooting a scene like this, you simply have to decide whether you want to shoot for highlights or shadows.

As discussed earlier, it's usually better to preserve details in highlights, because areas of solid white are distracting. Areas of solid black just look like dark shadows that we can't see into.

In-Camera Retouching and Editing

Whether you shoot film or digital, one of the great breakthroughs of the digital image-making age is image-editing software. Adobe Photoshop is the best-known image-editing program, but no matter what software you choose to use, image-editing software allows you to make edits and adjustments to your images that would have been impossible with a traditional darkroom. Even if you're interested only in the type of basic adjustments that *are* possible in a darkroom, you'll find these much easier to execute in a digital editing program.

Your D90 includes a number of image-editing features in the camera. From the Retouch menu, you can remove red-eye, crop and resize your images, perform color corrections, and improve tone and contrast. These features are effective and easy to use. The biggest question you'll face is, should you bother to use them?

Compared to your computer, your D90 has a very small screen that's not color accurate, is somewhat slow when compared to the processing power of a modern desktop or laptop computer, and while the editing features built in to the camera are good, they don't offer anywhere near the degree of control that even the most basic image-editing program can provide.

However, depending on your particular needs, in-camera editing might be handy. Obviously, if you don't *have* a computer with image-editing software, then the D90's editing controls will be very welcome. Or, if you travel without a computer but want to start editing images before you get home, you might be glad to have an editing station within your camera. Finally, even if you don't want to do your final edit with the D90, the camera's build-in editing facilities provide you with a quick way to see what an image will look like after a particular edit.

Editing an Image Using the Retouch Menu

When you use any of the D90's retouching tools, your original image is not altered. Instead, the camera makes a copy of the image and applies the edit to that copy.

To retouch an image, follow these steps:

1. In playback mode, navigate to the image you want to edit.
2. Press OK to display the Retouch menu.
3. Navigate to the retouch edit that you'd like to apply, and press OK.
4. Configure the edit to taste, and press OK.

If you like, you can also pick the edit you want to perform first, and then choose the image you want to apply it to:

1. From the Retouch menu, select the edit you want to apply.
2. The D90 will show you a thumbnail screen, from which you can select the image that you want to edit.
3. After picking the image, configure the edit to taste, and press OK.

No matter which technique you use, the D90 will first duplicate your image before applying the edit. The retouch edits are described in detail on pages 212 to 223 of the D90 manual. If you have a high-end editor like Photoshop or Capture

NX, then you won't find any editing features that you can't use in your editing software. If you have a less capable editor, though, then there are a few edits that might be particularly useful. Distortion correction, fish-eye, d-lighting, and filter effects are all high-end edits that entry-level software may not have.

Choosing a Color Space

Earlier, you learned about color spaces, which are the mathematical models into which a camera maps color so as to describe exactly how red, for example, a specific shade of red might be.

By default, the camera is set to sRGB, which is a popular color space that is well-suited to web based delivery of images. Many online printing services expect images to be in sRGB. The D90 also offers the Adobe RGB color space, which offers a wider gamut of colors than sRGB.

Color space choice in the camera is not critical if you have an image-editing program that lets you change color space, such as Adobe Photoshop. Even if you do, though, if you prefer working in one color space over another, then setting in-camera can save you the trouble of converting later.

For now, just leave Color Space set on sRGB. As your image-editing and printing skills become more sophisticated, you might choose to switch to Adobe RGB later.

Summing Up

I've covered a lot of functionality in this chapter, and it may seem that I'm arguing some kind of progression of skill level—that you start with Auto, progress to Program mode, and then one day ascend to Manual control. Nothing could be farther from the truth.

Each of the shooting modes on the D90 offers different advantages, and some are more appropriate to certain conditions than others. You can take great shots in Auto mode, or you can come home with useless, incorrectly exposed images. The same can be said for Program, the priority modes, and Manual mode. Each mode offers different advantages, so it's important to have an understanding of each. You'll also want to practice with each mode, both to understand its controls and to better assess its utility. Just as giving yourself an assignment can help with your visualization and composition skills, you might want to limit yourself to a particular mode for a day's worth of shooting. Manual mode will definitely test the limits of your understanding of exposure, metering, and reciprocity, but this understanding will make the other modes easier to use as well.

CHAPTER 8

Finding and Composing a Photo

EXPLORING THE ART OF PHOTOGRAPHY

As with most creative endeavors, you can divide your photographic study into two areas: craft and artistry. Craft encompasses your technical understanding of photographic process—how different parameters affect your image and how you use the controls on your camera to set those parameters. Artistry is the process of using your craft skill to represent a scene, person, or moment as a photographic image—ideally an image that evokes something of the "truth" of your subject that you felt when shooting. In this chapter, you're going to focus on the artistry side of things and explore how you visualize and compose an image.

Learning to See Again

If you're like most people, you've probably experienced something like this: You can't find your keys (or your sunglasses, your favorite pen, your wallet, or whatever) so you look on your desk, in your pockets, in your coat, and on the kitchen table. You try to retrace your steps to determine where you might have been when you last had your keys. You look and look and then, finally, an hour later, you see them sitting out in the open in the middle of your desk—right there in the first place you looked.

This type of maddening situation happens because although it's very easy to look at something, it can be far more complicated to actually *see* it. We tend to use the words *look* and *see* synonymously, but for a photographer, there are very important differences between the two terms.

Let's return to the lost key scenario. How is it that you can look at the desk, specifically trying to find your keys, and not see them? The answer has to do with the fact that your eyes are far more than a simple optical instrument. It's very easy to draw a parallel between a digital camera and your eye—they both have lenses with irises, and they both have separate receptors for red, green, and blue light. But the optical system in your head has a very important additional component attached to it, in the form of a human brain. Although we like to think of our eyes as camera-like devices that capture whatever scene is in front of us, our brains dramatically alter our perception of what we're seeing. Not seeing the keys on the desk in front of you is a prime example of this phenomenon, and there's a good reason your brain has evolved to work this way.

Think about crossing a busy street while running an errand. You know there are cars bearing down on you, and you know how far each car is, how fast it's going, and how to navigate across the street without getting hit; and most likely you know all of this while also thinking about your errand and how it will go and what you'll do afterward. However, despite this huge amount of information, when you get to the other side of the street, if someone were to ask you the color, make, and model of each car you passed, you probably wouldn't be able to recall. If you're a car freak, you might be able to, but if pressed to go further and tell the gender of each driver, you'd probably be out of luck. Even though your eyes were taking in all of this information—just as a camera would—your brain was editing it away.

Processing visual input requires an incredible amount of your neural bandwidth—bandwidth that you need for other things such as keeping track of

errands, and so forth. So that you aren't overwhelmed with visual information, your brain tends to edit or "abbreviate" your visual experience. So, when crossing the street, rather than seeing a "large metal vehicle resting on four wheels, with a clear glass window on top, six dead grasshoppers stuck to the front grill, a license plate that reads 'ILUVNY,' and a middle-aged woman in curlers behind the wheel," you very often just register "car." By reducing the complexity of a large vehicle down to a simple concept and a simple iconic image, you don't have to spend so much time registering all of the details that you end up getting run over. Instead, your brain takes a shortcut that allows you to get on with your day, albeit in a way that makes the world possibly less visually rich.

When looking for your keys, you will look at the desk, and your brain will decide that it already knows what it looks like, not bothering to register details that it feels it already knows. There normally aren't keys sitting there, so you don't see them. This is why someone who's not so familiar with your desk might walk in the room and spot the keys immediately.

Little kids are different. Because the world is a new place for them, they notice every detail of the objects around them. They have to because they haven't yet learned to abbreviate the visual complexity of the world down to simple symbols like "car" or "desk." But for a photographer, the "visual complexity" that makes up the world is also the raw material for your photographs. So, you don't *want* your brain to be abbreviating your experience, you want to see every detail. In other words, you want to learn to *see* again as you did when you were a kid.

Unfortunately, the older you get, the more knowledge of the world you have, so the more your brain can fill in a lot of blanks for you, relieving you from the hassle of seeing. So, is it possible to make it stop doing this? Recent research has shown that the longer you look at a scene, the less contrast you are able to perceive in that scene. An image or scene will increasingly go flatter, contrast-wise, as your brain devotes fewer resources to it. The theory is that if you're looking at something for a while and it hasn't killed you, your brain decides that there's no need to devote precious resources to higher-quality visual processing of that scene.

So, to a degree, your brain stands in the way of your seeing accurately. However, you can still do many things to try to open up your senses and learn to better spot the interesting visual matter around you. The more you do this, the more you will discover raw material that can be transformed into photos.

FOOD FOR THOUGHT

INTENTIONALLY CONFUSING YOUR VISUAL PROCESSING

Another way to see how much your brain is involved in the visual process is to look at optical illusions, even something as simple as this line rendering of a transparent cube:

When you look at this two-dimensional representation of a cube, it appears to flip back and forth in space. This is an example of your brain failing to properly interpret the visual data that your eyes have collected.

Your eyes are properly registering a series of lines on a flat piece of paper, but your brain is stepping into the process. It notices that the arrangement of these lines usually represents a particular 3D object—cube—as if they were truly a three-dimensional shape. Because it isn't actually a cube, your brain gets confused, and the orientation of the cube appears to flip around. This is a prime example of how your brain manipulates your visual experience after your eyes have already gathered up raw visual data.

Seeing Exercises

Just as a musician can train their ear to recognize pitch, intervals, and chords, a photographer can train their eyes to be more open and receptive to the world. In other words, you can practice and improve your ability to see.

One of the most important aspects of learning how to see is knowing what seeing feels like. However, if it's been a long time since your visual sense was really open, then it may be difficult to know what the difference is between seeing and not seeing. One of the easiest ways to get your eyes going is to go somewhere new. Perhaps you've noticed this when you travel or go on vacation. When you first get to some place very foreign, or new, you often notice lots of little details. This is partly a survival mechanism—you're a little more wary than usual, a little more alert, so all of your senses are going. It's also because you have lots of new stuff to see.

This is one reason that a lot of people think "I want to do some photography. I need to go somewhere." They've recognized before that when they travel, they really see stuff. Although it's sometimes simply because you're in an especially scenic place, I think it has as much to do with your visual sense being more charged and effective. Paying attention to what this feels like next time it happens to you is a good way to learn what it feels like to really see. Once you know the feeling, it can be a little easier to find it again.

Here are some ways to get your sense of seeing going, without having to travel.

Warm Up

Don't assume you can work at your job all day and then dash out the door and suddenly be a photographer. You wouldn't expect to play a musical instrument without warming up and certainly wouldn't expect to do well at any kind of athletic event without warming up. Although not tiring, the act of seeing is physical. It's not physically straining, but it's something you have to feel. It can take some time to calm down from the everyday stresses of your life and open yourself up to your visual sense.

When you first step out the door, take a picture. It doesn't matter what it is—take a picture of your foot, the light pole across the street, a manhole cover, a water meter in the sidewalk, anything at all. Taking that first shot will put you into the physicality of shooting. You'll see through the D90 viewfinder and be reminded of the frame shape and size you'll feel with the camera in your hands. All of this will help get you out of the distractions of your everyday life and into seeing and thinking about images.

Give Yourself an Assignment

I hear a lot of people say, "I'm going on vacation this summer, and that's when I'll take a lot of pictures." As discussed earlier, it's definitely easier to find images

when you're somewhere new, especially if it's somewhere really photogenic. But photography takes practice, and you need to do it regularly. What's more, good pictures can happen anywhere, but only if you're open to them. If you can't work on your own block, around your own house, then there's no guarantee you'll be able to do good work in an exotic location.

One way to get yourself to practice and to breathe new life into familiar locations is to give yourself an assignment. Perhaps it's a subject—"old cars," "fire hydrants," "doorways"—or maybe it's a phrase or a word—"beauty and the beast," "contentment," "no pain, no gain." The subject matter or word doesn't have to mean anything to anyone else, and you can interpret it any way you want. The idea is to give yourself some way to frame your view of your location. This will often make you see familiar ground in a new way.

I keep three ongoing projects: "My street," "My neighborhood," and "San Francisco." Sometimes, when I have a moment to spare, I'll pick one of these things and go shooting. Confining myself to just my street is the hardest, while the neighborhood is easier, and having the whole city to work with is even easier. But trying to work on just my street is interesting, because it makes me look for unusual lighting or compositions amongst very familiar locales.

Images from my ongoing "My street," "My neighborhood," and "San Francisco" projects, respectively. Defining some projects for yourself can make it much easier to find things to shoot.

As with any creative endeavor, practice is the key. It's not just about memorizing what shutter speed and aperture do, and how to control them, but about practicing composition, seeing, and interpretation.

Look at Other Photos

Photography is a strange form because, while aspiring writers will all be able to easily name their favorite writers and books, I encounter very few aspiring photographers who know much about the history of their chosen form. Few can name a favorite photographer or pick up on references to famous, important works of photography. Familiarity with great works, though, is an easy way to improve your own shots.

Go to the library or bookstore, or do some Google searches, and find work by some of the great masters—Ansel Adams, Henri Cartier-Bresson, Paul Strand, Elliot Erwitt, and Alfred Stieglitz. Spend some time looking at their images with an eye toward both simply seeing how they make you feel and figuring out what was done technically to create the image. Pay attention to how the images are composed, and try to think about what the photographer might have done, exposure-wise, to achieve a given effect. By reverse-engineering their solutions, you'll learn a lot about how they saw a scene and what choices and decisions they made to turn that scene into a finished image.

> **TIP:** Study Other Photographers
>
> Looking at other works can be inspiring and energizing and is a great way to practice seeing when you don't have the time or opportunity to go shooting.

Practice

I already mentioned practice, but it's important, so I'm gonna mention it again: Practice. Practice a lot. Not only will you learn your camera better, but you'll get better at seeing and recognizing images. If you want to take it to the extreme, you can do like photographer Joe Buissink who if he doesn't have a camera but sees an image that he would like to shoot, says "click" or snaps his fingers. This "shooting without a camera" keeps him in the habit of seeing photographically, acknowledging when there's a shot he wants to take, and taking a moment to think about how he might compose it.

How to Make a Photo

Every so often my grandmother decides to go to a portrait studio. As with many people of her generation, she's always said that she's off to "have her picture made."

Nowadays, of course, we would say that we're going to have our picture "taken," but this is something of a misnomer, because a good picture is *made*. To "take" a picture implies that the subject is just there, as is, and that your camera records a perfect representation of it. But that's not actually how a good photograph happens. The process of taking a good picture, whether it's a portrait, a still life, a landscape, a street shoot, or anything else, involves making a lot of decisions and solving a lot of problems. It also often requires you to shoot a lot of pictures as you experiment and try different ideas. Good images are not taken, they are *made* from the raw material of the scene you've decided to shoot.

In the rest of this chapter, I'm going to talk about the process that you go through to make a picture, from recognizing a scene to composing a shot to making exposure decisions.

Recognizing a Potential Photo

The photographic process begins, of course, by finding something that you want to take a picture of. Although sometimes a subject is obvious—"Look! Godzilla is attacking the Eiffel Tower, I'd better get my camera!"—more often, interesting photos are hidden from those who aren't necessarily looking for a picture.

From beginning shooters, I often hear questions like "How do you find stuff to shoot?" They think that you must go find interesting objects, stunning vistas, or beautiful landmarks. But good pictures usually begin with nothing more than a simple impulse based on something you've seen—a play of light, a beautiful color, an interesting piece of geometry. You might be walking down the street in the late afternoon and find a weathered door that the setting sun is throwing into deep, textured relief. Or perhaps you come across an otherwise mundane object that's being brightly lit by the sunset. Or maybe you find a curious piece of repeating geometry or some kids engaged in a very serious game of tag.

Sometimes, you'll find scenes that you simply think are beautiful or interesting, and at other times you might see something in the corner of your eye that captures your attention but when you look directly at it find yourself unsure as to what it was that initially intrigued you.

In *all* of these, that initial impulse—whether it's strong and obvious or fleeting and difficult to interpret—is "how you find stuff to shoot." Often, after that impulse, you'll immediately have an idea of the finished image in your head and can begin to work. At other times, you'll have no idea how to shoot the scene. In

these instances, it's very easy to decide that your idea wasn't any good and not even try to take a picture. But don't give in to this self-doubt. Trust those initial impulses, and if you have even the foggiest notion that a picture might be possible, then start to work.

> **TIP:** Watch the Light
>
> All photos begin with light, and different types of light have different qualities. Excepting portraits, just about any subject looks better when it's struck by light that's coming from a lower angle. The angled light will reveal more detail and texture on the image. This means morning and afternoon are the best times for shooting. The midday sun produces a very flat light and rarely yields a good picture. Pay attention to the light! If you look out the window and see lots of beautiful contrast in the late afternoon, get outside with your camera! If you see a fascinating subject but find your pictures of it to be a little boring, try returning to that subject in the morning or afternoon. You may find that under better light, your subject really comes alive. Good photography often requires getting up *very* early, but this is how it is when your medium is light-based.

Look Through That Camera

Sometimes, on outings with a class, I'll have students who say they aren't getting any images. But when I watch them, I realize they aren't actually shooting very much, if at all. What they mean is that they're walking around looking but aren't seeing anything they think will make a good image. Unfortunately, what they're not understanding is that learning to view the world as a camera sees it takes a lot of practice.

If you find you've been walking around for a while in good light and you *aren't* seeing anything you want to shoot, you might simply be in a location that isn't providing any good material. However, it might also be that your eyes and brain just aren't seeing things photographically. Sometimes you have to look through your camera before you begin to see potential photographs. If you find yourself stuck, lift the camera up to your eye and start looking through it. The frame of your viewfinder often crops the world in ways that you can't visualize when you're walking around, and these crops often reveal interesting images. You may

have to shoot your way through some unusable, outright bad images before your photographic senses get working. If you suffer through this process, though, you may find yourself seeing more things to shoot.

If you try this and *still* aren't finding things, then either there really isn't anything you're interested in shooting or your photographic juices just aren't flowing. Don't let this discourage you. Relax, give it a rest, and come back another day.

Photography as Abstraction

Although it's easy to believe that a photograph is a realistic representation of a scene, it's really not, for very obvious reasons. Photos are flat, two-dimensional objects, possessed of far less color or contrast than a scene in the real world; they convey nothing of the sound, smell, or feel of a scene, and they force a very cropped view.

Your job as a photographer is to try to figure out how to capture the feel of a moment or a scene with that flat image. Obviously, this is no small feat, but that's why great artistry is difficult to achieve.

Working Your Subject

Occasionally, *very* occasionally, you'll take a shot, and it will be exactly right. But don't expect this kind of good fortune very often. More often than not, you'll have to do some work to turn the scene you're shooting into a good image. You'll have to try different compositions, shooting from a variety of locations and trying different exposure ideas, different focal lengths, and different vantage points. In the simplest terms, *working* a shot means trying as many different things as you can think of.

Even if you have a very clear vision of what the image should be, you should *still* try lots of different things, because once you're looking through the lens, you might start to see things very differently and get new ideas.

Many people think if they can't get the image in one shot, then they must not be a good photographer. But this isn't how photography—or any artistic endeavor—works. Artistic expression is a process of experimentation and discovery, and as a photographer, the way you experiment and discover is to shoot lots of different compositions that explore many different ideas.

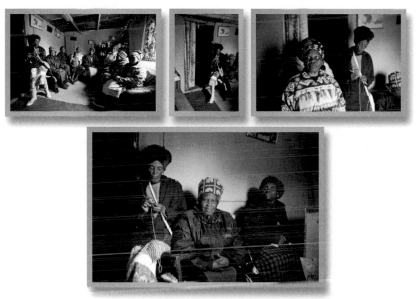

I tried many different angles and compositions before I finally found the shot that was "the keeper." Often, you'll find the right shot only by working your subject heavily.

There are no rules to working a shot, other than to try anything and everything you can think of. However, it's almost always true that as you get in closer, your shot will improve. We'll discuss this more when we discuss composition later in this chapter.

> **TIP:** Take Your Time
>
> It can take time to make a good image: time to find the right angle and composition, time to thoroughly work your shot, time to figure out what it is about the scene that you're trying to capture. When possible, try to take your time and work through your options, and think about your exposure and composition strategies. Obviously, fleeting moments like the big play at a sporting event or a street shot involving moving people don't allow for repeated shooting. However, if you're shooting these types of moments for a while in the same location, then you'll have time to adjust your exposure strategy to the current lighting and to experiment with different angles on the action.

SHOOTING THROUGH FEAR

Unless you're a war photographer or you like to shoot in hazardous locations, photography is really not a dangerous endeavor. Nevertheless, people will succumb to all sorts of fear-based behavior when trying to take pictures. The most common one is that they will stick to the ideas that they know work, or that have worked before, rather than trying something new and risking the bad feeling that comes when something doesn't work.

This approach has two problems. First, what worked before in one shot might not work in another. But more importantly, this type of fear keeps you from exploring. It may be strange to speak of "courage" in a practice as harmless as photography, but often you have to muster courage to thoroughly work a shot. And what you have to be courageous about is failure.

The reason that most people don't work their shots enough is that they're afraid they'll get home, look at their shots, see that most of them are bad, and then feel "Oh no, I'm a lousy photographer." So instead, they take the one or two shots that are safe—the shots that are obvious or that have worked before. Although these shots may not be bad, after a while you will become very bored with them.

The process of working a shot is like sketching before a painting or drawing. Just as a painter sketches or a composer writes out motifs or ideas, you have to shoot some coverage of your scene from different angles, exploring different ideas, before you can zero in on the idea you like best. *All* good photographers do this, which means they *all* come home with a lot of images that are unusable, because many of these images were just process images that were required to get to the final shot.

Don't succumb to the fear of failure. Experiment, try things, get in close, and have the courage to take the shots that you don't normally take.

Choosing a Camera Position and Focal Length

Once you've spotted a subject and decided to start working it, you're ready to begin composing your shot. All composition begins with a choice about where to stand.

"But why do I need to think about where to stand?" you may be saying. After all, you've spotted the image; shouldn't you just take the picture? Not necessarily. The odds that you happen to have recognized a shot from the absolute best position in the world for shooting it are pretty small, and camera position can have a huge bearing on what your final image looks like.

Obviously, standing closer or farther, or off to one side or the other, can make a big difference in your shot. But camera position also affects your choice of focal length, and focal length can have a huge impact on the sense of space in your scene.

Understanding How Focal Length Choice Affects Your Image

Although a zoom lens is a great convenience that keeps you from having to move around so much when you're shooting—rather than walk across the street, for example, you can just zoom in—it also tends to make for lazy photographers and to keep shooters from thinking about the right focal length for their scene.

Zooming a lens does much more than simply make a far subject appear closer. When you change focal lengths, a lot of things in your image change. Consequently, it's important to understand what a longer or shorter focal length does to your image.

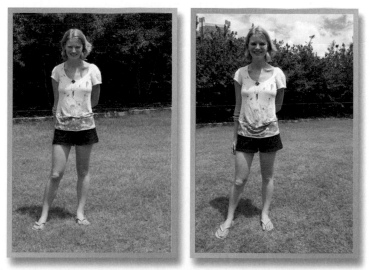

These two images are framed the same way, but the camera position and focal length changed, resulting in dramatic differences in the composition of the image.

My goal in both shots was to have my subject as large as possible. In the left image, I was standing farther away and so had to zoom in to get her to fill the frame. In the second image, I moved very close and so had to zoom out to a shorter focal length. Although both strategies fill the frame with my subject, look at the huge differences in the background of the image.

In the left image, the background is filled with plants; in the right image, we can see some architecture and a fair amount of sky. Note, too, the difference in the sense of space in the image. In the left image, the plants in the background appear closer, while in the right image they look farther away and shorter.

When you zoom in (or, if you're using prime lenses, when you choose a lens with a longer focal length), the sense of depth in your scene gets compressed. Objects in the background will appear closer, and the overall composition of shapes, as well as sense of space, can be very different.

So, rather than standing in one place and zooming around to get your shot, it's important to pay attention to how different focal lengths affect the sense of space in your image. By choosing a different camera position and focal length, you can choose to make a space seem more spacious or more intimate (or, depending on the subject matter, more desolate or cramped).

Note that the compositional differences shown in those two images are all visible through the viewfinder, so you don't even need to take a shot to experiment with focal length changes.

Focal Length and Portraits

When shooting a portrait, it's also very important to pay attention to focal length because, just as the sense of space in a large scene changes dramatically depending on your focal length choice, people's faces can be similarly distorted.

Again, here are two images framed with the subject taking up the same amount of space:

Focal length choice and camera position are also critical when shooting portraits.

The left image was shot with a slightly telephoto lens. For the image on the right, I switched to a wide-angle lens and moved in closer. Obviously, the wide-angle lens has greatly distorted the man's face. Note, too, the change in background. In the left image, the oven in the background looks very close, while in the right image it appears farther away. The wide-angle lens has stretched the distance between his nose and ear and between his head and the background.

Portrait photographers typically use a focal length that's a little longer than a normal lens. On the D90, 50mm is just about perfect for flattering portraiture. When combined with a large aperture, you'll get nice portraits with a soft background.

Composing Your Shot

Composition is the process of arranging the elements in your scene—the shapes and objects that comprise your foreground and background—to create a pleasing image.

Earlier you looked at some simple composition rules—fill the frame, lead your subject, don't be afraid to get in tight. These guidelines can greatly improve your snapshots and are relevant to all kinds of shooting. For more complex subjects and to produce more compelling images, though, you'll want to think about some additional compositional ideas.

There's no right or wrong to composition, but some compositions are definitely better than others. Rules are made to be broken, of course, and many compositions won't ascribe to any particular compositional theory or rules. However, when trying to make a photo—that is, when you've found an interesting subject and you're trying to figure out how to shoot it—remembering these compositional ideas will help you explore and experiment and will probably lead you to better results.

Balance

One of the simplest compositional ideas is balance. Balance in a photo works just like balance in the real world. Different elements in your photo have compositional "weight," and you need to balance those against each other.

The contrail in the left image serves to balance the compositional "weight" of the cliff. If we remove the contrail, the image falls a bit out of balance.

Compositional balance is a tricky thing because you don't need elements of equal size to create balance. Just as a small piece of lead on a scale can balance a tremendous number of marshmallows, some small graphic elements can balance elements that are much larger. This is almost always true with people. We put a lot of import on people, and a single person in a frame can balance a huge amount of other compositional elements.

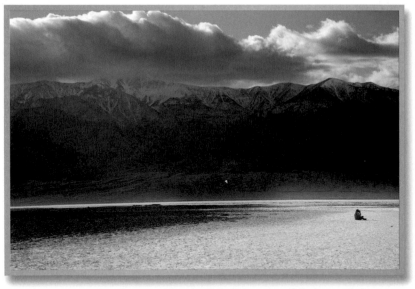

Humans carry a lot of compositional weight. Even a small figure can balance a very large element.

You won't always balance shapes in a composition. Sometimes you will find balance by putting tones—light and dark—against each other.

Here, the light line at the top of the image balances the dark shape at the bottom.

Sometimes, even empty space can create a balance. Consider this image:

Sometimes you can balance an element in a scene using empty space.

This image is a good example of breaking a rule, because we're plainly breaking the "lead your subject" rule. In this image, though, it works. The woman's pensive, reflective expression makes the empty space behind her more powerful. That space is evocative of emotional weight that is bearing down on her or of her past. Graphically, the mostly empty space on the left balances out her presence on the right.

Geometry

Geometric shapes make great compositional elements and almost always make an image more interesting. Geometry can be anything from a strong line to a repeating pattern. You can see examples of geometry in some of the balance images we already looked at. The strong line of the airplane contrail makes for compelling compositions and packs a lot of compositional weight.

Circles, lines, patterns—all of these geometric shapes make great compositional elements that you can use to create more interesting images.

Sometimes, pure geometry itself can be interesting.

This fairly abstract scene is composed of pure geometry.

Repetition

Roughly akin to geometry is repetition. Repeating geometric or tonal patterns in an image are another powerful compositional device.

Repeating elements and textures almost always make for interesting compositions.

The Rule of Thirds

If you imagine a grid laid over your image that divides the picture into thirds, both horizontally and vertically, then the intersections of those grid lines make good places to put compositional elements. This is known as the *rule of thirds*, and it will often lead you to good compositions.

The rule of thirds can provide a good guideline for positioning elements in the frame.

TIP: Don't Be Afraid to Put Things in the Middle

It is possible to get *too* creative. When worrying about the rule of thirds, balance, and all these other things, you might be too clever and forget that, often, the best composition is to leave your subject in the dead center of the frame.

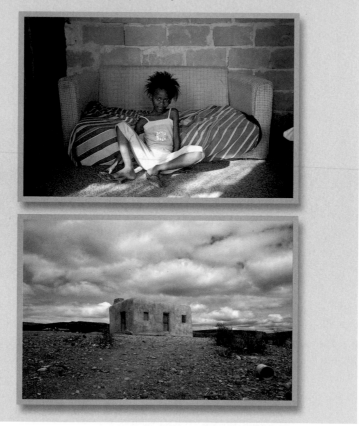

Foreground/Background

If you've ever had someone stand you in front of a statue or a landmark, then you've experienced this rule: A photo needs a foreground and a background. Another way of thinking about this is as a subject and a background. What's more, the relationship between those two things is very important.

Earlier you learned about the idea of using the entire frame, or *filling* the frame. Choosing what to fill the frame with is an important part of good composition.

For example, here's a person standing in front of the Golden Gate Bridge:

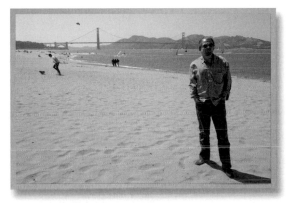

This image shows the whole bridge and the whole person, but showing everything isn't always the best approach.

While we've filled the entire frame and though we can see the entire bridge and the man's whole body, the image doesn't really have a strong subject. In fact, the bridge is as much the subject as the guy, who serves little purpose other than to indicate scale.

If we want this to be a picture of a person in front of the Golden Gate Bridge, we're better off framing tighter.

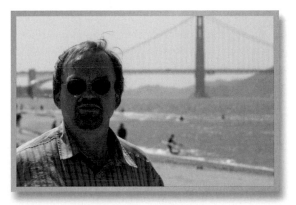

Here we have a tighter shot that's easier to read but still provides a sense of place.

By filling the frame with more of the person, we know they are now definitely the subject of the image. Yes, we've had to crop the bridge, but the image still plainly conveys the person in their environment. If you want a picture of the bridge,

that's a different subject and a different photo, and you probably don't need a person in there at all.

Sometimes you'll come across a beautiful or compelling vista that will be enough to serve as a subject all its own. You'll still want to think about framing and composition and consider some of the rules that I've discussed, but you won't have a definite foreground and background.

While this image doesn't have a definite foreground element, the scene itself is compelling enough to be a subject all on its own.

At other times you might come across a compelling vista but not be able to find a composition that feels right. This might be because the scene lacks a subject, so your eye doesn't really know how to "read" the image. If you can find something to use as a subject, you'll often find it's easier to compose.

The scene on the left is much improved by waiting for the funicular to come into the frame and serve as a subject.

Sometimes, patience is the most important photographic tool at your disposal. If you find a nice background, wait and see whether someone walks into it to complete the composition or to serve as a subject.

Composing with Light and Dark

Earlier, you saw an example of a light airplane contrail balancing a dark horizon. Very often, you'll build composition out of light and dark, not just out of geometry.

Light is the raw material of photography, so don't forget to pay attention to light and dark elements within an image —they can make great compositional elements.

Also, don't worry if you can't find an exposure that reveals all the detail in a dark area. Often, a completely black shadow is just what an image needs. We don't need to see detail everywhere in an image, and choosing what to show and what to hide is part of the process of making a compelling image.

You can't see any detail in the shadow area of this image, but that's okay. The dark shadow makes the pool of light more pronounced, and any detail in the shadow would simply distract us from the sleeping cat.

Less Is More

The world can be annoying in many ways, but for photographers, one of the biggest annoyances (after running out of media cards in the middle of a shoot) is that there's just too much stuff in the world.

Painters have it easy; they start with nothing and add only the things that they want in their scene. Photographers, though, have to contend with power lines, street signs, people who walk into their compositions, and trees that have one branch that's pointing in the wrong direction, and so on and so forth.

One of your most important jobs as a photographer is to find compositions that reduce the clutter in a scene so that the viewer is not confused about what to look at and so that their eye finds its way through the image.

If you work to fill the frame, as discussed in Chapter 1, you'll go a long way toward reducing extraneous clutter in your scene. When you're working a subject and trying to find different ways of shooting, one of the easiest variations is simply to get closer.

Though not always the case, getting in closer to your subject often will yield a more interesting image.

Closer usually yields a less-cluttered, cleaner image. When shooting people, getting in closer can be intimidating because you must move closer to your subject. Obviously, you don't want to make them uncomfortable, but don't be afraid to entertain the idea of moving a little closer when the situation feels right.

When shooting in public, closer often means separating yourself from the crowd and moving toward a scene. This can often leave you feeling like everyone is looking at you. In reality, they probably *aren't* (everyone is used to seeing people with cameras these days), but more importantly, so what? They notice you for a few moments and then go on about their day, while you return home with an interesting photo.

Some, All, or None

If you look back over the images I've used as examples, you'll find a lot of overlap of compositional ideas. For example, in the funicular picture, note that the funicular is positioned according to the rule of thirds.

You'll find that you can easily mix and match these compositional ideas to build up a good image, and as you've already seen, you might occasionally throw these ideas out altogether. Sometimes you'll be conscious of these rules; sometimes you'll simply go by feeling. If you practice these techniques, you'll soon come to find that even when you review images that you shot by feel, they still conform to many of these concepts. Studying the work of other photographers is also a great way to learn how they put these ideas to use, and sometimes such study makes it easier to understand another shooter's thought process and the choices they made.

Where these rules can be especially helpful is when you come across a scene that you want to capture but you don't know where to begin. Start by thinking about camera position and focal length, and look through the lens to see how the sense of depth and space in the scene changes as you adjust position and focal length. Then start thinking about subject and background and about geometry and pattern, repetition, and the rule of thirds. These can all serve as guidelines as you explore the scene through your camera lens.

Art and Craft

Throughout this whole process of working a shot and trying to make a composition, you will be constantly employing the technical concepts you've learned so far.

For example, you might be working a scene, moving around and getting in close and then find a focal length and camera position that creates a wonderful sense of space and that allows a composition that is balanced, with a nice subject/background relationship. But then you realize that what would make it perfect is to soften the background. So, you choose to go to a wider aperture using program shift, by turning the Main dial until an exposure set comes up that has a smaller f-stop number.

But then maybe you realize that your subject is very dark and so needs to be underexposed. So, you use exposure compensation to dial in a 2/3rd stop underexposure.

You shoot the shot and then review the image to check both your composition and the histogram, which will tell you how well your exposure has worked. In this way, your technical knowledge and handling of the camera combines with your artistic decisions.

Practice

Although it's possible to contrive guidelines for specific photographic situations— get down low while shooting kids, fill the frame when shooting portraits, and so on—as you've seen, the process of making a good photo requires a lot of decision making and a lot of choice and experimentation. Rather than learning specific rules for specific situations, it's better to learn what it feels like to see, what makes a good composition, and how your exposure settings affect your image. With these basic building blocks, you'll be able to go far beyond simple formulas for different situations. You'll be able to find your own solutions that better convey what you feel about a particular scene.

We can discuss all of these ideas and rules for hours, and the discussion can be very enjoyable and enlightening, but more than any lesson, more than any new piece of gear, more than any piece of postproduction software, the single thing that will do the most to improve your photography is practice.

You must practice seeing; practice composing; practice your understanding of the effects of exposure, camera position, and focal length; and practice with the controls of your D90 so that you can quickly adjust and adapt to any situation without having to think too much about the camera. You want your focus to be on composition. Practice will make all of these things possible. So, get out and shoot as much as you can, and pay attention to what works and what doesn't.

Because your camera records your exposure and focal length parameters for each shot you take, it's easy to review images and understand exactly what exposure you used for every shot. Paying attention to the effects of these choices will help you learn.

Specialty Shooting

USING SPECIAL FEATURES FOR SHOOTING
IN SPECIFIC CONDITIONS

As you've already seen, different photographic conditions require different approaches. In this chapter, you're going to look at special features and techniques you can use for shooting concerts, panoramas, low-light shots, and more. The D90 provides all of the features you need for just about any type of shooting, even complex shots involving multiple exposures and special processing.

Live View

Though not a feature you'll use every day, Live View can be a lifesaver in certain tricky situations such as concerts, macro shots, or occasions when you need an angle that you can't get holding the camera normally.

By this point in the book, you should be the type of person who can bandy about terms like *SLR* and *reciprocity* with ease. With your understanding of SLR mechanics, you should now be able to see why digital SLRs traditionally have not let you use the LCD screen as a viewfinder, the way you can do with a point-and-shoot camera.

To create an image to show on the LCD screen, the image sensor needs to be able to see out the lens. But in an SLR, there's a shutter and mirror between the sensor and lens, so the sensor is, effectively, blind. This means there's no way for it to see to be able to show you an image on the LCD screen. The D90, though, provides a special feature called Live View that *does* let you use the LCD screen as a viewfinder.

Of course, one of the great advantages of an SLR is the high-quality, through-the-lens viewfinder that shows a bright, clear image and allows you to block out the rest of the world while you compose your shot. However, Live View can be useful in a few situations where a normal SLR viewfinder is difficult to use. Live View is ideal for the following:

Product and still-life shooting When you have your D90 mounted on a tripod and are trying to shoot a static composition, Live View can be a great boon. With it, you can easily arrange and adjust your camera position, subject, and lighting and see the resulting shot on the LCD screen. If the camera is mounted at a difficult angle, this can be much easier than trying to see through the viewfinder.

Macro shooting Shooting up close often requires you to hold the camera in strange positions—way down low or squeezed into tight, difficult-to-access locations. With Live View, you can line up your shot while keeping an eye on the LCD screen to see exactly what your final composition will be.

Concert and event shooting When shooting a crowded concert or event, it's often hard to get a good vantage point since crowded events tend to be full of people. With Live View, you can hold the camera over your head and see your framing on the camera's rear LCD screen.

Shooting from within this crowd with Live View was easy, because I was able to hold the camera at arms length, over my head, and frame the shot on the LCD.

Activating Live View

You can activate Live View at any time by pressing the 🔲 button on the back of the camera. You'll hear a clunk as the mirror flips up, and then the viewfinder will light up with your current scene. (Note that Live View will work in any mode.)

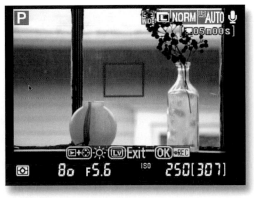

The default Live View screen.

The camera shows a fair amount of status information, including all of the status you normally see in the viewfinder, as well as shooting mode, autofocus mode, white balance, image size, and quality. There are some additional readouts for shooting movies. I'll cover those later in this chapter.

You can change the information that's shown in the display by pressing the **Info** button on the back of the D90.

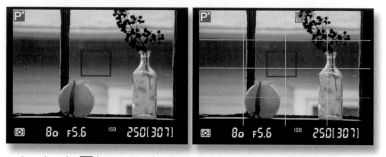

*Pressing the **Info** button toggles through other Live View display options.*

As with normal shooting, a half-press of the shutter button will autofocus, meter your scene, and then beep when it's ready to shoot. You can then press the shutter down the rest of the way to take the picture. The results will be shown onscreen, as normal.

Focusing in Live View

Three focusing modes are available when working in Live View:

Face Priority attempts to detect and focus on any faces in your scene. Simply press the shutter button halfway, and the camera will detect faces and focus. Faces must be facing the camera and need to be somewhat large in the frame. For shooting portraits, face detection is an ideal choice for focusing.

Wide Area is well-suited to landscape shooting. It assesses a fairly wide area in the image, as delineated by the red box that appears on the display. You can move this box around using the four arrow buttons. Place the box on the area you want to be in focus, and then half-press the shutter button.

Normal Area is just like Wide Area but analyzes a smaller portion of the screen. If you want to ensure that a specific, smaller detail is in focus, use Normal Area instead of Wide Area, and place the focusing box on the detail that you want to use as your focus target.

To change focusing modes, press and hold the **AF** button while turning the Main dial. The focusing mode icon at the top of the screen will change.

In Live View mode, you can choose from Face Priority, Wide Area, or Normal Area focusing. The focus mode you've selected is shown at the top of the screen.

While focusing, the box will flash green. When it turns into a solid green box and the camera beeps, then focus has been achieved, and you can take the shot.

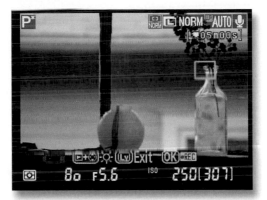

To focus on the flower vase, I used the arrow buttons to move the focusing target to the area I wanted in focus and then half-pressed the shutter button. When the camera achieved focus, the red focusing box turned green.

Note that focusing in Live View is much slower than normal. This is because the camera had to use its imaging sensor and internal processor to calculate focus, rather than dedicated focus sensors and electronics. However, for the types of shots that you tend to use Live View for, this slower performance shouldn't prove to be too much of a hindrance.

Manual Focus

For speedier focusing, you might want to use manual focus. Use the autofocus/ manual switch on the lens or body, just as you normally would, and turn the lens focusing ring to focus. Manual focus is a little trickier in Live View simply because it can be hard to judge focus on the LCD screen.

To aid in focusing, you can use the ⊕ button to enlarge the view on the viewfinder. This can make it easier to determine when you have achieved focus. Note that you can use this feature even when autofocusing.

Manual focus is easier if you zoom in to a detail that you would like to focus on.

Once you've focused, if your subject does not move toward or away from the camera, then you can simply keep shooting. For these situations, manual focus is the fastest way to work with Live View.

WARNING: Live View Caveats

There are a few details to understand about Live View. First, you can't leave the camera in Live View mode for more than an hour. If you're working on a tripod and setting up shots—for a product shoot, for example—then you'll want to turn off Live View when not working with the camera. The LCD screen on the D90 generates a fair amount of heat, and excess heat can make your images noisier, so it's worth it to turn the LCD screen off when unnecessary.

- You can change the brightness of the viewfinder during Live View by pressing the Playback button and then using the up and down arrows to brighten and darken the screen. To return to Live View, press the Playback button again.

- When shooting into bright lights, you might see strange smears and flares on the screen. Don't worry about these; they will rarely show up in your image. Just to be sure, pay close attention when reviewing your images.

- Both exposure compensation and exposure lock (which you'll learn about shortly) can be used in Live View mode.

For more details on Live View, consult pages 43–47 of the manual.

What You Don't See in Live View

Although Live View is very handy for the circumstances mentioned earlier, there's one thing to bear in mind when using an LCD screen as a viewfinder. As I've discussed, your eyes can see a much wider range of tones than your camera can capture, and good photography is often about how you choose to represent these different tones. When you look through a normal viewfinder, you can see the whole scene, just as your eye really sees it.

With Live View, though, your view of the scene is inherently limited to the dynamic range of the camera. For the image shown in Live View, the D90 will try to preserve the highlights so that they don't blow out to complete white. This usually means that shadow areas in your image will go very dark and show very little detail.

Also, bear in mind that Live View is more like a video camera than a still camera. The D90 must keep 30 frames per second delivered to the screen, which means it's not possible for it to take long exposure shots that might reveal brighter shadows. So, although your image may have a very different exposure than what you see in Live View, the camera will have time to do a longer exposure when it actually shoots the shot (of course, this is also true when looking through the normal viewfinder).

Live View's limited dynamic range can make composition a little trickier because some compositional elements that you see with your eye may be obscured in Live View. With practice, you can learn to work around this, and at first you may not even notice it, simply because you don't miss what you can't see. But ultimately, composing with a real viewfinder almost always allows a better view of your scene—and therefore more creative options—than a view on an LCD viewfinder. This is not a deficiency of the D90; you'll find this problem in any camera that uses an LCD screen as a viewfinder.

Shooting Panoramas

No matter how wide your lens might go, there will still be times when you face a vista that just can't be captured in one frame. In the old days, your only choice would have been to shoot a series of images and layer them together to create a collage.

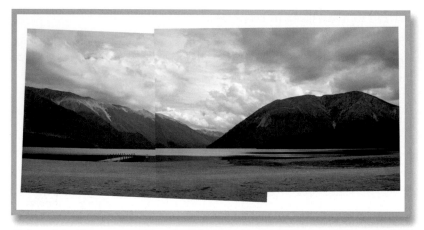

Before digital image processing, the only way to create a photographic panorama from multiple shots was to make a collage.

Nothing is wrong with this technique, and it can actually be quite evocative, but thanks to digital image processing, you have another option. Now you can take those same images, and, rather than layering them together as a collage, you can digitally merge them into a single seamless image.

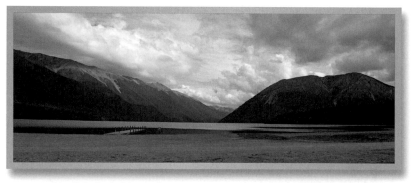

With digital stitching software, you can seamlessly merge individual images into a completed panorama.

Shooting this type of panoramic image requires a combination of shooting tech-nique and special software. You must shoot your images in a particular way to ensure that they contain the information you need to construct a good panorama and then use special *stitching* software to create the seamless merge. Your Nikon Software Suite Disk includes a panoramic stitching program called PhotoStitch.

Choosing a Focal Length for Panoramas

Making a successful panoramic shot begins by shooting usable images. A lot can go wrong when you're shooting a panorama, so you have to take care to shoot your source images carefully to ensure the best result.

First, you must choose a focal length. If you choose a shorter (wider-angle) focal length, then you won't need as many shots to cover the width of your panorama. However, as we've already seen, a shorter focal length will have a deep depth, which will render many objects in your scene very small. Also, a super-wide angle might confuse some stitching programs.

*This panorama was shot with a shorter, wider-angle focal length.
Although a wider angle lets you cover a wider area with fewer shots, it means the
distant objects will be smaller.*

If you choose a longer focal length, distant objects will appear larger, but you'll have to shoot more frames, which will increase your chances of making an error and ending up with unusable source material.

*This panorama was shot with a longer, more telephoto focal length.
It took more images to cover the scene, but objects in the foreground and
background are larger and more prominent.*

Consequently, your best option is to aim somewhere in the middle and choose a moderate focal length that reveals the details you want to see but is still wide enough that you don't have to shoot a lot of frames to cover your scene. Once you've selected a focal length, it's time to think about exposure.

Panoramic Exposure

From a panoramic photography standpoint, one of the things that's really annoying about the world is that it's not lit perfectly evenly. This problem is much more pronounced when shooting a panorama than when shooting a single frame.

If you look at most any panoramic scene in the real world, you'll probably find that one end is brighter than the other. The reason this is a drag for panoramic shooting is that the area that's brighter will expose differently than the area that's darker, and when you try to stitch your images together, you could very well end up with weird color bands in the sky.

This panorama was not evenly exposed. The vertical bands in the middle of the image are the result of the stitching program trying to reconcile the different exposures.

To compensate for this, you'll want to use the same exposure for all your shots. This will ensure that all the components of your panorama have the same overall brightness and tone and will stitch together smoothly. On the D90, this is easy to achieve, thanks to the auto exposure lock located on the back of the camera.

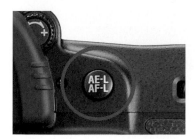

Use the AE-L button to ensure all your images use the same exposure.

Using Auto Exposure Lock

Try this: Point your camera in a predominantly bright direction, and half-press the shutter to take a meter reading. Note the shutter speed and aperture that are chosen. While holding the shutter button down, point the camera in a darker direction. You should see the exposure settings change. The camera has chosen different exposure settings, which makes sense since you're looking into an area that's darker. Now return to your initial bright scene—the camera will re-meter. Press the AE-L button. An AF-I icon should appear in the viewfinder status display to indicate that your exposure is now locked.

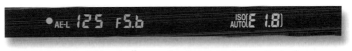

The AE-L icon indicates that exposure is now locked.

Now, no matter where you point the camera, that locked exposure will be used. (Obviously, the locked settings may not be ideal for your reframed shot, but the camera is doing what you asked—holding the exposure settings where you locked them, no matter what you're pointed at.) Thanks to exposure lock, it's possible to shoot a whole panorama of images, all with the same exposure.

If you let go of the AE-L button, the camera will re-meter for your current framing.

Choosing an Exposure

Although it's easy enough to use the AE-L button to lock your exposure across an entire panorama, you still have to choose *which* exposure to lock on to. Should you lock on the brighter end, which will cause the camera to stop down and use a fast shutter speed, thus possibly underexposing the darker end of the panorama? Or should you meter off the darker end and risk blowing out the bright side of the panorama? Obviously, the easiest way to balance these two problems is to split the difference and meter off some place in the middle. To do this, pick a mid-range point in your panorama, frame it with your chosen focal length, and press the shutter button halfway down to meter. Then press the exposure lock button to lock your exposure. Now you can swivel to the starting end of your panorama and start shooting.

Holding the AE-L button in while you pan the camera can be a difficult. If you prefer, you can take note of the final metering that you've chosen to use and dial it in to Manual mode. Now the camera will shoot with those settings until you alter them.

Shooting Panoramic Frames

In theory, shooting a panorama is very simple. You work from one side to the other, panning the camera and shooting frames that overlap by at least a third on each end. In practice, it's a bit trickier than this because, to get usable frames, you need to be sure that you're not tilting the camera when you turn to the next frame. Also, it's essential that you pan *the camera* and not your body.

Panning Tips

Personally, I find it easiest to work from left to right, and sometimes you might want or need to go the other direction. So, after you've assessed your exposure needs and locked exposure (if necessary), choose the end you want to start on, and frame your shot. After taking the shot, rotate the camera, and shoot the next frame. Again, aim for about one third of the frame to overlap the previous shot. To achieve this overlap, just pick something in the frame to use as a reference point.

Try to hold the camera level—parallel to the ground—as you rotate. Most importantly, though, be sure to rotate the camera! The camera needs to be rotated around its focal plane, but if you simply rotate at the waist, then you're rotating the camera around the middle of your head. This can cause troubles later when you try to stitch. So, instead of just pivoting your body, hold the camera where it is, and rotate it independently of your body. You may have to move your feet to rotate yourself around the camera while you do this.

It can take practice to get good at shooting straight, usable panoramas, so you'll want to shoot multiple tries to improve your chances of getting something useful. Also, before you start shooting, it's a good idea to rotate through the whole panorama to ensure that your focal length choice fits everything in the scene.

Also, panoramic shooting will get easier after you've stitched a few panoramas and seen the effects of different problems. So, it's a good idea to practice shooting at home, where you can stitch right away, before you head off to an exotic panoramic location.

TIP: Panoramic Tripod Heads

If you're really serious about panoramic shooting, then you might want to invest in a special panoramic tripod head. In addition to holding the camera level throughout its rotation, a panoramic head will provide ratcheted stops that ensure proper overlap. Check out *www.kaidan.com* for more info.

Stitching a Panorama

Once you've shot your panoramic frames, you'll be ready to stitch. You'll need to copy the panoramic frames to your computer using your method of choice. Then you'll need some panoramic stitching software. Photoshop and Photoshop Elements both include excellent stitching tools.

Low-Light Shooting

A lot of new shooters think that low light means shooting with the flash. And although the flash can often yield good pictures in low light, with your D90 you have far more low-light options, thanks to its excellent high ISO capability. You must use care when shooting in low light, but with a little practice you'll probably find that there's a whole world of subject matter that reveals itself when light levels dim.

When to Use Flash in Low Light

Your flash works well when you have a subject that's close to the camera and you want it lit up very brightly, using a light source positioned where you're standing. But flash photos can often look weird or even outright bad. If you're not careful with your exposure, then your subject can look harshly lit, while your background may not be lit at all. I'll discuss flash exposure in detail in the next chapter.

Another problem with flash shooting with the camera's built-in flash is that it washes out the natural light in your scene. Very often, when you're out at night, what might strike you about a particular scene are the unique colors that are created under street lights or other lighting sources that appear only at night.

Finally, many times shooting a flash is inappropriate or simply not allowed. Concerts and performances, art galleries, or any situation where you don't want to be intrusive all rule out flash shooting as a way to get a shot in a low-light situation. For all of these situations—and simply to have more tools in your creative arsenal—you'll want to learn about other low-light shooting techniques.

Shooting in Low Light at High ISO

You've seen how you can increase the D90's ISO setting to buy yourself more exposure latitude when choosing a shutter speed or aperture, but you'll most often increase ISO when you want to shoot in lower light. Very often, this won't be extreme dark but rather just a small change to compensate for lower light indoors. For example, if you move indoors in the late afternoon, even into a room with windows, you might need to increase your ISO to 200 or 400.

On the D90, you can easily shoot at up to ISO 400 without suffering a noticeable noise penalty in your final image. So, if you're shooting indoors and notice that your shutter speed is staying very low, crank up the ISO to 400 and see whether that improves things.

In extreme low light—outside at night, in a concert, or in a performance—you might need to go to a higher ISO, such as 800, 1600, or 3200. Although these settings will yield a little more noise in your image, it's an attractive noise that looks very much like film grain.

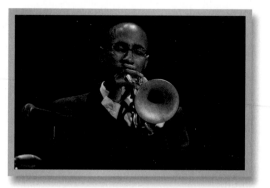

If you're shooting in very low light, you can increase the D90's ISO.

Depending on your final output, you may not even be able to see the noise. For example, if you're printing at 4 x 6, a lot of the noise will be sampled away as the image is downsized.

How do you know when to go to a higher ISO? If you can't get a shutter speed that's fast enough to shoot handheld in low light or fast enough to suit your creative goals, then increase the ISO to 800 or higher.

It's worth doing some tests on your own to determine whether the highest ISOs—1600 and higher—yield more noise than you like. It's better to determine which ISOs you find acceptable before you go shoot.

WARNING: Don't Forget to Change Back!

If you spend an evening shooting in low light at ISO 1600, be sure to set your ISO back to Auto or something less noisy like 200–400. Although shooting in bright daylight at ISO 1600 or higher won't hurt anything, your images will have slightly more noise, and your camera will bias toward faster shutter speeds.

As you may have already noticed, after you get to ISO 3200, the D90 offers some additional ISOs: H0.3, H0.7, and H1.0. These are third-stop ISO increments above ISO 3200. In other words, H1.0 is the equivalent of ISO 6400 (a doubling of ISO 3200, or a one-stop increase).

These ISOs can be used in a pinch, when you absolutely must have more light sensitivity, but you'll probably find them to be extremely noisy.

To help combat this noise, you'll find a High ISO NR option (or high ISO noise reduction) in the Shooting menu. This feature attempts to reduce noise in images shot at ISOs higher than 800. By default, it's set to Normal, a moderate level of noise reduction. You can change it to Low or High or turn it off completely. Why not leave it set to High all the time? Noise reduction can impact sharpness, so your goal is to find an acceptable balance of noise versus sharpness.

When noise reduction is turned off, the feature is applied only to images shot at ISO H 0.3 or higher.

Low-Light Techniques

Unfortunately, shooting in low light is a little more complicated than just choosing a high ISO and shooting away. Your main concern is to be aware of shutter speed. Remember the handheld shooting rule (shutter speed should never go below 1/*effective focal length*), and keep an eye on the shutter speed in the viewfinder status display. Note too that you can usually hear a slow shutter speed, if you're paying attention. If the "click" of the camera takes a bit longer than you're used to, you might want to check in and see what your shutter speed is set to.

Shooting with a Long Shutter Speed

Sometimes the light is so low that you have no choice but to use a slow shutter speed. Although this may not make for ideal shooting, a slow shutter speed image is usually better than getting no image at all. When shooting at longer shutter speeds, remember the following:

- You'll want to take extra pains to shoot a stable shot. Remember your posture, find something to lean on, find a place to set the camera, or carry a tripod.

- Remember that although you might do a great job of holding still, if your subject is moving, it might come out blurry.

Sometimes, intentionally blurring your subject can be evocative, but if you're trying to document an event, such as a dance performance, then long shutter speeds won't be appropriate.

If you're shooting a landscape or other nonmoving subject, then you can choose an extremely long shutter speed. The D90 lets you select up to 30 seconds for a shutter speed, or you can use Bulb mode to keep the shutter open for as long as you want.

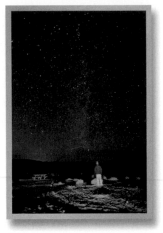

Using Bulb mode, I was able to shoot this extremely low-light shot.

For this image, I used a 90-second exposure. Obviously, the camera must be mounted on a tripod when you're shooting such a long exposure. Bulb mode was required to get the long exposure, and because I didn't want to stand there with my finger on the shutter (both because it's uncomfortable and because it risks introducing camera shake), I used a remote control to trip the shutter. Nikon makes both wired and wireless remote controls that are ideal for this type of shooting.

Long Exposure Noise

When you shoot with very long exposures, you run the risk of introducing an additional type of noise to your images. When the shutter is left open for a long time, some pixels on the image sensor can get "stuck." These pixels will appear in your final image as bright white specks. Fortunately, the camera has a built-in mechanism for handling this situation.

In the Shooting menu is an item called Long Exp. NR, or long exposure noise reduction. By default, this feature is turned off. If you activate it, the camera will employ a special noise reduction technique any time you shoot an exposure longer than eight seconds.

The problem with long exposures is that pixels on the sensor can get "stuck" and end up registering light longer than they should. Long exposure noise reduction

works to eliminate these stuck pixels. However, when this feature is activated, there will be a pause after your exposure for the same duration as the exposure itself. So, for example, if you shoot a 30-second exposure with long exposure noise reduction turned on, then you'll have to wait an *additional* 30 seconds after the exposure before you can shoot again. The camera will flash "Job nr" on the control panel during this process.

> **WARNING: Beware of Heat**
>
> Noise levels in your high ISO images will increase as the camera gets warmer. It takes a fair amount of heat to create a noticeable change in noise, and the most significant source of heat is usually the camera itself. Try to avoid Live View and extensive use of the LCD screen when shooting high ISO images, because the LCD screen can heat up the camera significantly. Also, *don't* try to cool the camera by putting it in a refrigerator. The sudden change in temperature can damage internal components.

Aperture Control for Low-Light Conditions

Low-light shooting almost always precludes any kind of aperture control, because the only way to get a shot at all is to have the lens wide open. So, don't expect to shoot a lot of deep depth of field shots unless you have a tripod and are shooting a nonmoving subject. In these instances, you can stop the lens down and shoot a very long exposure.

Shooting Sports or Stage Performances

Although sporting events are often held at night and stage performances are often in dark auditoriums, these events are not necessarily "low-light" events. A football field, for example, is usually well lit. However, even with all the floodlighting, you still probably won't be able to get away with shooting at ISO 200 or even 400. Also, for a sporting event you'll probably want some motion-stopping power in your exposure and so will be using a longer shutter speed. This means you'll most likely be shooting at ISO 800 and up.

The D90's Sports shooting mode is very good, but if you want more power, you'll want to switch to Shutter Priority, crank the ISO up, and set a shutter speed that's fast enough to freeze the action. Ideally, you'll have a long telephoto lens with image stabilization. Good sports shots are often the result of anticipation. If you know when the big play is about to transpire and know who the key players are,

then you'll want to get focused on them early so that you can get the shot when the action unfolds. To improve your chances of getting the precise moment of interest, switch the release mode to Continuous Servo.

Press the shutter button just before you think the key moment will transpire and burst through. Remember, the camera's shooting buffer can fill up if you shoot for a long time, so try to keep the length of your bursts low.

If you're shooting in an auditorium, your lighting challenge will be a little more difficult, because a stage usually alternates between very bright areas and very dark areas. As with sports shooting, your main concern will be to try to freeze action, so set the camera to a high ISO, use Shutter Priority, and choose a shutter speed that's fast enough to freeze motion—at least a 30th of a second for normal speed motions, faster if performers are moving quickly. In extreme low light, this shutter speed may result in your images being severely underexposed. Don't worry about this, because you can always brighten the images later using an image editor. This will result in noisier pictures, but the only alternative is to shoot with a longer shutter speed and risk blurring motion.

Both of these situations are well-served by a "fast" lens, meaning a lens with an aperture that can open extremely wide. An f2.0 telephoto, or a super-fast prime such as the Nikon 50mm 1.4 or 1.8, makes an ideal low-light event lens.

Low-Light White Balance

Low-light situations can play havoc with color, both in your eyes and in your camera. Your eyes, of course, see very limited color in low light. As the light dims, the color receptors in your eyes cease working, and your vision shifts over to black and white only. Although your vision won't actually look like a black-and-white photo, you will have markedly lower color sensitivity than you would in brighter light. Color reproduction is difficult for your camera in low light because low-light situations are usually lit by an odd assortment of lighting types (for instance, the intentionally colored lights in a stage performance), the combination of which plays havoc with your camera's white balance.

If you're shooting in JPEG mode, the best thing to do is carry a white card and manually white balance. If this isn't possible, then plan on having images that will have a very reddish-orange cast. This is not necessarily a bad thing, because it's close to how our eyes see in low light. Your best white balance choice when shooting in low light is to shoot in raw format, which you'll learn about in Chapter 11.

Another option is to consider converting your low-light images to grayscale. Since low-light shooting is largely about luminance, rather than color, black-and-white photography is well-suited to low-light subject matter. As you're out shooting, try to visualize your scenes as grayscale scenes. You can convert your images to grayscale later or switch to the Monochrome picture style you learned about in Chapter 7.

Shooting Video

Although your D90 is an excellent still camera, it's also a very capable video camera.

To shoot video with the D90, follow these steps:

1. Activate Live View by pressing the ⬜ button.

2. Frame your shot and focus, just as you normally do when using Live View. The D90 displays the amount of time available for shooting in the upper-right corner of the display.

3. Press the OK button to start recording video. Just to the left of the Flash button are three small holes on the front of the camera. This is the camera's microphone. Be very careful not to cover it up while shooting. While recording, a record icon will flash on the top of the screen, and the remaining time display will count down.

4. Press OK again to stop recording.

The D90 offers three different movie frame sizes, and you can pick the size you want from the Movie Settings screen in the Shooting menu. Navigate to Movie Settings, highlight Quality, and click OK. You'll be presented with three options.

The default setting is 1280 x 720, which has a 16:9 aspect ratio. This is the same aspect ratio as a high-definition television. In this mode, the maximum length of a single movie is five minutes.

The other two choices offer a 3:2 aspect ratio, which is the same as what the camera uses for stills. The 640 x 424 option is a good choice for any video that you want to display on a standard-definition television, while 320 x 216 is a good choice for videos you'll post to the Web. When shooting either 640 x 424 or 320 x 216 video, the maximum length of a single movie is 20 minutes. Note, however, that maximum movie time is also dependent on the write speed of the media card that you're using. For best video results, you'll want to use a speedy memory card.

If you're used to shooting video with a point-and-shoot camera, it's important to remember that the D90 does *not* autofocus when you reframe. So, if you are panning with the camera to follow a subject and that subject is getting farther away, then they will fall out of focus. As long as your subject remains at the same distance they were at when you focused, then they should remain sharp, even if you zoom.

Note, too, that you can lock exposure using the AE-L button, just as you can when shooting stills. This can help ensure that the exposure doesn't suddenly brighten or darken as you pan the camera around.

In general, shooting video with the D90 requires a little more planning than when shooting with a point-and-shoot. You can't just start the recorder and leave it, because of the movie length limitation, and you can't count on everything remaining in focus. Finally, as with shooting stills in Live View, if the viewfinder is on for an hour, it will shut down automatically to keep the camera from overheating.

Shooting Multiple Exposures

With a film camera, it's possible to expose the same frame of film more than once. In the old days, this often happened by accident, if the film advance mechanism in the camera failed to roll the film to the next unexposed frame. But film shooters often created multiple exposures on purpose, because it provided an easy way to create dreamy, composite images.

You can create multiple exposures with the D90 by going to the Shooting menu and choosing Multiple Exposure.

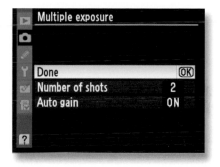

From the Multiple Exposure screen you can choose the number of shots you'd like to include in the multiple exposure. Each of these shots will be superimposed on the other.

The Auto Gain control tells the D90 to automatically adjust the exposure of each successive shot to keep the entire image from blowing out to complete white. It's usually best to turn Auto Gain on, but you might want to experiment to find an effect you like.

Although multiple exposures can be a nice effect, it's often better to shoot the frames normally and composite them later in an image-editing program, which will provide far more control over the blending of the images.

Flash Shooting

USING A FLASH AND OTHER TOOLS FOR BETTER
CONTROL OF THE LIGHTING IN YOUR SCENE

Using a flash is not hard, but it *is* something that sometimes requires a little bit of extra thought and planning. In fact, one of the most important things to learn about your camera's flash is when *not* to use it. You've already learned some low-light shooting tricks that provide you with additional strategies for shooting in dark situations, but sometimes you simply need more illumination to get a good shot. The D90 has a capable built-in flash, as well as support for Nikon's entire line of external flashes. In this chapter we'll look at both built-in and external flash use, as well as some additional ways that you can control light, whether or not you choose to use a flash.

Controlling Existing Light

Before getting into a full discussion of flash shooting, let's look at some simple non-flash-related strategies you can employ to control the light in your scene.

In Chapter 7, you learned about fill flash, and you saw how you can use the D90's built-in flash to fill in some of the more shadowy areas in your scene to create a more even exposure. Although the flash can work well for this situation and is definitely easy to carry, sometimes a better alternative is to use a reflector.

Consider this image:

The lighting in this image, direct sunlight, is pretty harsh and contrasty.

The direct sunlight is so bright that it's causing deep shadows under her eyes, cheekbones, chin, and hair. In general, the image has too much contrast. You could use a fill flash to even out the exposure a little bit, but then you'd run the risk of the image looking a little flat. If you have the time, gear, and personnel to pull it off, you can choose a different solution. Using a diffuser, a piece of sheer white fabric, you can diffuse the sunlight to create a much softer look.

The diffuser serves the same function as a cloud. It diffuses the sunlight so that it's not as harsh, and the result is an image with lighter shadows and highlights that are not as small and bright.

*Here, a diffuser is placed between the light source
(in this case, the sun) and the subject.*

*With the diffuser in place, you get a much gentler light that softens the shadows
under the eyes, chin, and hair.*

Although this image is much better, I can still do more. The shadows under the eyes and chin are still a little prominent, so I'll use a reflector to bounce some light up into them, rather like a fill flash would.

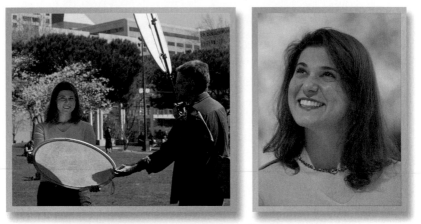

Here I'm using a diffuser to cut the intensity of the sunlight and a reflector to add some fill light back onto the subject.

Using a reflector like this is not difficult. Just try to put it at a 45° angle to the light source—in this case, the sun. You'll be able to see the difference in person as you move the reflector around. Just watch the shadows, and when you see them lighten, you know you've positioned the reflector properly. Expose and shoot normally.

If you don't have a friend to help hold the reflector, then you can use a tripod and a remote control to trigger the shutter, or you can use the self-timer. You'll need to get in place quickly, so you'll probably want to experiment with the reflector position before you take the shot.

You can use any large piece of reflective material. Although a large piece of white cardboard or foamcore isn't the easiest thing in the world to carry, any photo store will carry collapsible reflectors that fold into a small circle, usually about a foot in diameter. These can pack easily into a backpack or suitcase. What's more, these reflectors come in different colors, from white to silver to gold, allowing you to get more or less *reflectance*, or reflected light that has a color tint to it.

As mentioned earlier, you can sometimes use your camera's flash to get the fill, instead of the reflector. However, if you're standing farther away from your

subject—perhaps so as to use a more flattering focal length—your flash might be out of range, especially on a very bright day. Because a reflector is close to your subject, it might actually provide more illumination than your flash can.

Using the D90's On-Camera Flash

In Chapter 7, you saw how you can use the on-camera flash to even out an exposure by brightening a dark subject when your background is too bright. You've also seen how you can use fill flash to even out darker shadows in a scene.

But there will be times when you're in a dimly lit room and simply need some extra light. In these snapshot-type situations, the D90's on-board flash can do a good job of illuminating your scene, but you might need to take a little more control to get a good shot.

Flash Exposure

When you half press the shutter button while the flash is popped up, the D90 calculates an exposure, just as it does when the flash is down. However, with the flash up, it bases its exposure on its understanding of how much light the flash will be able to add to the scene. The camera will never pick a shutter speed slower than 60 to ensure handheld shooting. It will also never pick a shutter speed faster than 200, because it's not possible for the entire sensor to be exposed to the flash if the shutter speed exceeds 200.

When you take a shot after metering, the camera will turn the flash on. When it sees that enough light has been added to the scene to properly expose it at the current settings, it then turns the flash off. In other words, although it might appear that the flash is always just a quick flash of light, the D90 is actually carefully monitoring the situation and firing the flash for longer or shorter periods of time.

> **WARNING:** Waiting for Recharge
>
> Before the flash can fire, it must charge up, a process that is usually very speedy. As your battery weakens, though, flash recycle time can worsen. The D90 will display a busy indicator in the viewfinder while the flash is charging. When the busy indicator is displayed, you'll still be able to shoot, but the flash will not fire.

Flash with Priority and Manual Modes

If you're using the flash in Shutter Priority mode, then the camera will not let you select a shutter speed faster than 1/200th. As always, it will automatically calculate an aperture that's appropriate for your speed.

In Aperture Priority mode, no matter what aperture you pick, the camera will never choose a shutter speed faster than 1/200th.

In both modes, though, you can have shutter speeds that are much slower than 1/60th. This allows you to achieve the same slow-sync shutter effect that the Night Portrait scene mode creates (you learned about this mode in Chapter 1). *Slow-sync shutter* means the camera combines a flash shot with a long exposure to create a scene that has good exposure in both the foreground and the background.

If you haven't read the "Understand Flash Range" section in Chapter 1, you should do so now.

Although the Night Portrait mode is an easy and effective way to get slow-sync effects, if you're shooting raw or want more white balance or ISO control, then you'll need to use Aperture Priority or Shutter Priority mode.

> **REMINDER:** Tell Your Subject Not to Move
>
> As with Night Portrait mode, when you shoot using a slow-sync shutter, it's important to tell your subjects not to move until you say it's okay. Most people will move as soon as the flash fires, but if the camera is set for a very long exposure, this can create blur.

In Manual mode you can select any combination of shutter speed and aperture, but as you would expect, you can't choose a shutter speed faster than 1/200th of a second. As always in Manual mode, if you dial in exposure settings that would result in an over- or underexposure, the camera will warn you by flashing the exposure compensation display to indicate the amount of exposure error.

Flash Exposure Compensation

In addition to changing the shutter speed and aperture settings as you normally would, you can also tell the camera to add more or less flash to your scene. For example, consider the flash exposure compensation image at the top of the next page.

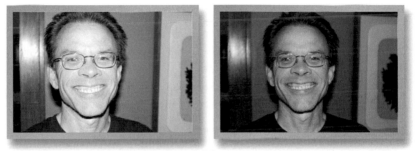

The flash in our left exposure is too bright, but we can dial it back using flash exposure compensation to produce the right image.

The flash has added a lot of brightness to the scene, but in the process, the subject has overblown highlights on him that make him look too harshly exposed. By using *flash compensation*, you can tell the camera to use less flash so that more of the natural light in our scene is used and the harsh highlights are reduced. I shot the image on the right using a flash compensation of -1 stop.

To control flash compensation, press and hold the ⚡ button, and turn the subcommand dial. You specify flash exposure compensation in stops, just like you do normal exposure compensation, and the D90 offers a flash compensation range of -3 stops to +1 stop. Flash compensation settings are shown both in the viewfinder and on the control panel.

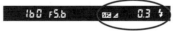

Flash compensation is displayed on the right side of the viewfinder. Here, you can see a flash compensation setting of +.3 stop.

I didn't know ahead of time that one stop would be correct, but because you can review your image and histogram as soon as you take the shot, it's easy to find the right exposure. So, if you go into a situation like a party in a dark room and plan on shooting flash, you might want to try a few tests right away to determine a proper flash exposure. Then you can shoot with those settings as long as the lighting doesn't change significantly.

> **TIP :** Don't Forget the Histogram
>
> Because the D90's LCD screen isn't a perfectly accurate representation of exposure, it's important to check the histogram if you think there's a chance of overexposure. If you see a white spike on the right side of the histogram, then you'll need to adjust your flash exposure compensation and shoot again.

Improving Flash Range

Flash exposure compensation also lets you increase the amount of flash that gets added to a scene. However, this increase does not improve the range of your flash. Remember, all your camera can do is control how long the flash is on, but just as a desk lamp doesn't light up a bigger area if you leave it on for longer, your D90's flash doesn't get a longer reach with an increased exposure setting.

However, you can effectively improve the range of the flash by increasing the camera's ISO. Light intensity falls off as it travels farther from its source, and when the camera's image sensor is dialed up to a higher level of light sensitivity, it will be able to pick up the fainter levels of light that have traveled farther away. Page 266 of the D90 manual provides a chart that gives you an idea of how much of a range increase you can expect at different focal lengths.

Red-Eye Reduction

If you've spent a lot of time shooting flash snapshots with a point-and-shoot camera, then you've probably seen *red-eye*, that creepy phenomenon that causes your subject's eyes to glow red. The red glow is nothing more than the reflection of the flash's light off the back of the subject's irises. (Dogs' eyes, by comparison, reflect blue light.) Although image-editing tools can remove this effect, it's often better to try to solve the problem while shooting to save editing time later.

The closer the flash is to the lens of a camera, the more likely it is that you'll get red-eye, because the light from the flash can bounce straight off of your subject's eyes and back into the camera. Because the D90 has a flash that sits a ways from the lens, the chance of red-eye is far less than it is with a point-and-shoot. However, it still can happen, which is why the D90 has a built-in red-eye reduction feature that can very effectively eliminate the effect.

To activate red-eye reduction, press and hold the 🔲 button while turning the Main dial until the flash display on the control panel shows the red-eye setting.

The control panel shows the current flash mode. Here, I've selected red-eye reduction.

When red-eye reduction is activated, every time you half-press the shutter, the camera will activate the red-eye reduction lamp, the one that flashes when you use the self-timer. The idea is that the lamp will cause the irises in your subject's eyes to close down, thus reducing the chance of red-eye. For this to work, you must be certain that your fingers don't block the lamp.

Obviously, the lamp can be a bit distracting and in some venues might be very inappropriate, so you'll most likely want to turn the feature off when you're not using it.

WARNING: Don't Shoot Too Close with the Flash

Even if you dial flash exposure compensation down two stops, the flash will still put out a good amount of light. When shooting with the flash, it's best to stay at least 3 to 4 feet from your subject. Any closer can severely overexpose them.

Using an External Flash

On the top of the camera sits a *hotshoe*, a fairly standard camera interface that allows you to use a number of different accessories. It's called a hotshoe because it's an interface that provides electrical contacts through which the camera can communicate with an attached accessory (as opposed to a coldshoe, which has the same type of mount but provides no communication between the camera body and whatever is in the shoe).

You can attach an external flash to the hotshoe on the top of the camera.

You can use the hotshoe to attach special wireless or wired remotes, levels (for ensuring your camera isn't tilted), umbrellas to keep your camera dry, and

other specialized accessories. But hotshoes are most commonly used for external flash units.

Even though the D90 has a built-in flash, there are a number of reasons to use an external flash. They're more powerful, so they can cover a longer range and offer more latitude for exposure adjustment. Flash units all provide a specification called a *guide number* that indicates how powerful the flash unit is. For example, on page 270 of the D90's manual, you'll find a listing for Guide Number: 17/56 (ISO 200, in meters/feet). This number represents a constant that you can use to determine the range of the flash at a given aperture. For example, a guide number of 43 indicates that the flash can fully illuminate an object roughly 10 feet away when shooting at f4. (Ten feet multiplied by 4 is 40.)

These numbers used to be important for calculating manual exposures and for figuring out how to expose when using multiple flashes. If that last paragraph didn't make sense to you, don't worry; you really don't need to keep track of this stuff anymore, because the camera and flash will do it all for you.

Nikon sells seven different flash units that are compatible with the D90. The SB-800 offers a guide number of 184, so if you're willing to spend the money (and carry an extra component), you can pack a lot of illumination power into your camera bag.

Having the extra power doesn't just mean you can light up a subject farther away. With a larger flash, you'll be able to fill a larger area with more light.

External flashes also offer the advantage of being able to *slave* multiple units together. With multiple flashes, you can create complex lighting solutions. You've seen how you can use a fill flash to improve images shot under direct sunlight. With multiple flashes you're in control of several light sources, allowing for a tremendous amount of lighting creativity. The use of multiple flashes is far beyond the scope of this book and something that most shooters don't need.

However, external flashes also give you the option to tilt and bounce the flash, rather than aiming directly at your subject. This is probably the greatest advantage of an external flash, and when combined with the stronger power of these units, the tilt/swivel capability allows you to create very natural-looking lighting.

One of the biggest problems with flash pictures is that the flash is always located in the same location as your camera. In other words, the main source of illumination for your subject is located just a little above your head. This is very rarely how real-world light sources work, so flash pictures always look like, well, flash pictures.

In the real world, we're used to light coming from overhead, and we're also used to those light sources being larger than a single bulb the size of the D90's flash head. Lighting that shines onto the front of a person, from a very small source, simply doesn't look natural to us.

Bouncing a Flash

When I speak of *bouncing* a flash or a light source, it's easy to think of that bouncing as being billiard-ball-like, or like bouncing a laser off a bunch of mirrors. With this analogy, then you might think you have to worry about lining up the flash just right so that the light bounces in a way that will strike your subject. Fortunately, this isn't the case.

The flash on your D90, or an external flash unit, emits light in a conical pattern. So, as the light travels farther away, it spreads out. If you point the light at the ceiling to use it as a big reflector, then by the time the light hits the ceiling, it will be fairly widely dispersed. The ceiling will reflect that light back down and create a light that's much more natural-looking, both because it will be coming from overhead and because it will be very diffuse, rather than the point light that your flash produces if you aim it directly at a subject.

Consequently, when you think about lighting, you shouldn't just think of the source; you should think about the path of the light. If light is shining from a source directly onto your subject, then, yes, the light source is your source of illumination. But if the light is bouncing off something else, say, a reflector, then the reflector is your light source. This is an important distinction, because a reflector can change the characteristics of a light. It can alter its color or make it more diffuse.

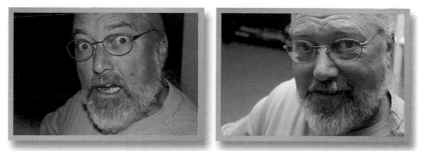

In the left image, we used the D90's built-in flash. In the right image, we used an external flash pointed at the ceiling. Note that the bounced flash lights up a larger area including the background, is more diffuse (there are no bright highlights on his face), and creates a very natural-looking, overhead light.

With a Nikon Speedlight like the SB-800, you simply tilt the flash head up. The flash calculates the appropriate exposure for a good bounce and is usually very accurate in its calculations.

If you're dealing with an especially high ceiling, then you may want to tilt the flash forward a little so that the bounce goes directly over your subject.

Just as you can use flash compensation to increase or decrease the amount of flash power in the built-in flash, when an external flash is connected, this same control will increase or decrease the output of the external unit.

As with the internal flash, check the camera's histogram to ensure you have a good exposure. If you see an overexposure, adjust flash exposure compensation and shoot again.

CHAPTER 11

Raw Shooting

USING RAW FORMAT TO GAIN MORE CONTROL
AND BETTER IMAGE QUALITY

Although the Nikon D90 produces excellent JPEG images, if you do a lot of image editing, want the absolute best color you can manage, or tend to shoot in extreme lighting situations that make exposure and white balance tricky, then you'll want to look at raw shooting. Shooting raw has its drawbacks, but by the end of this chapter, shooting in raw will probably become a regular part of your photographic life. In fact, don't be surprised if you eschew JPEG shooting altogether.

What Is Raw?

In Chapter 7, you saw how, with JPEGs, the camera takes the data off the image sensor and performs a number of processes to it, from white balance adjustment to gamma correction to a number of corrections and adjustments similar to what you might apply in an image editor. You also learned that one of the last things the camera does before saving a JPEG image is to throw out a lot of color data so that the 12-bit image that the camera captured can be stored in the 8-bit space that the JPEG format specification dictates. Earlier, I also told you about JPEG compression and how it is a lossy compression scheme that can, when used aggressively, degrade your image.

Although the D90's high-quality JPEG compression is very good—you'll be hard-pressed to find evidence of JPEG compression in a D90 file saved at high quality—if you later perform a few edits in your image editor and save the file *again* as a JPEG, then you might start seeing some blocky patterns. Similarly, though the camera has to toss out 6 bits of data per pixel when it saves to JPEG, you won't necessarily notice a lack of color in the JPEG files saved by the camera. However, once you start editing and begin to brighten or darken areas, you might notice that gradient areas of your image (skies or reflections on a curved surface, for example) start to look chunky as you push your edits further. This is a result of the camera having to jettison some of its color data to save the file as a JPEG.

When you shoot in raw format, the camera skips all these image-processing steps—including the bit depth conversion and JPEG compression. Instead, the raw data that is captured by the image sensor is read and saved. No demosaicing or color conversion is performed. The data is saved, and *all* the processing that the camera would normally perform is skipped entirely. Instead, you will later use special software on your computer to perform the calculations that are necessary to turn the raw data into a usable image.

T I P : Picture Controls and Raw Files

If you're using a picture control, it's noted in the raw file, but picture controls affect the raw conversion of your image only if you use Nikon's Capture NX software. Other raw converters ignore these picture styles. So, if you're shooting raw and *not* using Capture NX, there's no reason to use picture styles, unless you're shooting Raw + JPEG, in which case the JPEG images will receive the picture style effects. Note, though, that the image review shown on the camera's LCD after you shoot *will* show the effects of the picture control. Adobe Camera Raw 5.2 ships with profiles that mimic Nikon's settings, but you'll need to activate these by hand. Camera Raw will not automatically detect that you were shooting with a particular profile.

Why Use Raw?

Using raw has many advantages, and I've already mentioned two important ones—the full bit depth of your image is preserved, and there's no JPEG compression—but there are other reasons.

Changing White Balance

As I explained in the previous section, when you shoot raw, *all* white balance adjustment functions are deferred until later and performed on your computer. This means you can set the white balance to anything you want *after you've shot the image!* So, if you were shooting in an especially tricky white balance situation, you can simply perform the equivalent of a manual white balance while editing your image on your computer.

With a raw file, you can achieve radically different white balances after you shoot your image.

Highlight Recovery

Raw files also allow you to perform a seemingly magical type of edit. You've seen what happens to a JPEG image when you overexpose the highlights: They turn to complete white and lose all detail. No matter how you edit the image, that detail is gone, and those areas will remain white.

With a raw file, though, there's a good chance you'll be able to recover the lost detail in your overexposed highlights.

If recovering data from nothing seems impossible, know that an overexposed, white area is not necessarily devoid of data. You've already learned that a pixel is composed of separate red, green, and blue elements. Sometimes when you overexpose

an area in a scene, you don't overexpose all three color channels. Sometimes only one or two channels get clipped, while another channel is properly exposed.

In these instances, the raw conversion software you use on your computer can reconstruct the wrecked channels by analyzing the channel that's still intact and thus restore image data.

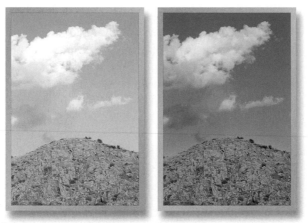

In the left image, notice that the bright parts of the clouds have been overexposed to complete white. If you were shooting JPEG, there'd be nothing you could do to repair this problem. Because the image is raw, though, you can recover the overexposed highlights to restore detail to those areas.

This means you can't recover *all* clipped highlights. Any highlight that is completely overexposed—that is, a highlight that has clipped all three channels—will be unrecoverable.

The ability to recover highlights doesn't mean you don't still need to be thoughtful about exposures, but it *does* give you a safety net for times when you—or your camera—choose an exposure that results in overexposed, blown-out highlights.

More Editing Latitude

Let's return for a moment to the 8-bit vs. 12-bit issue and take a closer look at the raw file's bit depth advantage over JPEG files. Simply put, shooting with raw is like having a box of 64 crayons, rather than a wimpy box of 16 crayons. Straight out of the camera, you won't see a difference between a 16-bit processed raw file and an 8-bit JPEG file. But once you start editing, you'll find that raw files offer a lot more flexibility.

Smooth gradients and transitions are a critical component of quality color. Although it's easy to think of the sky as simply "blue," the sky is a huge range of colors from dark blue up high to light blue near the horizon. Later in the day, you might see it go from blue to purple to red, all in a perfectly smooth gradient. Most objects and surfaces in the world have a similar variation in color because of multiple light sources, shadows, and reflections that strike the surface at various angles.

Smooth gradients are critical to an image like this, which has a sky that ranges from dark blue to orange. Gradients are also necessary to render the foggy portions. Chrome and reflections have similar requirements.

Because our visual world is composed largely of gradients and variations of colors, it's essential that your camera be able to produce a huge range of intermediate tones. For a gradient to appear realistic and smooth, you want it to be composed of as many colors as possible. Although an 8-bit JPEG file can render smooth gradients, when you begin to edit that file—brightening and darkening or changing colors—the smooth color transitions in your image may start to suffer.

Consider a staircase. If you need to build a staircase that rises 15 feet but you have only a small amount of wood, then you'll have to make very large steps to cover these 15 feet of rise. These steps will be strenuous to climb. But, if you need to build a staircase that rises 15 feet and you have an abundance of wood, then you can build refined steps that are the perfect height for most people's gait so that they're easily ascended. Gradients work the same way. If you have only a few colors to work with, it can be hard to build a gradient that looks smooth and natural.

JPEG images can create nice gradients, but once you start to edit them, things can quickly fall apart. For example, consider this nice smooth gradient that goes from dark gray to light gray:

A smooth gradient.

Let's say we wanted to expand the contrast in this gradient. That is, we want to darken the dark tones and lighten the light tones so that the gradient stretches from full black to bright white. The problem with such an edit is that your image-editing software can't make up new tones. Computers simply aren't smart enough to figure out intermediate tones in a situation like this. Instead, it has to take the existing tones and brighten them or darken them. The result looks like this:

Gradient with posterization.

See the ugly banding patterns? That's called *posterization*, and it happens any time you try to expand a range of tones without adding new intermediate tones. Every edit you make to an image "uses up" some of the editing latitude that's inherent in the file, because each edit—whether it's a change in brightness or a change in color—shifts some tones around and introduces the risk of posterization.

With a raw file, though, you're starting with so much more color data than what you have in a JPEG file that you have much more editing latitude. You can perform more edits and push them much further before you see any posterization artifacts. If you do a lot of adjustment and editing, this is a critical reason to use raw.

A True Digital Negative

The fact that raw processing takes place in the computer and not in the camera has certain advantages. First, you're in control of it, so you can tailor the processing exactly to your taste. For example, you can choose to recover highlights, render some areas brighter, or change the white balance. Second, your camera is designed to perform as quickly as possible. It can't sit around all day meticulously processing an image, because it needs to be sure it's ready to shoot the next picture when you ask it to do so. Consequently, the processing employed inside the camera uses slightly less sophisticated algorithms than what a desktop raw converter will use. This means you'll probably get better color out of your desktop raw converter than you will out of a JPEG file that's been processed by

the camera. It's a slim chance, because the JPEG quality in the D90 is very good, but for a tricky image it can be important.

Finally, the raw file is truly like a negative. It's simply raw data, and the final image that results from that data depends on the software you use to process it. Raw conversion software is improving all the time as imaging engineers discover new algorithms and refine old ones. This means that years from now you might be able to reprocess the same raw files in a newer raw converter and get better results. In the short term, this also means you can process the same image in different ways to get very different results. For example, you might process the image one way to produce a very warm result and another way to produce something much cooler. By processing the raw file in different ways, you can achieve very different adjustments without using up any of your image-editing latitude.

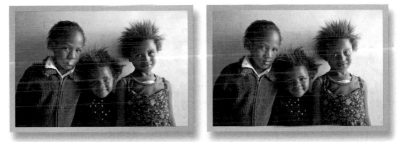

On the left is a fairly accurate representation of this scene; on the right is one that has been warmed up. Both were processed from the same raw file.

Easy Batch Processing

With a raw converter, it's easy to apply the same edits to multiple images. For example, if you come back from a shoot and find that the white balance is off on all your images and that they're all about half a stop underexposed, you can easily apply a white balance change and exposure adjustment to the entire batch at once. With JPEG files, you'd have to open each JPEG and apply the edits, being careful to save in a way that won't further degrade your image.

Raw Hassles (the Disadvantages)

I shoot exclusively raw on all the cameras that support raw format. But raw shooting does present some extra headaches that you won't find when shooting JPEG images. As software improves, these headaches are getting fewer and fewer, and it's easy enough to work around them. However, before you dive into the world of raw, you'll want to consider the following caveats.

Raw files take up more space Raw files are larger than JPEG files—sometimes a lot larger. JPEG compression is very effective at squeezing the size of an image. On the D90, you'll typically find that shooting in raw adds about 10 MB to the size of *every image* you shoot.

On the D90, you can fit about 137 high-quality JPEG files on a 1 GB card, but only about 67 raw files. (I say "about" because file size varies depending on the content of the file.) Obviously, this larger file size means you'll need more storage cards for your camera. But it also means you'll need more disk space for your postproduction work and more long-term storage for archiving—whether that's hard disks or recordable CDs and DVDs. Fortunately, storage of all kinds is cheap these days, so ramping up to a raw-worthy storage capacity is not too expensive.

Other people may not be able to read your files There's no standard for raw format images. Every camera maker uses a different raw format, and sometimes they even change formats from camera to camera. JPEGs are a standard, so it's easy to hand other people images straight out of your camera and know they'll be able to read them. With raw files, they'll need a raw converter that supports your camera.

Your software of choice may not support the D90 Because there's no standard for raw format, companies that make raw conversion software have to build custom raw profiles for every camera they want to support. When a new camera comes out, this often means you have to wait until your software of choice supports it.

Your workflow might be a little more complicated With JPEG files, you simply take the images out of the camera and look at them in any program that can read JPEGs. And there are a *lot* of programs that can read JPEGs. Your operating system probably shipped with a JPEG viewer, you can open them in any web browser, you can open them in almost any image-editing program, and your email program and cell phone can probably even read them!

With raw files, before you can even look at the file, you must pass it through a raw processor Windows Vista and the Mac OS both have raw converters built in to the operating system, which means you should at least be able to see a preview of the raw file (assuming you've installed an update that adds support for the Nikon D90), but if you want to edit or create a file that you can give to someone else, then you'll have to first run the images through a raw converter.

Although this may sound like a hassle, the process is actually not so bad, because raw-processing software has improved tremendously over the years. You may have to learn one or two more steps, but once you do, you'll probably find that shooting raw is no more difficult than shooting JPEG and is well worth the extra control.

Shooting Raw with the Nikon D90

Telling the D90 to shoot raw is very simple, you just select one of the raw options from the Quality menu that you saw in Chapter 6. After all the JPEG options, you'll find the raw options. Raw tells the camera to save a raw file, while Raw + Fine, Normal, and Basic tell the camera to save a raw file *and* a JPEG file. Why would you choose both? The advantage of Raw + JPEG is that when you get home, you have a JPEG file that you can use right away, without hassling with any raw processing. After you choose your raw format option of choice, you can start shooting normally.

> **TIP:** Raw + JPEG to Get Dual Advantages
>
> Some people, especially those on tight deadlines, shoot Raw + JPEG because they need to deliver only JPEG files to their client, and the D90 JPEGs are excellent quality. So, after a shoot, they can sort through their images, pull out the JPEG images they like, and send them on their way. If one of the files has a bad white balance or clipped highlight, then you have the raw file to use for correction. They can write out a better JPEG from the raw file and send that off. Shooting Raw + JPEG takes more space and slows the camera down. If you need to shoot sustained bursts, then Raw + JPEG is probably not a good idea, especially if you have a slower media card. If you're not ready to commit completely to raw, then Raw + JPEG is a good intermediate step.

Picture Controls, White Balance, and Raw

Picture controls and white balance are functions that are performed by the camera during the image-processing steps that happen after you take a shot. Because raw files have no processing applied to them, picture styles and white balance choice are less significant.

However, the white balance setting you choose is stored in the image's metadata. Later, your raw converter will read this setting and use it as the default white balance for that image. Because white balance in a raw file is completely editable

after you shoot, you're free to change it any way you want. When shooting raw, the white balance you set on the camera is simply a way to have a more convenient postproduction workflow. If you get white balance right in-camera, it will save you a couple of editing steps later. (This is as opposed to JPEG, where if you get white balance wrong, there's probably no way to correct it later.)

The picture control you choose is also embedded in the raw file. However, the only raw converter that reads this picture style data is Nikon's Capture NX, which is sold separately (a demo is included on the Nikon Software Suite Disk). If you're not going to use Capture NX for your raw conversions, then there's no need to use picture styles when shooting raw. If you're shooting Raw + JPEG, then the white balance and picture style choices you make are more critical, because they will be applied to the JPEG file that is saved alongside the raw file.

Processing Your Raw Files

When you're done shooting, copy your raw files to your computer using whatever technique you normally use for JPEGs. If you're using a version of Photoshop or Photoshop Elements, Lightroom, Aperture, or iPhoto, then you'll be able to work with your images just as if they were JPEGs. The browser functions built into these applications will be able to read the files (assuming they've been updated with D90 support) and display thumbnails. Lightroom, iPhoto, and Aperture let you use the same editing tools that you use for JPEG files when you edit a raw file. However, some of these tools, such as white balance, will have far more latitude when used on a raw file than they do on a JPEG. These editors will also provide additional tools when working with raw files, such as highlight recovery tools. Consult the documentation that came with your image editor to learn more about editing raw files.

T I P : Nikon's Capture NX

Nikon's Capture NX is another alternative for managing and editing your images. Capture NX offers raw processing for the D90, as well as incredibly sophisticated image-editing tools. With Capture NX, you can easily perform corrections and adjustments that are very difficult to manage in Photoshop or other image editors. Your camera might have shipped with a demo version of Capture NX. If it didn't, you can download one at *www.capturenx.com*. If you'd like to know more about Capture NX, check out my book *Real World Nikon Capture NX 2* (Peachpit Press, 2008).

Customizing the D90

CONFIGURING CUSTOM SETTINGS AND
ADDING LENSES AND ACCESSORIES

By this point, you should be very comfortable with the D90's interface and have a good idea of how to set and adjust a huge number of parameters. Nevertheless, everyone has different needs and different ways of thinking, so the D90 allows you to customize many of its features. And, of course, you can further refine the D90 as a photographic tool by adding different lenses. In this chapter, we'll look at a number of ways to customize and tweak your camera.

My Menu and Recent Settings

The D90 has dozens of features spread across its menus, but you'll probably regularly use only a few of them, and it can be a hassle to navigate to the exact feature you want. For this reason, the D90 provides a single customizable menu, called My Menu, that you can populate with only the commands you want. Depending on how many you use, you might be able to create a single My Menu page that contains all the functions you need.

The D90 also provides a Recent Settings menu that includes the 20 most-recently chosen settings. The Recent Settings tab sits below the Retouch tab.

The Recent Settings menu shows the last 20 items that you've used.

If you use only a few settings, they'll probably all end up on the Recent Settings menu and most likely won't change, so it might be that Recent Settings is the only menu you'll need to use, once you've had the camera for a while.

You can change the Recent Settings menu into a completely customizable menu by selecting Choose Tab from the very bottom of the Recent Settings menu. You'll be presented with a configuration screen that lets you change the Recent Settings menu into the My Menu custom menu.

You can change the Recent Settings menu into the fully customizable My Menu by selecting Choose Tab from the bottom of the Recent Settings menu.

Building My Menu

When you activate the My Menu page, it will immediately present an Add Items option, in addition to some other menu management commands.

Add Items lets you add commands to your custom menu.

Choose Add Items, and the camera will show a list of each of the camera's menus. Pick the menu that contains the command you want to add; then find the item itself, and click OK. You will next be prompted to choose a position for the newly added item. Use the up and down arrow buttons to position the item where you want it in the menu; then press OK.

I used My Menu to hold some menu commands that I frequently use. Now I won't have to dig through the normal menu structure to find them.

You can use the Remove Items and Rank Items commands in My Menu to delete items or to reorder items.

What should you include in My Menu? Active D-Lighting is a powerful setting, but I don't always want it active, because it can sometimes reduce contrast in a scene, so I like to keep it handy. If you use picture controls, then you'll want easy access to the Set Picture Control item. Rotate Tall lets you control how big

an image is displayed on the LCD screen. Sometimes you don't want the image rotated, so this can be a handy item. Although the camera cleans its sensor at power up and power down, there might be times when you need to activate it manually. You might also want to consider adding the noise reduction settings that you explored in the previous chapter.

Custom Settings

Alongside the other menus, the D90 provides a Custom Setting menu, which contains a number of options that allow you to fine-tune a huge number of camera characteristics. Earlier, you caught a brief glimpse of this menu when you changed the autofocus area mode setting.

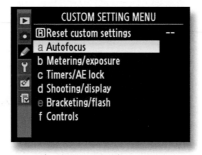

The Custom Setting menu.

The Custom Setting menu is divided into six categories. However, if you pick any category, you'll be taken to a scrolling list that includes all six categories. So, if you dive into the Autofocus section but it turns out that the setting you need is in Timers/AE Lock, that's okay, because if you simply continue to scroll, you'll eventually find the setting you want.

In this section, I'll look at a brief description of each function and explain why you might want to use it. With each description, I've also included a reference to the D90 user's manual.

Customizing Autofocus Settings

The Autofocus settings include a number of parameters that you can use to tweak and adjust the autofocus mechanism on the camera.

AF-Area Mode You've already seen this menu and so should understand that it lets you change how the camera selects a focus point when autofocusing. See pages 173–174 of the D90 manual for more details.

Center Focus Point This allows you to change the size of the center focus point. The normal, default setting is well-suited to most situations. The Wide Zone option is good for quickly moving objects that can be hard to get a bead on when focusing. See page 174 of the D90 manual for more details.

Built-in AF-Assist Illuminator As you know, if the D90 has trouble focusing, it will light up the autofocus assist lamp that's located to the left of the hand grip. If you're shooting in a situation where this might not be appropriate—a performance, museum, or very dark location—then you can turn this feature off. See page 174 of the D90 manual for more details.

AF Point Illumination Normally, when you autofocus, the selected focus point lights up in red for a moment, after the camera locks focus. If you choose, you can deactivate this feature. See page 175 of the D90 manual for more details.

Focus Point Wrap-Around By default, when you're manually selecting a focus point and you get to one of the points on the edge, you cannot select any further in that direction. If you activate "wrap-around," focus point selection can be a little easier. See page 175 of the D90 manual for more details.

AE-L/AF-L for MB-D80 The MB-D80 is an optional battery pack that can be attached to the bottom of the D90. In addition to providing longer battery life, it also includes an extra shutter button and AE-L button, which are easier to access when shooting in portrait orientation. This setting lets you customize the function of the AE-L button on the MB-D80. See page 176 of the D90 manual for more details.

Live View Autofocus As you've learned, Live View offers three different autofocus options. This setting lets you determine which mode is active by default.

Customizing Metering/Exposure Settings

If you regularly use exposure compensation or flash exposure compensation, then you might want to look at some of these settings, which allow you to tweak and fine-tune those controls:

EV Steps for Exposure Cntrl When using exposure compensation or flash compensation, the D90 defaults to 1/3-stop intervals in compensation. With

this setting, you can change the interval to 1/2-stop. This gives you a less gran-ular degree of control but makes it easier to make some calculations in your head, if you're prone to that sort of thing. See page 177 of the D90 manual for more details.

Easy Exposure Compensation By default, to change exposure compensa-tion, you must press and hold the ⊠ button while turning the Main dial. This can be cumbersome if your hands are small or if you're wearing gloves. With this option, you can change the camera's behavior so that you don't have to hold down the button to change exposure compensation. When set to On, you can turn the appropriate dial to change exposure compensation. In Pro-gram or Aperture Priority mode, you'll use the subcommand dial; in Shutter Priority mode, you'll use the Main dial.

Center-Weighted Area This option lets you control the size of the area that is used to bias center-weighted metering. Smaller makes it possible to ensure a particular object in your scene is properly exposed; larger will improve your chances of an overall better exposure. See page 178 of the D90 manual for more details.

Fine Tune Optimal Exposure If you find that a particular metering mode consistently over- or underexposes, you can tweak the camera's metering using this option. So, for example, if you find your particular D90 is always, say, a third of a stop under, you can tell it to automatically adjust itself up a third of a stop. See page 178 of the D90 manual for more details.

Customizing Timers/AE Lock Settings

You can customize exposure lock, the self-timer, how long the LCD screen stays on, and more, using these settings:

Shutter-Release Button AE-L By default, if you want to lock exposure, you must press and hold the AE-L button. You can change this parameter so that exposure locks as long as you half-press the shutter button.

Auto Meter-Off Delay By default, when you half-press the shutter and the camera meters, it will continue to display the metering for six seconds before discarding it. You can change the amount of time it holds onto the metering, by altering this setting. A longer setting can be handy if you're working on a

product shot or some other type of shoot that takes a while to set up. See page 179 of the D90 manual for more details.

Self-Timer The D90's self-timer defaults to a duration of 10 seconds between the time you press the button and when the camera finally fires. You can change the length of this delay to 2, 5, or 20 seconds. Longer delays are better if you need more time to get in the shot. A two-second delay is handy when you're working on a tripod and want to prevent camera shake. Press the shutter button, and after two seconds, the camera should have stopped vibrating. See page 179 of the D90 manual for more details.

Monitor-Off Delay You can change the amount of time that the LCD screen remains on using this option. Normally, if no actions are taken on the camera, the monitor shuts off after four seconds. Shorter times are good for preserving battery life; longer times are handy if you need more time to work with the screen. See page 180 of the D90 manual for more details.

Remote on Duration If you're using a remote control, this option lets you control how long the camera will wait for a signal from the remote. See page 180 of the D90 manual for more details.

Customizing Shooting/Display Settings

Look in this menu to silence the camera's beep, add a grid to the viewfinder, and more.

> **TIP**
>
> To change a setting, simply navigate to it, and then click OK. The camera will present an editing screen that lets you adjust your chosen parameter.

Beep You've probably already noticed that the D90 beeps on all sorts of occasions. If you are shooting somewhere where silence is imperative, you can turn off the beep with this option. See page 180 of the D90 manual for more details.

Viewfinder Grid Display When turned on, the D90 will display a grid of lines in the viewfinder to aid level shooting. This can be very handy when taking landscape shots. See page 181 of the D90 manual for more details.

ISO Display and Adjustment This allows you to control whether ISO is displayed in the viewfinder and control panel. This also lets you configure the camera so that the ISO can be changed with a command dial, rather than a combination of the ISO button and command dial.

Viewfinder Warning Display This allows you to specify warnings that are displayed in the viewfinder. You can choose to see a warning when the Monochrome Picture Control setting is activated, when the battery is low, or when the camera lacks a memory card. See page 181 of the D90 manual for more details.

Screen Tips This lets you control whether help information is displayed. See page 182 of the D90 manual for more details.

CL Mode Shooting Speed When shooting in the slower continuous mode, you can choose from one to four frames per second for the camera's continuous speed. This allows you to fine-tune performance to your particular shooting needs. See page 182 of the D90 manual for more details.

File Number Sequence This lets you control how the camera picks up file numbering when a new card is inserted. See page 182 of the D90 manual for more details.

Shooting Info Display This lets you control the coloring of the **Info** display. You can choose dark on light or light on dark. Depending on whether you're in direct sunlight or low light, changing the coloring can make the screen easier to see. See page 183 of the D90 manual for more details.

LCD Illumination Normally, if you want to turn the light on behind the control panel, you have to manually use the LCD light switch (turn the power switch past on). You can change this option to activate the light any time the camera meters. For working in low light on a tripod, this can be handy. See page 183 of the D90 manual for more details.

Exposure Delay Mode Normally, the shutter fires when pressed all the way down. With this option, you can insert a one-second delay. This will very likely prevent blurring that can be caused by camera shake when you press the button. This is useful when working with long exposure times. See page 183 of the D90 manual for more details.

Flash Warning When this feature is active, the D90 will flash the ⚡ icon in the viewfinder whenever the flash is needed. See page 183 of the D90 manual for more details.

MB-D80 Battery Type This lets you specify the type of batteries you're using in the optional MB-D80 battery grip.

Custom Bracketing/Flash Settings

The D90 boasts an excellent flash system, and these controls let you customize it further:

Flash Shutter Speed Allows you to specify the slowest shutter speed allowed when using slow-sync or red eye reduction flash. This can be handy for fine-tuning your night shots, though this is probably not a feature you'll use very often. See page 185 of the D90 manual for more details.

Flash Cntrl for Built-in Flash Lets you change the built-in flash from auto output to manual adjustment. This also allows you to activate more advanced flash features such as a modeling flash and the ability to slave other flash units off of the D90's built-in flash. As you learn more about flash photography, this feature will become handy. See page 185 of the D90 manual for more details.

Auto Bracketing Set Lets you specify all the parameters that are bracketed when using the auto bracketing feature on the camera. You've learned how you can use auto bracketing to automatically bracket exposure, but you can also use it to bracket flash exposure, white balance, and d-lighting. If you're not sure exactly what d-lighting, flash exposure, or white balance fine-tuning setting to use, bracketing these features might be a good way to get the shot. In reality, you'll probably find that you use bracketing only for exposure. See page 191 of the D90 manual for more details.

Custom Controls

The D90's physical controls are very customizable. Using these options you can swap dial functions and more:

☼ Switch By default, rotating the power switch to the ☼ position activates the control panel backlight. Using this option you can configure it to also activate the shooting information display.

Assign FUNC. Button On the front of the D90 body, between the lens and the handgrip, is a programmable button. Using this feature you can configure it to perform any one of 10 functions. This can be a handy way of getting quick access to a commonly used feature. I configure mine for spot metering. Although matrix metering is great for most shots, I like having quick access to a spot meter for tricky lighting situations. See page 197 for a complete list of options.

Assign AE-L/AF-L Button Normally, the AE/AF Lock button lets you lock exposure. Using this option, you can fine-tune it to lock different combinations of exposure and focus. See page 200 of the D90 manual for more details.

Customize Command Dials The D90's two command dials are critical for changing settings and configuring the camera. You can change their behavior using this custom option. If you have an easier time reaching one dial or the other, you might want to reverse their functions. You can also change how they are used to drive the camera's menu system. See page 201 of the D90 manual for more details.

Reverse Indicators By default, the exposure compensation readout shows positive values to the left and negative values to the right. Personally, I find this completely backward. Fortunately, you can reverse this readout using this setting.

Lenses

One of the great joys of working with an SLR is having the option to change lenses. If you're stepping up to the D90 from a point-and-shoot camera, then there's a whole world of new shooting possibilities for you to explore (and a whole new way to drain your wallet).

By changing the lens on your camera, you can do the following:

- Shoot with different focal lengths, from super-wide to extremely telephoto.

- Get higher-quality images. A better lens can improve contrast, color, sharpness, and other less definable characteristics of an image.

- Shoot in lower light. A faster lens—that is, one that can open to a wider aperture—will give you the option to shoot in much lower light. An f1.4 lens, for example, can make it possible to shoot at handheld shutter speeds in outright dark situations.

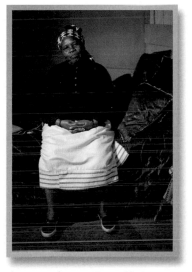

With an extremely fast lens—such as a 50mm f/1.2—you can shoot in extremely low light at faster shutter speeds, making it possible to capture images that would be impossible with a slower lens.

- Shoot with different effects. Fish-eye lenses, the Lensbaby, and other specialized lenses let you create effects that would be unattainable with other lenses and very difficult to produce with editing software.

Choosing a Lens

Your first decision when choosing a lens is to determine what type of shooting you think you want to be able to do. The 18-105mm lens that ships with the D90 is a great, general-purpose, "walk-around" lens. It delivers good quality and is stabilized for easier low-light shooting. It also has a focal length range that's suitable for most everyday situations. So, what might you want in addition to this lens? Think about these questions:

- Do you often find you want to be able to zoom in closer than you can with the 18-105mm lens or that you're regularly cropping your images to focus on a specific detail? If so, you should probably opt for a telephoto lens of some kind.

- Conversely, are you regularly frustrated by the 18mm end of things because you don't feel it's wide enough? Then you might be better served by a wide-angle.

- Do you shoot a lot in low light and find yourself unable to get sharp images because your shutter speeds are too slow? If so, you need a faster lens, one with a very wide maximum aperture (f2.8, 2, 1.8, 1.4, or 1.2).

- Do you find yourself frustrated with a lack of sharpness in your image or strange color fringes around certain high-contrast areas?

The purple and green fringes on the edge of this column are examples of chromatic aberration. These areas are places where the lens has not focused all of the wavelengths of light equally, leaving some out of registration with the others.

If you have this type of problem a lot, then you need a higher-quality lens. In addition to opting for better quality (which, yes, means more expensive), you'll still need to identify your focal length and speed needs.

Once you've identified the type of lens you're looking for, you'll be ready to start comparison shopping to find the specific model that's right for you.

Nikon Lens Taxonomy

Over the years, Nikon has made lots of different lenses. As new lens technologies have come along—auto focus, vibration reduction, new glass technologies—Nikon has indicated these features and technologies by appending initials to the name of the lens. If you're shopping for a used lens, you might find some old designations, such as C, which used to indicate that the lens was coated to reduce flare and diffraction. Since this is now a standard practice, Nikon no longer uses this designation.

These days, you need to worry about only a few indicators, especially if you're shopping for a new lens:

- AF indicates that the lens is autofocus capable. That means it will work with the autofocus system on the D90, in the way that you've experienced with your kit lens.

- AF-S lenses are autofocus lenses that use a *silent wave motor* to move the focusing mechanism. These lenses are quieter than regular AF lenses. You'll typically find this designation only on longer lenses.

- VR indicates that the lens sports Nikon's vibration reduction feature, which helps reduce the tiny vibrations that your hands produce. With a VR lens, you'll be able to use longer shutter speeds in low light.

- DX lenses are lenses that are designed specifically for the sensor size found on the D90 (and its predecessors and siblings, such as the D50, D60, D80, and D300). There are some excellent DX lenses, and there's no reason to avoid DX options. However, note that a DX lens will *not* work on a Nikon 35mm film camera or on any Nikon cameras that have a full-frame sensor, such as the D700 and D3. So, if you think you might ever upgrade to one of these cameras, then you may want to think twice before investing in DX glass.

Finally, Nikon's brand name for its lenses is Nikkor, so any lens that you see sold by Nikon will have Nikkor in the title.

Let's look at a specific lens listing from Nikon's catalog: the AF-S VR Zoom-Nikkor 70-200mm f/2.8G IF-ED. This is a 70-200mm zoom lens with Nikon's quieter auto-focus system. It has a maximum aperture of 2.8. The G indicates that the lens does not have an aperture ring—aperture can be set only electronically from the camera. This indicates that the lens may not work with older cameras that rely on manual aperture control. The IF indicates an internal focus mechanism, which means the lens will not physically extend and contract as you focus. If you regularly shoot in harsh, dusty environments, this can be an important feature. Finally, ED means that the lens uses extra-low dispersion glass. This helps cut down on the colored fringe artifacts that you saw previously.

Let's take a look at one more example, the AF Zoom-Nikkor 70-300mm f/4-5.6G. This is an autofocus zoom lens with a zoom range of 70-300 mm. At its widest angle, 70mm, it will have a maximum aperture of f4. At its longest range, it will have a maximum aperture of 5.6. The maximum aperture will vary accordingly throughout the zoom range.

Prime vs. Zoom

Prime lenses have a fixed focal length. So, a 50mm prime lens can shoot *only* at a 50mm focal length (which is effectively a 75mm focal length on the D90). Zoom lenses, as you've seen, have variable focal length. It used to be that prime lenses always offered better image quality than zoom lenses, but that's not always the case now. However, as you saw earlier, having a fixed focal length can be a very interesting way to shoot because it makes you compose and frame in a very specific way. So, you may find that you *like* not having the zooming options, especially if you're hungry for a fast lens. The fastest lenses available are all primes. But in general, as far as image quality goes, you don't have to feel like you're giving up quality if you buy only zoom lenses.

Some Lens Suggestions

Here are my recommendations for currently available Nikon lenses that fill the different lens categories I mentioned earlier.

Telephoto Zoom

Nikon AF-S DX VR Zoom-Nikkor 18-200mm f/3.5-5.6G IF-ED This is not the sharpest, highest-quality lens that Nikon offers, but its startling zoom range of 18-200mm, combined with its small, lightweight design and reasonable price tag, make this the *ideal* walk-around lens. You'll be hard-pressed to find a situation that can't be covered by this spectacular zoom range. Engineering a lens with this kind of range isn't easy, and Nikon has done a great job with it. Still, though, you'll see occasional colored fringes, softer images at the extreme of the zoom and aperture ranges, and a generally lesser overall image quality than you'd get with an expensive Nikon zoom or prime lens. But, for most everyday tasks, having to carry only one small lens that can cover so many situations makes this a hard option to beat.

Nikon AF Zoom-Nikkor 80-200 f/2.8D ED If you're serious about sports or nature shooting, this long, fast, high-quality lens will offer excellent results. Although it lacks vibration reduction, its fast 2.8 aperture lets you use faster shutter speeds.

Wide Angle

Nikon AF-S DX Zoom-Nikkor 12-24 f/4G IF-ED Although the 18-105 offers a nice wide angle, the 12-24 offers an ultrawide view (equivalent to an 18mm

lens on a 35mm camera) and great image quality. If you like shooting with a wide angle of view, this is a great lens.

Prime

Nikon AF Nikkor 50mm f/1.8D This is probably one of the best values in lenses that you'll find for the D90. Offering exceptional optics and a fast maximum aperture of 1.8, this lens can be found for around $100. Don't expect much in the way of physical quality—it's a cheap plastic lens, and it feels like it. But if you need to shoot in low light, this is a great lens. Remember, a 50mm on your D90 is going to be equivalent to 75mm on a 35mm camera. So, this lens ends up being a great portrait lens with a flattering focal length and a wide, background-blurring aperture.

Specialty Lenses

Nikon AF-S Micro Nikkor 60mm f/2.8G ED If you're interested in macro photography, this is a great alternative that offers very great quality in a small package.

Nikon AF Fisheye-Nikkor 16mm Fish-eye lenses aren't for everyday use, but if you're looking for an unusual perspective, they can be a lot of fun, and this lens offers great quality in a solid package.

> **TIP: Third-Party Lenses**
>
> Nikon is not the only company that makes lenses, of course. Sigma and Tamron, among others, make some very good lenses that are compatible with your Nikon D90, including models that compete with the lenses mentioned here. These lenses are worth considering, but do your research, and see what other users are saying about their experiences with the particular models you're interested in.

Evaluating a Lens

Once you've picked a lens (or lenses) you think you're interested in, you'll want to get your hands on it and take it for a test-drive. If you have a local camera store that stocks these lenses, they should be able to answer any questions you have and may even let you try the lens in the store. Take your camera with you, and shoot some images. When you get home, you can examine the results up close to try to assess quality.

Presumably, by the time you're ready to test a lens, you will already have determined that it has a focal length range and maximum aperture that suits your needs. Consider these additional issues when evaluating a lens:

Sharpness Look at the fine detail in your sample shots. Does it hold up? Is it clearly rendered? Does the camera stay sharp throughout its aperture range? Shoot at wide open; then shoot again at f16 or f22. Is there a sharpness drop-off? If there is, that's not a deal breaker. Most cameras have an sharpness sweet spot that sits within a specific range of apertures. Ideally, you want this range to be as wide as possible.

Chromatic aberrations Are there weird purple, blue, or magenta fringes around high-contrast areas in your scene? This can be hard to test in a camera store, but if they'll let you step outside, try shooting through some trees against a bright sky or along telephone wires. You'll most likely find these issues on the edges of the frame. Also, try a range of apertures. Sometimes, these colored fringes show up only at the extremes of the aperture range.

Distortion Does the image bow inward or outward at the edges of the frame? Wide angles will almost always have a little distortion, and you can usually correct it in a good image editor. Still, it's good to know whether the lens has these issues.

The upper-left image suffers from barrel distortion, which causes the lines to bow outward. The upper-right image is fairly distortion free, while the lower image has a problem with pincushion distortion, which causes its lines to bow inward.

Vignetting This is a darkening of the corners that usually appears in wide-angle lenses and usually only with wider apertures. Although it can be corrected, it's something you'd rather avoid, so look carefully for any vignetting problems.

This image suffers from vignetting, a darkening of the corners. Vignetting isn't always bad, and in this image it serves to draw more attention to the center. However, you don't always want vignetting, so it's good to know ahead of time whether a lens has this tendency.

TIP: Rent Lenses for Evaluation

A number of online lens rental services will rent you lenses by mail for very reasonable prices. This can be the best way to make a decision about a lens because you can shoot with the lens for a few days, on your own terms. Check out *www.rentglass.com* or google *lens rental*.

Index

autofocus
 and autofocus assist, 122
 in Auto mode, 4, 5–8
 center-point, 119
 Continuous Servo, 118, 119
 custom functions for, 260–61
 for focus point selection, 114
 lens controls, 46–47
 in Live View, 215–16, 217
 mode location, 32–33, 34
 problems in low light, 121–22
 in Program mode, 112–22
 Single Servo, 116, 119
 when autofocus doesn't work, 120–21
Auto Gain control, 233
Auto mode
 Auto Select mode and, 119
 for exposure, 109–10
 LCD control panel in, 10
 menu system, 37–39
 for snapshot shooting, 4–8
 for white balance, 131, 136, 137
 See also autofocus; Full Auto mode

B

backgrounds
 with backlighting, 21–22, 150
 in composition, 206–9
 to create blurring of, 123
 and depth of field, 104–5
 with fill flash, 180–81
 issues with, when shooting, 20
 in Night Portrait mode, 15–16, 174
 in Portrait mode, 14
backlighting, 21–22, 150
back of camera controls, 36–37
balance, in composition, 201–3
barrel distortion, lens, 272
batch processing, 253
battery
 compartment location, 37
 levels in viewfinder status display, 8
 packs, 261, 265
 recharging, 2, 239
 tips for using, 29–31
bending, to view subjects better, 20
bit depth
 and editing latitude, in raw shooting
 format, 248, 249, 250–52
 as relates to color in digital photography, 108

black, exposure and, 155–56
blower brushes, for lens cleaning, 47–48
blurring, intentional, 123
 See also shutter speed
body cap, for lenses, 44
body parts of the camera, 32–37
bottom of camera features, 37
bouncing a flash, 245–46
bracketing
 button, location, 33
 custom functions for, 265
 exposure, 171–73
 white balances, 8
brightness, 180, 241
 controlling light and, 101
 and digital image sensors, 94
 and histograms, 160
 and JPEG image processing, 177
 of the LCD screen, 57
 metering modes and, 150, 153
buffer, camera, in Drive mode, 140–41
Bulb mode, 97, 99, 228
bursts, shooting, 140–41

C

calendar view, 59–60
camera buffer, in Drive mode, 140–41
camera parts, 32–37
camera position
 for panorama shooting, 217
 for portrait snapshots, 17–19, 198–201
camera shake
 mirror lockup, for long exposures, 228–29
 relationship to shutter speed, 103
 using self-timer, to avoid, 141–42
camera status display button, 39
candid shots, 17, 139
Capture NX, 248, 256
CardBus card reader, 74
card readers
 and manual image transfer, 82, 86
 to transfer images, 74–76
 using Windows or Macintosh, 76, 79,
 80–82, 86–87
CCD sensors, 92
center focus point, 117, 119, 261
center-weight
 area, 262
 metering mode, 151–52
channels, color, 109

Learn from a Master

Boundless enthusiasm and in-depth knowledge...

That's what Deke McClelland brings to Photoshop CS4. Applying the hugely popular full-color, One-on-One teaching methodology, Deke guides you through learning everything you'll need to not only get up and running, but to achieve true mastery.

- **12 self-paced tutorials** let you learn at your own speed
- **Engaging real-world projects** help you try out techniques
- **More than five hours of video instruction** shows you how to do the work in real time
- **850 full-color photos, diagrams, and screen shots** illustrate every key step
- **Multiple-choice quizzes in each chapter** test your knowledge

digitalmedia.oreilly.com